Rangefinder's

PROFESSIONAL PHOTOGRAPHY

Techniques and Images from the Pages of *Rangefinder* Magazine

Edited by

BILL HURTER

AMHERST MEDIA, INC. ■ BUFFALO, NY

Copyright © 2007 by Bill Hurter.
All rights reserved.

Front cover photograph by Fernando Escovar (www.fotographer.com).
Back cover photograph by Rainer W. Schlegelmilch (www.schlegelmilch.com).

Published by:
Amherst Media, Inc.
P.O. Box 586
Buffalo, N.Y. 14226
Fax: 716-874-4508
www.AmherstMedia.com

Publisher: Craig Alesse
Senior Editor/Production Manager: Michelle Perkins
Assistant Editor: Barbara A. Lynch-Johnt

ISBN-13: 978-1-58428-193-1
Library of Congress Control Number: 2006925661

Printed in Korea.
10 9 8 7 6 5 4 3 2 1

Notice of Disclaimer: The information contained in this book is based on the author's experience and opinions. The author
and publisher will not be held liable for the use or misuse of the information in this book.

CONTENTS

INTRODUCTION

Photography and cooking may not have much to do with each other except that a great shot, like a great entrée, has a set recipe of ingredients and procedures. Hence the idea for a photographic cookbook, with various recipes and procedures that define how a great photograph was made.

The concept is not new. In fact, Jen Bidner, one of the significant contributors to this book, coined the phrase in a book she authored called *The Lighting Cookbook: Foolproof Recipes for Perfect Glamour, Portrait, Still Life, and Corporate Photographs* (Amphoto, 2003). As a contributor to *Rangefinder*, one of the leading trade magazines for professional photographers, Jen helped the magazine introduce the concept to its readers in 2004. The feature, known as the "R*f* Cookbook," has become—and continues to be—one of the most popular features in the magazine. The contents of this book are derived from those articles in *Rangefinder*.

The photographers who appear in this book are well known for various specialties: portraiture, wedding, commercial, and fine-art photography—and just about every discipline in between. The writers who penned the articles are also frequent contributors to *Rangefinder* and well established journalists.

This book was edited by myself, Emily Burnett (feature editor of *Rangefinder*), and Oliver Gettell (editorial assistant of *Rangefinder*). The production was done by Michelle Perkins, senior editor and production manager at Amherst Media, and Barbara A. Lynch-Johnt, assistant editor.

We wish to thank all of the writers, photographers, editors, designers, and production staff that made this project a reality.

—Bill Hurter
Editor, *Rangefinder Magazine*

1. COMMERCIAL PHOTOGRAPHY

Above all, commercial photographers are consummate problem solvers.

Commercial photographers are primarily assignment photographers: "Photograph an ad for our new frozen chicken entrée, and give it a continental personality." Or the assignment might be to photograph an aerial view of an atoll in the South Pacific for a travel magazine.

Commercial photographers wear many different hats. One day, a commercial shooter might be a portrait artist, photographing a CEO for an annual report. The next day, the same photographer might be photographing a perfect soufflé for a restaurant ad. Commercial photographers are well schooled in a wide range of photographic disciplines. They must be lighting experts, technical wizards (because they are always pushing the limits of the various media they employ) and, above all, consummate problem solvers. Logistics, propping, posing, lighting, time management, cost, complexity, and many more variables enter into the commercial photographer's daily routine.

In this chapter we present some interesting and unusual assignments.

David Wendt, an automotive photographer who self-publishes his own calendars, photographs a rare 1934 MG-NA race car in a way that looks like the classic sports car is breaking a land-speed record.

Another interesting assignment was to photograph a Judith Lieber handbag in an extraordinary way. Fernando Escovar, a Los Angeles commercial shooter, was certainly up to the challenge.

A "typical commercial assignment" is outlined by Christian Lalonde. It called for six hotel and resort lobbies to be photographed in one day, with models and a set theme—the final digital image being due at the end of each shoot.

Regardless of the complexity of the assignment, commercial photography provides an educational forum in creative problem solving and diversified photographic techniques.

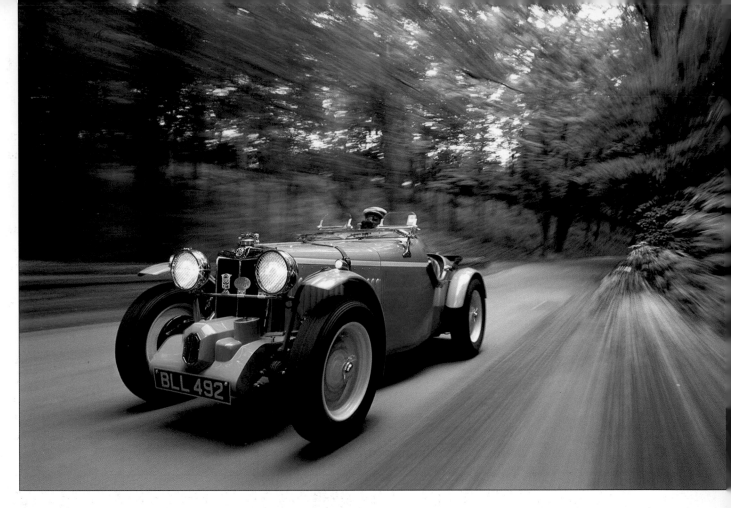

David Wendt: The King of Jury-Rigging Makes a 1934 MG-NA "Fly"

The self-described subjects of one of David Wendt's car calendars are "fast, expensive cars"—and the 1934 MG-NA racecar shown here certainly fits that bill. The bulk of Wendt's Cincinnati-based photography business is driven by his self-published calendars, which sell extremely well each year.

Wendt has learned, however, that it is not enough to do a showroom-style product shot of the car. To create calendars that sell tens of thousands of copies, he specializes in creating interesting and exciting photographs of vehicles.

Part of his flair comes from the spontaneity of his shooting style. "I like to 'wing' things on my shoots," explains Wendt. He prefers to show up and conceptualize the shot on the spot, rather than do a whole lot of pre-planning. And he is the king of jury-rigging.

To shoot this racecar, he started by scouting a location and finding the right model driver. Next he tied the vintage 1934 racecar to the bumper of his own Audi with a clothes-

line. He began building a unique camera rig that was secured onto his own car with a suction cup, clamps, light poles, and gaffer's tape. A long air plunger shutter release reached to his position so he could remotely fire the camera. His assistant drove the Audi, either towing the racecar or letting it roll backwards down a slope.

Amazingly, the total shoot took less than an hour, from his first arrival on the location, through building the rig, shooting the image (two rolls of 220 film), and tearing down the camera setup.

The final image was actually a digital combination of two exposures made on medium-format film. He had 4000dpi drum scans made of the best time exposure (two to three seconds to get a nice blurred background) and the best frozen exposure. He layered the frozen image over the blurred image and matched them as closely as possible. Next he erased most of the frozen image, keeping only the important details (such as the grill and headlights) so that they appeared sharper than was possible in the time exposure.

David Wendt's art prints, posters, and calendars are available through his website at www.wendtworldwide.com. The MG-NA racecar photograph shown in this article appeared in his 2004 *Fast Expensive Cars* calendar. —*Jen Bidner*

INGREDIENTS

Camera: Pentax 645N
Lens: 45–85mm Pentax zoom
Film: Kodak Ektachrome 100VS 220
Car Rigging: Clothesline from his bumper to the racecar
Camera Rigging: Makeshift device made from suction cups, light poles, clamps, and gaffer's tape
Accessories: Air plunger for triggering the camera

The color palette of the Costa Rican winter sky has no limits. Red dawn bleeds into the new day of the Central Americas. Gold and purple ebb and flow together at sunset. Along the western shore of Playa Hermosa, *la pura vida* is ever-present. The light itself expresses it with vitality.

This strip of coastline is beautiful. Surfers come from all over the world to ride the hollow beach-break, known for its board- and bone-breaking power. Iguanas roam about regally and perch in the warm sunlight. Costa Rican teak trees grow wild along the shores, and the jungle canopy covers the mountains to the east. The silt-like sand is as black as the metamorphic bedrock.

On this particular scene I ended up shooting a whole roll of 220 film—32 exposures with my Pentax 645N II. The tonality change of the light shifted so incredibly from burnt orange, to red, to the soft purples of this later shot that I couldn't take my eyes from it. The waves sent white, foamy surges up the steep beach embankment, which would reach an apex and then plummet back down into the ocean. The light beamed off the wet sand from the receding water and added an appealing element to the picture.

I stopped down the lens for enough depth of field (f/11), while slowing the shutter speed (four seconds) to allow the moving water to blur. With three stops of graduated neutral density darkening the sky, I kept the normal exposure on the sand in the lower right of the frame. Letting this section go black or overexposing the sky would have taken away from the image considerably.

I came away with many good shots, but two in particular stand out. The strange thing is how dissimilar they are. Although facing the same direction and varying by only fifteen minutes and 27mm in focal length, it is hard to tell it is the same scene. With the thunderclouds on the horizon, the light bends, and the colors change dramatically. A different show is promised every few minutes.

INGREDIENTS

Camera: Pentax 645N II
Lens: Pentax P-FA 645
 55–110mm f/5.6 at
 107mm setting
Exposure: 4 seconds at f/11
Film: Kodak E100VS, pushed
 ⅓ stop
Tripod: Manfrotto Carbon
 Fiber 3443
Tripod Head: Manfrotto 3030

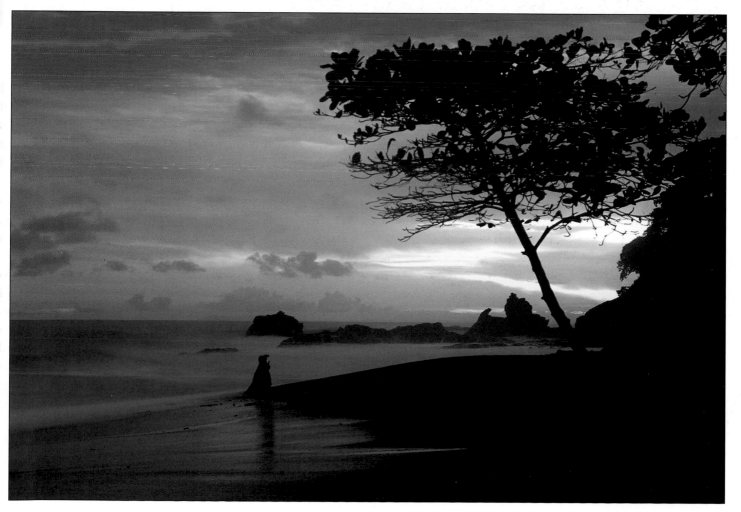

Mateo Muñoz: Onions Still Life

The process of creating work for advertising or commercial use is exciting and interesting and involves more than just interesting ideas. As a photographer, I try to literally and figuratively see the products or the project from every aspect, in 360 degrees. It's important for me to consider aspects such as point of market, retail cost, characteristics, and quality of the products, because this is the only way to create the right image for the client. My goal as a photographer is to help my client to sell more. The creativity is that element of the photograph that anchors people to the image.

This particular photo was created during one of my advertising classes at Brooks Institute of Photography in Santa Barbara, CA. The idea was to create an interesting image of produce.

The photo was captured with a Nikon D100 digital camera with a 105mm Nikon lens. On the left side was a medium softbox; on the right side, a white card to modify the density of the shadow. It was very important to do a white balance before the main capture. This helps to obtain neutral tones. In addition, I used Adobe Photoshop to open the RAW file. Photoshop gave me the ability to change the white balance if necessary. However, the only color correction made to the image was increasing the contrast and adding saturation in the green channel.

Digital cameras capture a wider range of tones compared with some films. Sometimes, this can make the file look flat. I find that adjustment layers are a great tool of Photoshop, giving me all the control I need to do changes in the future. In the photo of the green onions, the main layer was duplicated. To sharpen the image, the High Pass filter was applied with layer mode set to Hard Light. This allowed me to control and adjust the amount of sharpening without altering the main layer. Adjustment layers are also very useful when I am working with different outputs, because I can create any adjustment depending on the gamut of the output device. The final piece was printed on an Epson Photo Stylus 2200.

My goal was to deliver a clear, fresh message that would show the produce with beauty. This image is a good piece within my portfolio and represents my style well. On the other hand, I have to say that I am the kind of photographer who believes the right equipment is necessary to create the perfect image. I need to know and feel comfortable with the equipment. Digital technology is bringing more control and autonomy to my photography, and I love it.

INGREDIENTS
Camera: Nikon D100
Lens: Nikon 105mm macro
Lighting: Norman 2400 watt-seconds
Computer: Apple PowerBook G4
Other: PocketWizard radio slave
Software: Adobe Photoshop
Printer: Epson Photo Stylus 2200

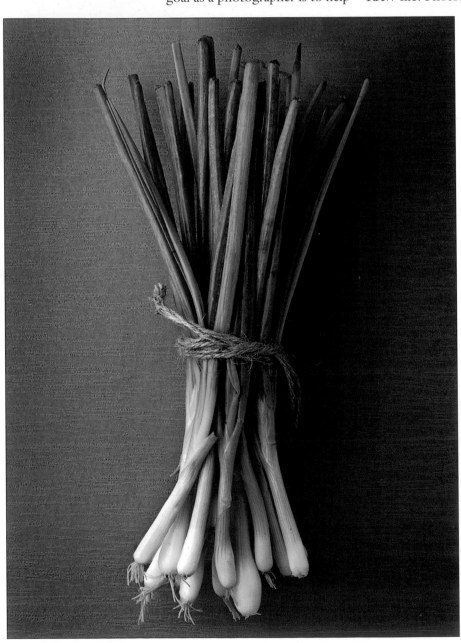

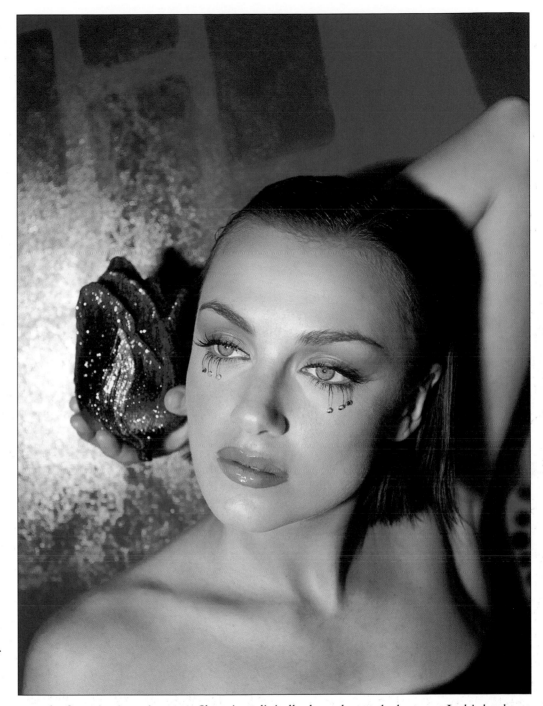

Sometimes, companies keep running their ads over and over again because they work—or because they get lazy. Then all of a sudden they must change it, or a new product has come out, and they have to change it now!

Here, the rose is actually a glitzy, glamourous evening bag. The imagery had to express the same feeling.

Choosing the model for the shoot was half the battle. We wanted a classy, vintage young face with a look that said "opulence." We started with rhinestones on her eyelashes and continued with a bold red painting in the background.

I placed a single, undiffused, tungsten 500-watt light in a parabolic reflector just slightly to the left of my camera angle, so that the light would not create a deep shadow on the model's nose. Also, the light needed to reflect off the painting around the rose handbag so it would separate from the rich red of the background.

Using my Canon 1DS with a 17–28mm lens at the 28mm setting, I shot in RAW file mode (11MP) with a shutter speed of $\frac{1}{250}$ second, an aperture of f/4, and an ISO of 100. I made slight adjustments to the shutter speed after viewing the images on the camera's LCD. After "feeling it," I stopped and put the CF card in the card-reader attached to my 15-inch PowerBook, and I opened the images up in the Preview application all at the same time. Once opened, we could really view the images and make more changes or get some new ideas.

INGREDIENTS
Camera: Canon EOS 1Ds
Lens: Canon EOS 17–28mm
Setting: RAW, 11MP
Exposure: $\frac{1}{250}$ second at f/4
Lighting: Tungsten 500-watt
Hardware: 15-inch Apple
 PowerBook with CF card
 reader

Shooting digitally has changed the way I think about lighting in the sense that with minimal lighting one can accomplish many looks. The ability to instantly verify the effect of your lighting makes shooting complex assignments on deadline much, much easier than in the past.

This basic set-up produced a rich and moody image. I later retouched the image in Adobe Photoshop to remove some slight imperfections. This image was a team effort with makeup by Jeffrey Paul and hair by Chad Cardoos, both from Los Angeles.

Fernando Escovar: Shoot for *Hollywood Hot Shoots*

Yes, photography is finally reaching the reality-TV airwaves with a show on the Men's Channel television network. *Hollywood Hot Shoots* is produced by Dice Films, which has a three-year deal with the Men's Channel to produce 26 episodes a year. They will run three times a week at different times. The show visits various photographers from around the nation and looks at how they shoot and how they deal with the drama of high-profile photo sessions.

The host, yours truly, will ask the questions, break down the set-up, and follow each of the photographers through each shoot.

The show is based mostly on celebrity photographers but there is also a segment in the program called "The Shot-Maker" where the show covers the photographers that capture amazing jet stills, action car shots, skydiving images, etc. *Hollywood Hot Shoots* is cc sponsored by Photoflex.

One of the first episodes is a photo session with Georg Lopez using a combination of lighting. The combo is dua purpose in this application. We used two Pampalites on C stands both directed at Mr. Lopez. These fluorescent-lik lights helped me focus and expose some of the shots, whil they also help the video crew capture great footage.

Along with a ProFoto Ringlite and a Canon EOS 1Ds a 100 ISO set on RAW (1/80 second at f/16), I handheld th camera and by moving side to side helped keep George' attention. It's hard photographing a great comedian; he ha us laughing, and we didn't have him for a long period o time. The lens I used was Canon EF 70–200mm f/2.8 USM with a solid white background. The CompactFlash card usec was an Extreme II, 2GB card.

For more information on *Hollywood Hot Shoots,* visit www .dicefilms.com.

INGREDIENTS
Camera: Canon EOS 1Ds
Lens: Canon EF 70–200mm f/2.8L USM
Exposure: 1/80 second at f/16
ISO: 100
Lighting: ProFoto Ringlite and Pampalites
Other: Extreme II 2GB CF card

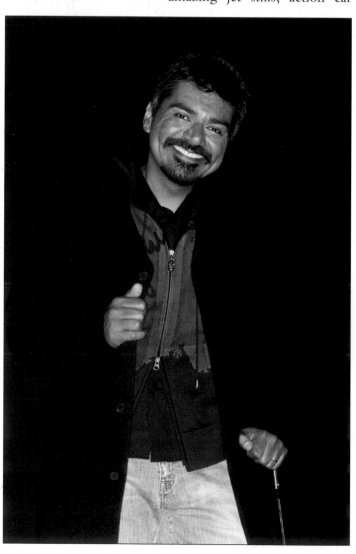

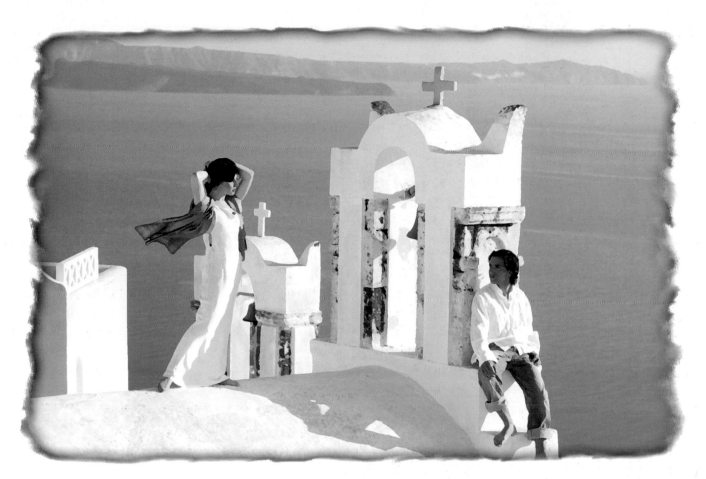

Bleu Cotton: *Lovers*

Bleu Cotton from Costa Mesa, California, photographed *Lovers* in Santorini, Greece. The image was created by a series of events and was produced by a team of strangers coming together within a 24-hour period.

Bleu and his wife, Alison, were photographing an engagement session in Athens, Greece, and were scheduled to continue the session with more formal poses on the island of Santorini. The engaged couple changed their plans and were unable to join Bleu and Alison on the island.

Bleu had brought a silk wedding dress for the formal portion of the scheduled session and now had no one to wear it. The series of events unfolded: Bleu and Alison befriended an Australian that spoke Greek. That evening while watching the sun set at the northern point of the island, Bleu knew he wanted to photograph the sunset with a couple's silhouette in the foreground. Their new Australian friend helped by translating for them and asked some Peloponnesian college students if they would mind being in the photograph. The initial images were made and viewed on his Canon EOS 1D. Bleu asked, again with the help of his translator, if the young woman would be willing to wear the silk dress and if the couple would model for them around the island the next afternoon; the couple agreed.

Bleu and Alison purchased a silk scarf to complete her outfit and asked her boyfriend to dress in jeans and a white shirt. They walked, explored, and photographed around the town of Oia. This all took place just one week before the tourist season started, so the strangers—models, photographer, stylist, and translator—had time to work together on almost-empty sidewalks, storefronts, and rooftops as they created images most couples only dream of having.

This image was photographed in RAW mode and converted to JPEG in the Canon Digital Photo Professional Conversion Program. It was then retouched in Photoshop, and the Nik Sun Filter and Photoshop Drybrush filter were applied. Finally, an edge from Auto FX PhotoGraphic Edges was added.

The final image was printed in a limited-edition series of 250 images, signed by the artist on watercolor paper as a Giclée print with hand-torn edges. Bleu sums up the experience, "Sometimes if you open yourself up to spontaneity, you can create masterpieces." Visit Bleu Cotton's website at www .bleucotton.com. —*Harvey Goldstein*

INGREDIENTS
Camera: Canon EOS 1D
Lens: Canon EF 70–200mm f/4L USM telephoto zoom
Exposure: $1/1600$ second at f/4 with $2/3$-stop exposure compensation
Software: Adobe Photoshop, Nik Sunshine filter

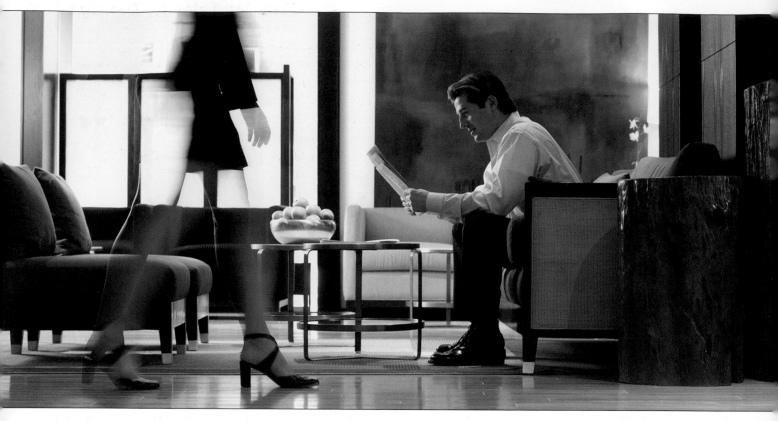

Christian Lalonde: A "Typical" Commercial Assignment

This is one of six images that we had to complete in a single day for Starwood Hotels and Resorts. All of the images were to be the same horizontal format, 6½x13½ inches. The assignment was given to us at 4:30PM on a Tuesday, photographed on Thursday, and the final files had to be delivered via FTP by noon on Friday—now that's a schedule!

All of the images were to have some sort of movement in them. I did not want to have to do all types of digital manipulations (due to time restrictions), so I opted for in-camera effects. At this location, we had a great mix of ambient and window light, but we still needed a kicker (backlight) on the male model. We used a 4x8-foot white panel to light up the background and model. I made sure that the exposure was a bit over on the chairs and background area with an extra softbox coming in from the back right.

I knew that the large window on the left, being overexposed, would give me a great movement effect because of the white space against the almost silhouetted model. We did several tests at various exposures, and ¼ second gave us the best results with the model's walking speed.

I then switched from JPEG format (for quick tests this results in less download time) to NEF (16-bit, RAW format) on the camera. We did our first RAW test, and that was it—we had it! I love digital!

When on location, I always carry a laptop on which clients can see the just-photographed images. I shoot right into the laptop, and the large screen is great for proofing with the clients. I usually place a cropping mask on the screen to show what the final format will look like. This image blew the clients away as soon as they saw it.

INGREDIENTS

Camera: Nikon D1X, shot directly into the Apple PowerBook G3 laptop
Lens: 50mm f/1.4
Strobe: White Lightning 1200s (2) and 600WS strobes (1)
Flash Output: f/4.5
Inside Ambient Reading: ¼ second at f/2.8
Exposure: ¼ second at f/4 on camera, 125 ISO, RAW format, custom curve, no sharpening; white balance off gray card
Computer: Edited on dual processor PowerMac G4 with LaCie 22-inch monitor
Software: Nikon Capture Control for direct download, Nikon Capture Editor for file processing, Adobe Photoshop for the final touches
Output: 6½x13½ inches, 300dpi, Adobe RGB 1998, TIFF

This image was shot as a personal project a few years ago. Here's how I came up with the idea: I'm a big fan of Corona beer.

This photo was shot in studio with two Bowen 600 strobes and a white cardboard reflector. I shot it against a black velvet backdrop in order to get a clean, pure black. My main light was a 2x3-foot softbox positioned over and to the left of my subject. I wanted to make sure to retain the highlight on the bottle all the way through. My reflector was positioned parallel to the bottle and directly underneath. I added a kicker, a Bowens 600 with a 30-degree grid, from the back right to give some separation and highlights.

I took the shot with a Linhof 4x5 view camera with a 210mm Rodenstock lens on Kodak E100 film at 1/500 second at f/8. I mounted the bottle on a studio stand and removed the bottom of the bottle in order to continually run beer through it. The iguana was placed on the bottle and held in place with Crazy Glue (just kidding . . . gravity did the job). I was simply very patient and had a container with padding positioned underneath in case the lizard fell—and believe me, it did. It took approximately three hours between refills and the model falling off to get 10 sheets exposed.

No digital retouching was used in post-production; everything seen in this image was done in the camera, although eventually I might rework the liquid to make it flow more naturally over the lime.

INGREDIENTS

Camera: Linhof 4x5 view camera
Lens: 210mm Rodenstock
Lighting: Bowens 600s (2); one with 30-degree grid, one with 2x3-foot softbox
Film: Kodak E100
Exposure: 1/500 second at f/8
Background: Black velvet
Reflector: White reflector (12x24 inches)
Other: Feeding tube and bottle

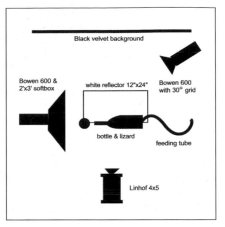

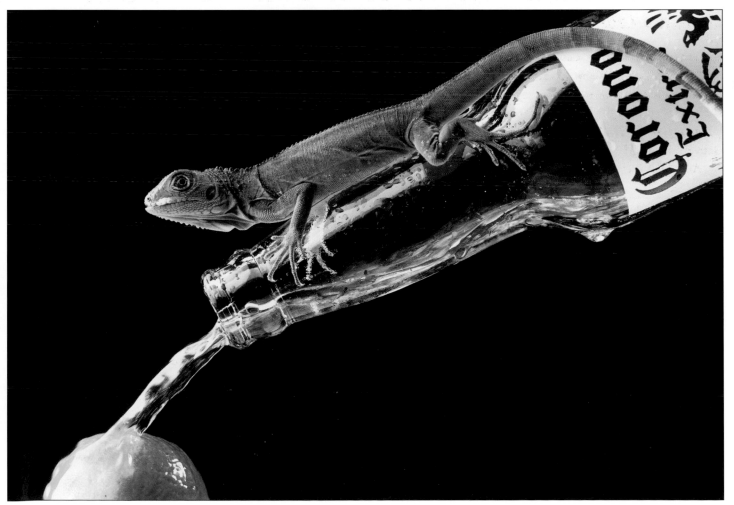

Gene Martin: Anatomy of an Editorial Shoot

I had the opportunity to photograph Les Paul, the guitar legend and recording pioneer, at his home in New Jersey. The assignment was to photograph him with "the octopus," the very first Ampex 8-track recording machine, for the cover of *Attaché*, the in-flight magazine for U.S. Airways.

This was the first time I'd photographed someone of this stature without my trusty Hasselblad and 120 film. The decision was made to capture the image digitally, so a Nikon D1X was chosen to shoot RAW files to be processed later through the 10MP feature in Nikon Capture 4.

After scoping out the area where the machine was stationed, all possible angles of view were evaluated for impact, practicality, and lens focal length. A stairway leading to the second floor provided us with an excellent vantage point to shoot from above, and the 60mm f/2.8D AF Micro-Nikkor lens was chosen.

We had Les sit in front of the old Ampex holding one of his signature guitars, the Gibson Les Paul model, in front of him. Using a black model added that "guitar element" without overpowering the image. Blending the black-bodied guitar into the dark area kept the focus on Les' face and the electronics in the upper half of the frame.

Our first job was to light Les and the front of the Ampex stack with a soft light. A Speedotron 102 flash head with

TOP LEFT—We started off with my colleague David C. Smith sitting in for Les to give me the general "feel" of the image. We metered f/8 at 125 ISO from our 24x36-inch PhotoFlex softbox. We then balanced a grid light to the output of the softbox from above and behind the meter stack to show detail in the reel-to-reel assembly. At this point we recognized our shutter speed would have to be adjusted to pick up a glow from the VU meters. **TOP RIGHT**—For test shot 2 we spot metered the VU meters on the front of the stack. We found ¹⁄₁₅ at f/8 to be just perfect for picking up the glow in the meters. We added another gridded head to light the electronics behind the reel assembly and discovered we needed to clean up the top area because it might be included in our frame. **BOTTOM LEFT**—In test shot 3 we see the front VU meter panel lit by the softbox and the VUs themselves glowing nicely from our slow shutter speed without losing detail. We added the blue gel to give a "splash" of color to the electronics behind the meter stack in what would have been a very "metallic"-looking shot otherwise. At this point we decided to further add color to the reel assembly with an amber gel to mirror the glow of the VUs. **BOTTOM RIGHT**—After gaffer taping the amber gel in place to "color" the tape assembly, it was time for Dave to step in once more for a final test shot. We could see that all the pieces had fallen into place and the nearly 50-year-old Ampex machine was ready for its "close up." The only thing missing was our legendary subject. It was time to clear the set, call in Les, and get shooting! The final image appears on the facing page.

a 24x36 inch PhotoFlex softbox was chosen with multiple layers of diffusion panels to lower the color temperature and warm up the overall image. I've been using this technique for years with film, and it, of course, works equally well with digital capture.

The next step was to bring up the illumination in the VU meters on the front of the stack. We had metered the softbox at f/8 at an ISO of 125. A reading off the VUs from my Sekonic spot meter told us that $1/15$ at f/8 would bring up the luminance just right without blowing out the detail in the meters.

I wanted to leave a sufficient amount of dark space to the left of the image for dropping in type but didn't want to sacrifice the detail in the reel-to-reel assembly. We then chose another Speedotron 102 head, a grid reflector with a 10-degree grid spot, and an amber gel to light the tape deck from above and behind with a color similar to the glow of the VU meters.

The last step was to add a touch of color to the electronics behind the meter stack and tape deck. Another Speedotron 102 head with a 10-degree grid spot and blue gel was used to light the area from behind the meter stack. A spot meter reading off the middle gray electronics board using Dean Collins' "Chromazone" method gave us the information we needed to adjust the power of that head to achieve just the right hue of blue we desired.

At this point all the elements came together for us to proceed with image capture. Back in New York City, we duplicated our RAW files to JPEGs for quick editing, then ran the selected RAW images through the 10MP feature in Nikon Capture software to

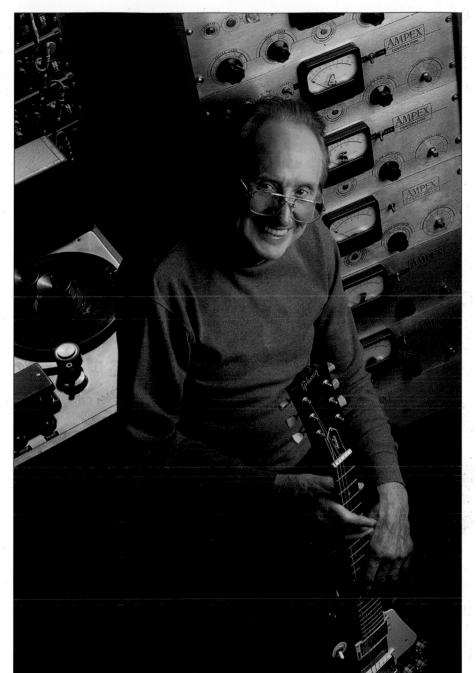

optimize our selections before importing them as 16-bit TIFFs to Photoshop.

Although we travel with a truckload of lighting gear to handle virtually any situation, all our images were shot with no more than three strobe heads, two grids, a softbox, some gels, and one 800Ws Speedotron 812 power pack. Nikon's digital capture proved to be the perfect choice for us to get what we needed quickly and move out, before becoming a burden to the 89-year-old guitar legend.

I must say, in closing, that Les was most gracious and accommodating—even inviting us to stay for dinner. I think a good time was had by all, and I know it was a memorable experience for me.

INGREDIENTS

Client: *Attaché* magazine
Camera: Nikon D1x
Lens: 60mm f/2.8D AF Micro-Nikkor
Meter: Sekonic spot meter
Media: Three Delkin 640MB CF cards
On-Site Editing Platform: Apple PowerBook G3 with Nikon Capture 4 and Adobe Photoshop
Lighting Gear: Speedotron 812 power pack, three Speedotron 102 flash heads, PhotoFlex softbox, two 45-degree grid reflectors, two 10-degree grids, and assorted colored gels
Exposure: $1/15$ second at f/8

Chuck Nacke: Fifteen Minutes and the Dalai Lama

Chuck Nacke was based in Moscow in the mid-1990s when he heard the Dalai Lama was coming to town. He had earned an international reputation covering what he termed the "Stan Wars," civil conflicts in former states of the Soviet Union such as Afghanistan, Uzbekistan, Tajikistan, Kazakhstan and Kurdistan. He had made memorable portraits of Russian leaders such as Mikhail Gorbachev, Boris Yeltsin, and Vladimir Zhirinovsky, as well as other world leaders visiting Moscow.

"I called the Tibetan Cultural Center in Moscow and suggested that I do a portrait," Nacke recalls. "They agreed because I said the image would be distributed by my New York City agent, Woodfin Camp & Associates, to news magazines and other publications throughout the world."

Nacke and an assistant arrived at a designated room in the center more than an hour beforehand to prepare. The assistant stood in for Polaroid portraits, since there would be no time to bracket or do a snip test (analyzing images from the first few frames in a light box). They set up a gray seamless backdrop behind where the Dalai Lama would stand and two Photoflex LiteDome softboxes with Norman heads to provide lighting on the Tibetan spiritual leader. Nacke pushed his Fujichrome Velvia to EI 64, and set the Nikkor 80–200mm f/2.8 zoom lens at 100mm for 1/200 at f/11.

"I knew exactly what kind of pose I wanted," Nacke remembers. "The advance planning was critical since you don't get a second chance at a photograph like this."

When the Dalai Lama finished a speech and was escorted into the room, Nacke made the images in the 15 minutes he'd been allotted, with the assistant handing him fresh cameras as he burned through as many rolls of film as time allowed. Although that wasn't much time for a formal portrait, it sure beat the four minutes and 20 seconds he'd been granted to make a full-page photograph of Zhirinovsky for *Vanity Fair* magazine.

The memorable Dalai Lama image has appeared in scores of publications around the world, and even shows up in a major encyclopedia. It's featured on Nacke's website (www.chucknacke.com), which showcases his work, plus that of other photographers in a part of the site called The Zine. Woodfin Camp still represents Nacke's work and licenses his images for publication. —*Robert Neubert*

INGREDIENTS

Camera: Four Nikon N90s
Lens: Nikkor 80–200mm, f/2.8 ED
Film: Fujichrome Velvia
Lighting: Norman Superlight, 800Ws powerpack, two Norman heads
Light Modifier: Two medium Photoflex LightDome softboxes
Accessories: Minolta Flashmeter IV; converter for converting voltage from 240 to 120

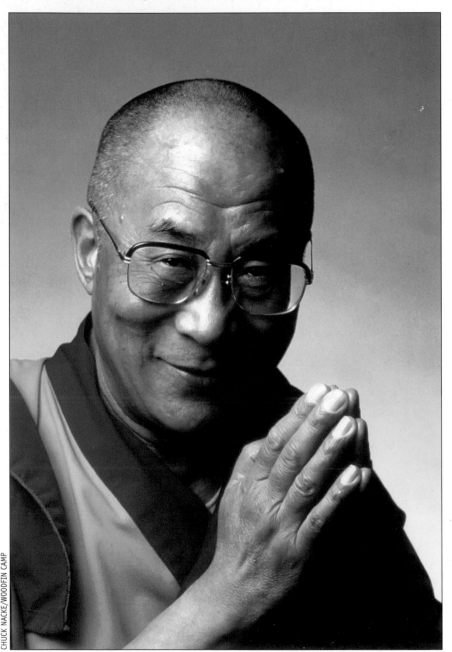

CHUCK NACKE/WOODFIN CAMP

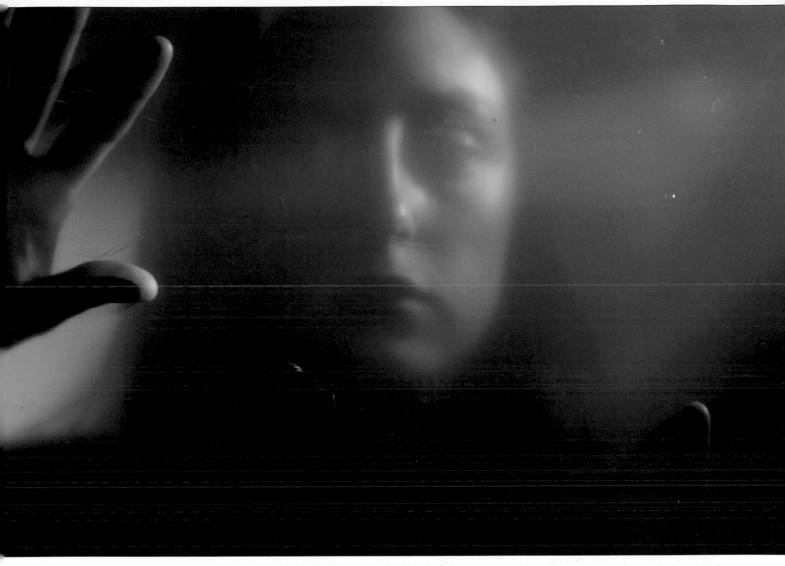

Jacob Rushing: Illustrating the Subconscious Mind

This image, taken while I was studying commercial photography at Brooks Institute, is intended to represent the subconscious mind and how this other, hidden part of us constantly tries to break through to what we've come to know as "reality." It was my goal to depict the ambiguity of the subconscious and the dreams that lurk there. I also wanted the shot to be a little dark and foreboding, and I knew that I wanted the element of water to be part of the concept.

In order to create the shot, I placed the model behind a translucent sheet of plastic. I photographed somewhat close to the plastic in order to show the little imperfections in the material through which I was shooting. The image was shot on a Nikon D70 digital SLR equipped with a 24–85mm f/2.8–4 zoom lens.

The model was lit with the Profoto 7B kit with two heads. The key light source was a bare head, modified by placing a glass vase filled with blue water between the light and the model. I chose to use the glass vase rather than just a blue gel because I wanted to achieve the effect of the refracted light. The second head served as a background light and was modified with a medium honeycomb grid and an 80A blue color conversion gel. I made subtle changes to color and density in Photoshop.

For this shoot the goal was to deliver a image that was thought provoking and merged the obscure with the actual, in a manner of haunting beauty. This shot is part of a style I am constantly shaping, a style I am building my current portfolio around. Digital technology is a vital tool for me; as a photographer, my personal challenge is to find the most innovative ways to utilize it in creating strong, meaningful photographs.

INGREDIENTS
Camera: Nikon D70
Lens: Nikkor 24–85mm f/2.8–4D IF AF zoom
Lighting: Profoto 7B kit with two heads
Other: Vase with blue water
Software: Adobe Photoshop

Oscar Lozoya: *Jugando con La Muerte*

Parody, humor, and a cautionary tale are intertwined in this superb black & white image from Oscar Lozoya's *La Muerte* series. The title, which translates as "Playing with Death," says it all; one only has to study the image to see the array of vices that tempt the hapless "victim" on the right.

Based in Albuquerque, New Mexico, Lozoya began his *La Muerte* series several years ago, infusing his black & white images with Hispanic humor that mocks and has fun with death. The "dead," their faces made up as skeletons, play everyday roles (albeit not exactly normal ones) as they spoof the afterlife.

INGREDIENTS
Camera: Mamiya RZ67 Pro II
Lens: Mamiya 180mm
Lighting: Speedotrons with softboxes for main and fill; Speedotron spot to light background photo on wall; Speedotron skimmers and hair light
Film: Kodak Tri-X 120

In *Jugando con La Muerte,* the cautionary message comes through loud and clear with vices such as gambling, boozing, drugs, smoking, and sins of the flesh all being flaunted before the intended victim as he plays with the dead. At the apex of the triangular composition, a portrait of the patron of vice, Doña Vismuerte, gazes down on the smoke-filled den of iniquity.

This well planned and brilliantly executed image was enhanced by a stroke of luck. Even though Lozoya says he'd like to say he planned for the rising cigar smoke to fit perfectly with the triangular composition, it was pure luck. But, given the subject matter, maybe some supernatural force was at work (or play)? No way! That couldn't happen, could it?

The lighting was fairly complex, and Lozoya placed the main light directly above the camera and a fill light beneath the lens to direct light under the accordion player's hat and illuminate detail in the shadow areas. A spotlight to the right was directed at the photograph on the wall in the background. A hair light and two skimmers illuminated the models' shoulders and hair, and also backlit the cigar smoke, making it stand out against the darkness of the unlit areas of the room.

This image is included in the "La Muerte" chapter of Oscar Lozoya's book, *The Art of Black & White Photography* (Amherst Media, 2003). —*Peter Skinner*

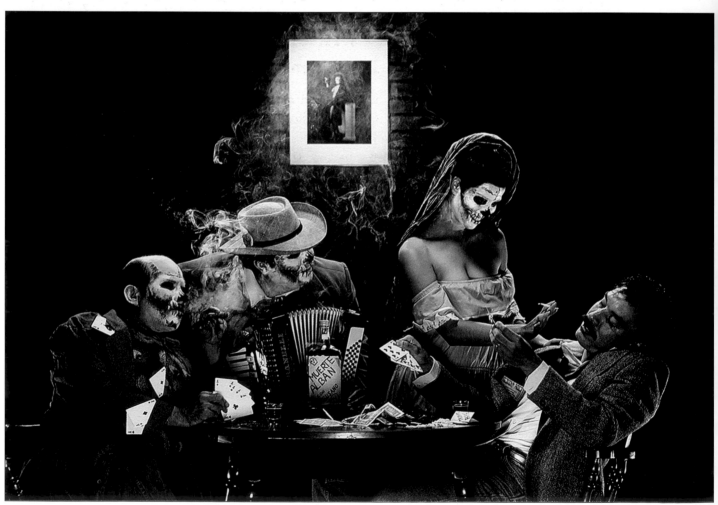

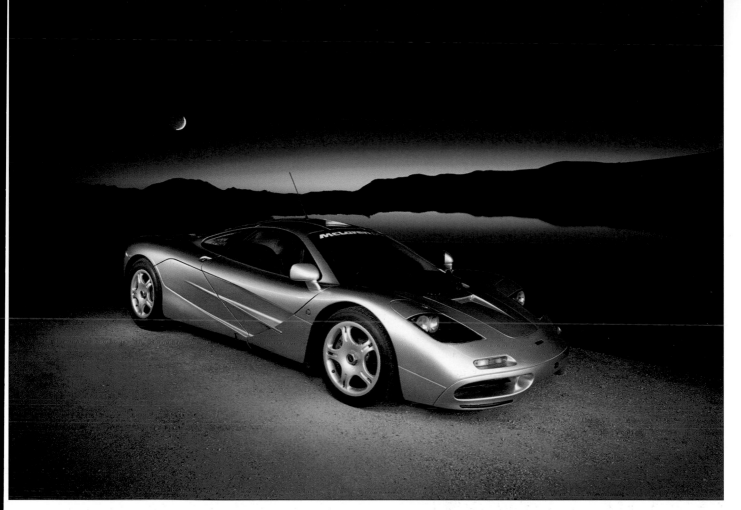

David Wendt: Light Painting the McLaren F1

I was lucky enough to take this McLaren F1 into the mountains of Colorado to shoot for my *Fast Expensive Cars* calendar. The owner wasn't able to spend any time with me while I was there, so he cut me loose with the car. Fun as this may seem, it came with its own set of problems.

It's a tight car, so I had to cut my equipment way down to fit (plus I had no assistant). I figured if I couldn't fit it in the car I was going to shoot, I didn't need it. As I drove off into the mountains, I had no idea where I would go—and I didn't count on the number of people who would stop to see this rare car. I was distracted by some very nice and extremely curious people who happened upon the scene.

This was a big problem since the sun goes down quickly, and people kept showing up until it was almost dark. The opportunity to park and set up a shot with the right background was almost lost to the darkness and indecision. On top of the 12,095-foot summit of Independence Pass, just east of Aspen, Colorado, it seemed I'd lost the opportunity to get anything of value. The car was parked just off the road. It looked nice, but it wasn't working very well. It was now so dark, I couldn't see any of the exposure settings on my trusty old Hasselblad.

I had all the basic equipment, including several Lumedyne battery-powered flash heads. While I was getting out a flash and a modeling lamp so I could see to get all the equipment put away, it hit me—light painting. I could shoot a long exposure and just walk along the car with the modeling light on and see what happened. There was no time for Polaroids or even any real light-metering. The exposure was set on bulb at f/8. I did two exposures before it became almost totally dark. The first was between six and ten minutes and the second was longer than that.

INGREDIENTS

Camera: Hasselblad 500cm
Lens: 40mm at f/8
Lighting: Lumedyne 400Ws head with 60-watt modeling lamp
Exposure: between six and ten minutes at 100 ISO

I used the lamp to look around and pack up, having no idea what the shot would look like. Upon my return home, I ran the film at the lab and was astounded to see the results of the first exposure. It looked pretty much like what you see here, but the moon was a blur in the sky, which I fixed in Photoshop. I tweaked a few of the lines on the car to help them show up a little bit better, and there you go—the McLaren F1 at 12,000 feet!

Reed Young: Recreating a 1961 Storefront Window

I was working on a project as part of my commercial photography course work at Brooks Institute of Photography, in Santa Barbara, CA, and it occurred to me to focus on the 1960s—a decade of contrasts. Since this summer marks the 35th anniversary of Woodstock, I originally thought I might do a photo in recognition of that 1969 "happening." But somehow I got sidetracked by 1961—it had a more classy, modern feel. Hence, this photograph is intended to depict a 1961 storefront window.

The hardest part in location scouting was finding a window that looked like 1961. The next problem was finding a storefront that had a considerable amount of space between the top of the window and the ceiling. This space was critical

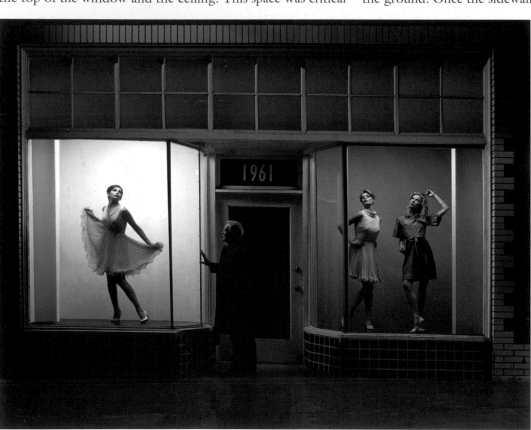

because I needed to light the interior with a large softbox above each platform. After a few days of aimlessly driving around, I finally found what would be the perfect place for the shoot: an art gallery.

The gallery window did not have platforms for the models to stand on, so we constructed them out of 2x4s, plywood and Mylar. The backgrounds were created using 2x4s and a big roll of paper.

When it came to lighting the scene, I started with the outside. I had a strobe with a softbox camera right, just accenting the wall and brightening up the scene a little. The only

other outdoor lighting came from a Q-flash on a boom arm about 30 feet in the air, camera left. The indoor lighting was a giant softbox above each platform. Originally, I planned to light the interior with top light only, but I noticed that if I didn't slant the softboxes, the models' eyes were in complete shadow. When this minor problem was finally taken care of, I was ready to start shooting.

The sidewalk, which might have been ignored, became an important part of the composition of the overall photograph. I realized it could provide depth to the image, so I decided to spray it down with water for two reasons: concrete is much darker when it's wet, and it creates a beautiful reflection on the ground. Once the sidewalk was sprayed, the models positioned themselves.

Because the models were behind the glass, I had to give the directions through a walkie-talkie placed under the women's platforms. I decided to place a man outside of the window to tell more of a story with the image. I came up with the idea one night when, walking home, I found myself in his shoes, looking up at the surrealistic portrayal of the woman and fashions of our time.

The digital manipulation used in post-production was minor. I changed the address to 1961 since that's the year I was trying to portray. I simply used Photoshop text and gave it a gradation to match the light in the scene. I also changed the convergence of the building by using the distort option in the transform menu.

INGREDIENTS

Camera: Mamiya RZ67
Lighting: Profoto 2400Ws packs; Quantum Q-flash; PocketWizards
Film: Kodak 100GX
Lighting: Profoto 3x4-foot softboxes
Models: Vera Kopp, Bianca Chiminello, Kara Fry, and Frank Merritt (Wilhelmina/LA)
Stylist: Antonio Vega (www.Zenobia.com)
Assistant: Alfredo Hernandez
Hair and Makeup: Elizabeth Dahl and Helena Lee

Compositing is a specialized field, to say the least. Take a number of photographs, from two to any number, and combine them in a single photograph with logic and organization and artistic flare. The final result must stand on its own artistically and not look like a collection of unrelated elements.

We decided to devote an entire chapter to this topic because there are many ways to achieve an effective composite. In this chapter we present six different compositing techniques.

Joe Elario got an assignment to photograph the Albany, NY, police department. How do you photograph a major city's police department at one time? Answer: You can't . . . unless you want to give crime a holiday. Elario decided to shoot the force in batches—seventeen different batches—and the image was later composited in sections to create a striking print that measured 23 inches in height and 8 feet in length.

High-school seniors often require composites as part of their package. Both Larry Peters and Ralph Romaguera show how they produce exceptional composites that reflect the many sides of their teenage subjects.

Additionally, Larry Peters and son-in-law, Brian Killian, show how each member of a high-school basketball team was photographed as he drove to the basket for a layup. At first glance, it looks like one person, but on closer inspection, you can see that each stroboscopic element of the photo is a different player.

Deborah Lynn Ferro and Suzette Allen both employ Photoshop's layers and layer styles to do some very clean compositing, while Larry Hamill examines the fine art of collaging in Adobe Photoshop.

The final result must stand on its own and not look like a collection of unrelated elements.

Joe Elario: Seventeen Photo Sessions, One Group Portrait

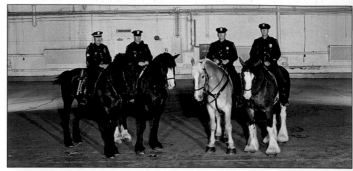

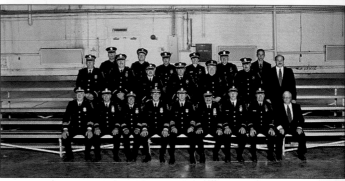

When Joe Elario got the assignment to photograph the Albany, New York, Police Department, he knew he was in for a challenge. The problem was not the subject. After all, people photography is his specialty; he runs a successful wedding photography business and acts as the official photographer for the Albany Mayor's Office.

The real challenge was the business of policing. The department couldn't simply shut down for the afternoon while all the members of the force posed for the picture. Even if you could leave the streets and phones unattended, there were multiple round-the-clock shifts to contend with.

Joe decided he would shoot the image in batches and have it digitally combined in the end. Little did he predict that this would take seventeen shooting sessions over a two-week period. The largest group was about 35 people; the smallest was a single detective who rushed in as Joe was starting to break down the set.

The second challenge was to find a room large enough for him to set up bleachers and lights and leave them set up for the duration. The solution was an old armory with the height and depth he needed. Unfortunately, it also had a particularly unattractive gray background wall. But since the image was being digitally stitched anyway, substituting an innocuous brick background wasn't a problem.

He made the decision to shoot each group in the center of the bleachers so he could focus his lights on the area and have consistency. His plan was to leave the lights in place so there would be absolutely no accidental changes in the lighting from shooting session to shooting session.

INGREDIENTS

Camera: Hasselblad 553 ELX with an 80mm lens
Flash: Six Elinchrom flash units with normal reflectors and Rosco diffusion panels
Film: Kodak Professional Portra 160VC
Background: Digitally created brick background
Digital Manipulation: Seventeen exposures combined into one (from one to 35 people per exposure)

The main light was created from three Elinchrom 600Ws flash units with normal reflectors positioned at camera. The reflectors were each softened with Rosco Diffusion panels. Three additional Elinchrom flash units were placed toward the rear of the group to produce a hair/rim light. These were also diffused in a similar manner.

The third challenge was the horses. In order to photograph them under the same lighting, the bleachers had to be moved. Luckily the young police recruits (dressed in gray in the final photo) were on hand to carry them out and then replace them after the shoot.

The final digital magic was done by a company that specializes in it, Miller's Professional Imaging (www.millerslab.com). The final print was output at 23 inches high and stretched to 8 feet in length. It is proudly displayed at the police headquarters. — *Jen Bidner*

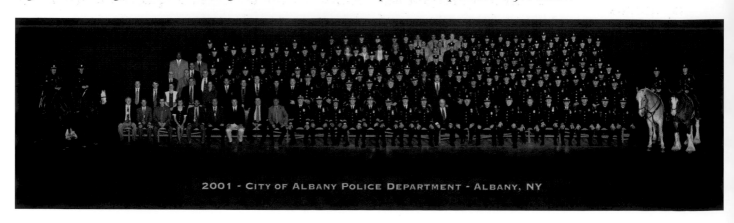

2001 - CITY OF ALBANY POLICE DEPARTMENT - ALBANY, NY

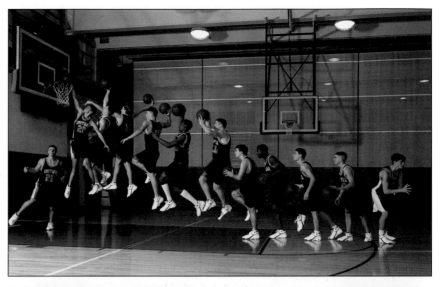

"We're not the studio that has the school's photography contract, but we offer to do the team shots (like this basketball photograph) for free. The school then uses the images in calendars and posters, and even sells advertising space on these products. In exchange, we are allowed to market our services to these students," explains Larry Peters.

Giving away a $500 session might sound like a bold move, but Larry Peters Studios attracts a great deal of the local senior-photography business in this manner. In fact, the studio photographs virtually every varsity sport in the area.

"When the students are willing to have fun with the idea, we get the best results," says Peters. One of his favorites was the girls' soccer team, which they posed on the field dressed in black cocktail dresses. It featured the tagline, "Real Women Play Soccer." Likewise, the swim team was shown "walking on water" with the slogan, "These Rocks Don't Sink!"

The studio finds that students who are impressed with the team shot are likely to come in for a personal version, such as the montage of Heather (bottom right), which was taken by Peters' son-in-law, Brian Killian.

Peters' Dublin basketball team shot (top right), which won a merit in print competition, was shot on Kodak VHC film with a Hasselblad camera and an 80mm lens. Peters set up his camera at half court and lined up the students parallel to the film plane. He then prefocused the camera and locked it in place.

The scene was lit with two Westcott umbrellas and Photogenic flash units. The lights were bounced into

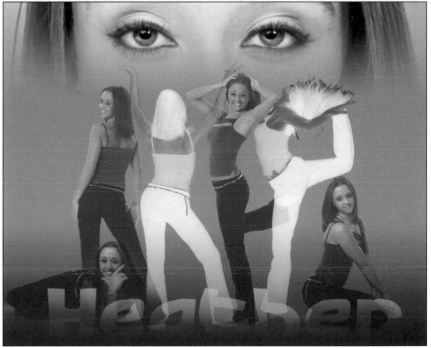

INGREDIENTS

Camera: Hasselblad with 80mm lens
Film: Kodak VHC (now Peters is fully digital and would shoot with a Phase One H10 digital back on his Hasselblad)
Flash: Two Photogenic studio flash units bounced into two Westcott umbrellas placed approximately sixty feet away
Digital Manipulation: Computer collaging

the umbrellas for reflective illumination from a distance of almost sixty feet away. He carefully metered across the whole line of students, and tweaked the lighting until it was even all the way across. The court lights were left on, but their illumination was insignificant to the overall exposure.

The students were then shot separately and later combined in the computer by Brian Killian. Today, Larry and Brian do this type of shot with a digital camera back because they can automatically use "pixel registration" techniques to piece together the collage. To make this task easier, they lock the camera on a tripod, and neither the exposure nor focus is changed. Larry now uses a Phase One H10 back for his Hasselblad, which yields an 18MB file.

The Heather composite uses similar computer wizardry, but the integration of positive and negative pictures adds flair to the image. This is anchored by a more traditional black & white glamour shot of Heather's eyes. The end result is a fanciful, yet balanced image that reflects the young lady's zest for life. —*Jen Bidner*

Ralph Romaguera's "Romatage" Sports Montage

Ralph Romaguera and his two sons, Ralph Jr. and Ryan, along with over a dozen employees, run three studios in the New Orleans area. One of his most popular products is the "Romatage" school-sports montage for athletes.

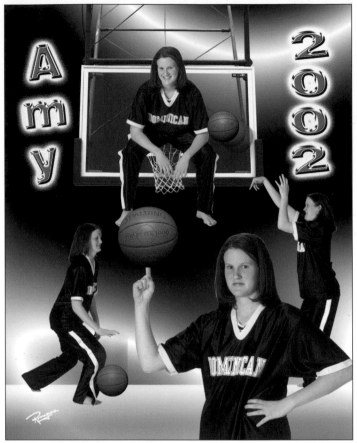

Romaguera's first such image took a long time to create, but now he has a formula that enables the photographers to shoot images that fit into a loose "template," like the one shown here of the basketball player, Amy.

"We start with a white background because we like to use the Pen tool to silhouette the picture," explains Romaguera. "It also eliminates the problem of the background creating color casts on musical instruments, trophies, or other reflective objects."

The entire shoot shown here took only a few minutes, with Amy striking various basketball poses without the ball. The images were taken with a digital camera and quickly silhouetted on the computer. The basketball was then added from a catalog of stock images that had been previously created by the studio. For the top and bottom balls, motion blur was added digitally.

School colors were then added to the background on a separate layer behind the silhouetted figures. This created the final, personalized look.

Romaguera created the lighting to go from left to right, "because that is the way we read. If I were working in Arabic I'd do it the opposite way." His main directional light was a Photogenic flash in a small 42-inch Westcott softbox placed at a 45-degree angle and feathered so the subject was lit by just the edge of the softbox. A second large softbox was then positioned at 90 degrees to the subject. "Both were as close to the subject as I could get them without having them in the picture," he explains.

Using this basic setup, within thirty minutes of walking in the door of a Romaguera studio, student athletes can actually be viewing a composite of their final image on the computer screen.

He no longer makes proofs, but take the orders then and there. "Every kid has a scanner, and with proofs we'd lose money to copies they'd make at home," he warns.

RomaTip #1: Look for the little things. If you can nitpick those little things that are "wrong," then everything remaining is "right."

RomaTip #2: "Real smiles happen at the corners of the eyes and mouth," explains Romaguera. He strives for smiling expressions without teeth. —*Jen Bidner*

INGREDIENTS

Camera: Kodak Professional DCS 760 digital camera (based on a Nikon F5 body) with Nikkor lenses

Flash: Photogenic studio flash units in a 3x6-foot Westcott softbox and a 42-inch Westcott softbox

Fill: Cards and kickers/hair lights as needed

Background: White to facilitate silhouetting on the computer (using the Pen tool)

Digital Manipulation: Computer collaging

Deborah Lynn Ferro: Designing with Photoshop's Styles

A new trend in albums is the custom, digitally designed album. These albums offer the client a more artistic design with a variety of text, artistic effects, and colors. These albums are one of a kind. With more photographers learning Photoshop, the ability to offer these albums and design them in-house greatly increases. With a digitally designed album, the traditional album's mats with inserted images are replaced with images that serve as backgrounds and colorful collages, bringing new visual excitement to contemporary brides.

Creating a variety of pages for the digital album can be a challenge, as it requires coming up with different artistic designs that stand out from all the standard templates available. So where do you start in the design process? Photoshop has created a series of actions called Styles, that, with a click of the mouse, will save you hours and make your pages look great. I used the following steps to create this collage of the bride getting ready. All the color effects, including black & white conversion, were done using Photoshop's Styles.

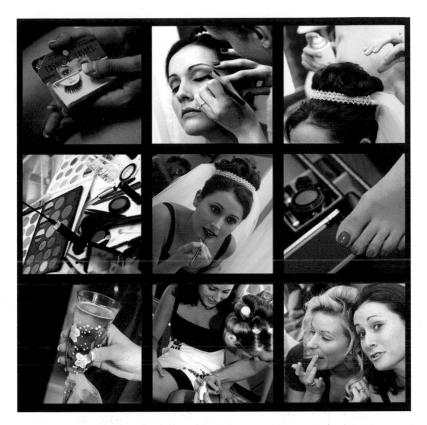

1. Create a background by going to File>New. With black selected as the background color, determine the size and resolution of your image. (For this example, the size was 10x10 inches and the resolution was 250ppi.)

2. Add a grid to your background by going to View> Show>Grid.

3. When making a collage, the resolution of your images should all be the same. This collage includes nine images cropped to 3x3 inches at 250ppi. Each image was color corrected, retouched, and flattened before beginning.

4. With the Move tool, drag each image over, one at a time, and line them up on the grid. You will have to maximize your window and zoom in to be sure that the images are properly aligned. After each image has been aligned, you can remove the grid by going to View>Show>None.)

5. To change the color and effect of each image, go to the Styles palette. Load styles by clicking on the arrow at the top right of the Styles palette and selecting Load Styles. Load any of the styles that you would use. (The styles for this collage were loaded from the Photographic Effects and Image Effects folders.) You can also adjust the view in this menu. I prefer to select the Text Only option, so I can read what specific effect it is rendering.

6. Activate the image you want to change, then click on a style to change it. The change is immediate and you can change the style by clicking on another style. This automatically deletes the last style and adds the new one. Continue with each image until you have achieved the desired result.

7. At this point you can also change the color of your background, if you wish. Click on your background in the Layers palette to activate it. Double click on the foreground color in the toolbox to open the Color Picker. Once you have selected the color you want, go to Edit>Fill and choose Foreground Color in the dialog box that appears.

8. Save your collage as a PSD (Photoshop document), to enable you to make any future changes.

Remember that Photoshop can give you more creative control over your images, but the time it takes to be creative depends on your level of experience in Photoshop. Using Photoshop's Styles not only reduces your work time but also increases your creative design ability.

INGREDIENTS
Camera: Canon EOS 1D
Lens: Canon EOS 28–70mm f/2.8 L
Flash: Canon 550
Media: Lexar 512MB CF card
Editing Software: Adobe Photoshop

Suzette Allen: Creative Senior Products

Suzette Allen knows high-school seniors are always looking for something new—and she is always looking for new products to sell them. The sample seen below is simple to make and easy to sell.

With a Fujifilm S2 camera, Suzette captured these images with a custom white balance on manual mode, using a Gossen Luna Star meter to establish the exposure.

This 11x14-inch composite was made in Photoshop. She began by making a blank document at 300dpi. Next, she dragged guides to ¾ inch from each side, lined up the images to the guides, and transformed them into this arrangement. Suzette then pulled more guides just inside the edges of each image (⅛ inch smaller than each image) and used these to create the mat opening.

To make the diagonal mat in the background match so perfectly, Suzette simply made a duplicate image of the document (Image>Duplicate). She then stretched each image on its layer to the edges and middle so the space was completely filled with the images and no background showed, then flattened the image. She notes that the pictures may be dis-

torted, but when the motion blur is applied (Filter>Blur> Motion Blur), it won't matter. Suzette's "trick" is to set the blur angle to 45 degrees and the distance 999. With this composite, Suzette applied the motion blur twice so the color transitions were smoother. This creates a mat that will match your images perfectly every time. Simply drag the new mat on top of your composite document. (It will center automatically if you hold the Shift key as you drag it.)

The next step is to create a layer mask. Then make marquees, snapping to the guides around each image and filling each box with black. This will punch holes through the layer to make the openings. There should now be a top layer with four cutouts that allow the images to show through.

To add the bevels that make it look like a cut mat, add a layer style (Layer>Layer Style>Bevel and Emboss). Choose: Style—Inner Bevel; Technique—Chisel Hard; Size—30 pixels. Keep the other settings at default. To add the V-grooves, press Cmd/Ctrl and click on the mask portion of the mat layer to get marching ants around the openings of the mat. Then, go to Select>Modify> Expand and enter 90 pixels. With this, the marching ants should be a little bigger than the openings. Make a new layer (Layer>New Layer) and select Edit> Stroke, then enter 10 pixels in any color. There will now be small lines around each opening.

Add another layer (Layer>Layer Style>Bevel and Emboss) and choose: Style—Emboss; Technique—Chisel Hard; Direction—Down; Size—5 pixels. The images are now embossed, but the color is visible. For transparent grooves, go to the Fill slider on the Layers palette and turn it down to zero.

This composite was completed by adding the student's name and "Class of 2005." Choose a color from one of the images with the eyedropper for the text. Applying a layer style to it will add dimension and style. Choose Layer>Layer Style>Drop Shadow. Then, select: Distance—21, Spread—12; Size—35. Next, go to Layer>Layer Style>Bevel and Emboss. Select an inner bevel and set the size to 27 pixels.

Suzette uses these composites as an add-on to her senior packages, baby portraits, and wedding photography. —*Harvey Goldstein*

INGREDIENTS

Camera: Fujifilm S2 Finepix Pro
Meter: Gossen Luna Star
Lens: Tamron SP AF 28–105mm f/2.8
Computer: PC, LaCie monitor
Software: Adobe Photoshop
Plug-ins: Nik Software Color Efex Pro 2.0

I find it challenging to photograph a city or scenic locale and then later combine the images into a collage. There are unlimited ways to merge digital files into a synergetic image. The spontaneous approach provides the opportunity for more chance occurrences.

When starting a collage, I create a folder to hold the images I feel have potential. Perhaps the most critical image is the base, upon which other images will be layered. The sizes of most of the collages I work on are the same dimensions as my digital capture, in this case 4064x2704 pixels. Once the background is selected, I use the Marquee tool in Photoshop to crop vertical and horizontal slivers of different images and drag them to my working file. These slivers can be compressed, expanded, skewed, etc., via the Free Transform command (Edit>Free Transform). Layer masks may also be used to create an illusion of weaving the different slivers together. Graduated masks in particular enable me to blend color and subject matter. Finally, I save my image with layers as a working file for future reference. Then I resave the image as a flattened version to be resized to my final output parameters.

Shooting at different times of the day expands your collage possibilities. I look for various architectural elements and repetitious patterns for added interest. Panning the camera at slow shutter speeds will add a sense of motion to otherwise static imagery. The more you shoot, the more options you'll have to create unique collages.

INGREDIENTS
Software: Adobe Photoshop, Adobe Bridge
Camera: Canon EOS 1Ds

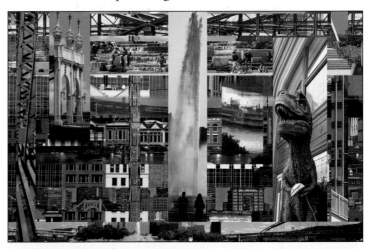

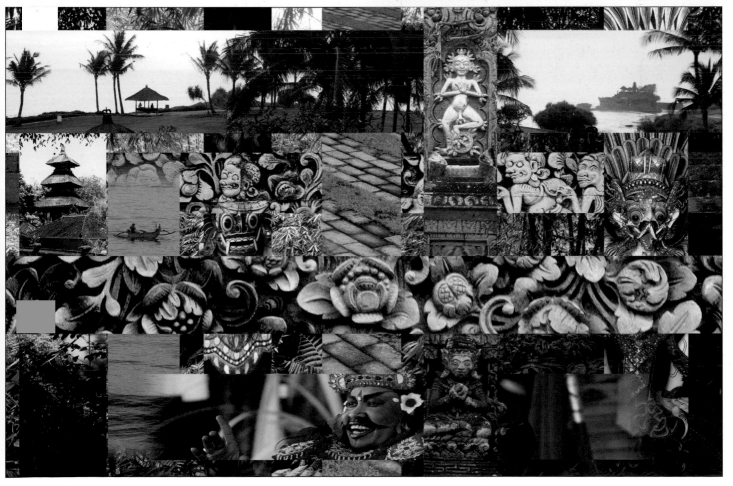

3. DIGITAL TECHNIQUES

There is no doubt that the advent of digital photography has changed everything. It's raised the bar creatively, erasing the boundaries of what could be accomplished with traditional photographic tools and techniques. It's also raised the bar financially for certain types of photographers, namely wedding photographers, who have been able to market new and exciting products to today's brides.

Digital techniques, as we have organized them here, are a little different than Photoshop techniques (a separate chapter; see page 51), in that they are more camera-based than software-based effects. Of course, there is naturally some overlap, because Photoshop has become an all-important aspect of digital imaging—so much so that virtually every image captured digitally goes through Photoshop at some point. With that said, here is a capsule summary of some of the techniques covered in this chapter.

Roy Madearis of Arlington, TX, has devised a portrait program that has increased his studio's family and children's portrait sales. The concept is called "Watch Me Grow," and it is an expandable album that allows Roy and company to augment a child's album as the child grows up. It's also a pretty handy means of getting repeat business.

Michael Campbell is a fine-art photographer from San Diego, CA. He is constantly amazed at the quality attainable with today's DSLRs. Campbell's *Immaculata* is a lovely church interior that boasts so much dynamic range that he ventures that the image could not have been made nearly as effectively using film.

Jerry Courvoisier is an educator and expert flower photographer who has come up with a way to turn an ordinary flatbed scanner into a camera for unusually beautiful floral portraits.

Robert Hughes used multiple programs, like Bryce, Ray Dream, and Photoshop, to illustrate a bride's introspective comment about her life.

Other terrific digital effects included here are Jim Rode's painterly effects; Fuzzy Duenkel's invention, the Fuzzyfilter; J.D. Wacker's tribute portrait to a modern artist; Jacob Rushing's own version of in-camera digital infrared; and master photographer David Williams' black & white digital printing techniques.

There is no doubt that the advent of digital photography has changed everything.

Roy Madearis: Stylized Retouching Boosts Sales

Roy Madearis of Arlington, Texas, has had great success with his "Watch Me Grow" children's portraiture program. The concept is simple: Start with the baby, and provide the family with an expandable album. After each portrait sitting, the studio adds the new picture to the existing album.

The image shown here is a child in the program. She was in for her three-year-old birthday portrait. The girl was photographed with a 2x2-foot softbox and Norman Photo Control flash units. She was positioned in front of a black backdrop. The fill was light from two heads that was bounced off the white walls of the studio.

The original image was captured with a Kodak SLR/n camera and a Tamron 28–105mm lens. The lens was set to f/8 and the 35mm film format equivalent the 70–105mm range.

After acquiring the digital image and making basic contrast, color and levels corrections, Madearis used the Digital Gem Airbrush Professional plug-in filter for Adobe Photoshop. This special filter was developed by Kodak's Applied Science Fiction (www.asf.com) and automatically smoothes skin tones and other surfaces without softening important details, such as eyelashes, eyebrows, or hair. According-

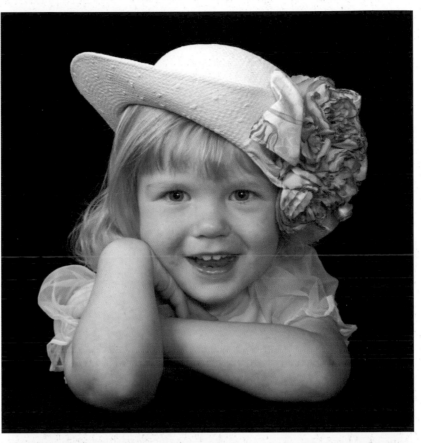

ing to Madearis, the filter performed the majority of the retouching on the image shown here; he then made some fine adjustments to the shot by hand.

Madearis has seen a dramatic increase in sales among customers who view both an original image (top) and a retouched version (bottom). Almost all of his customers choose to purchase the second, retouched image.

If you'd like to find out more about Roy Madearis and his images, visit his website at www.madearis.com. He also offers educational materials for photographers, designed to help them improve their marketing and promoting capabilities. Contact madearis@madearis.com for more information. —*Jen Bidner*

INGREDIENTS
Camera: Kodak SLR/n
Lens: Tamron 28–105mm
Flash Units: Norman Photo Control
Light Modifiers: Light bounced off white studio walls
Software: Adobe Photoshop and Digital Gem Airbrush plug-in

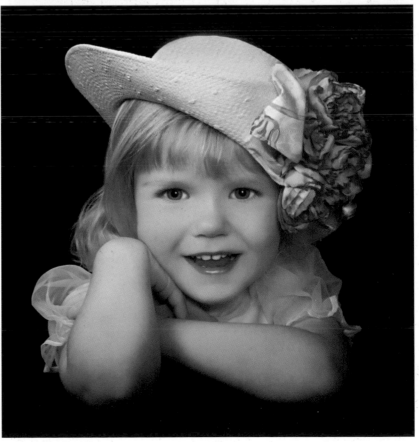

Michael Campbell: Capturing Light in the Dark

I wanted to give my Fujifilm FinePix S3 Pro a run for its money and decided to photograph a church interior. The most impressive church I could think of in San Diego is on the campus of the University of San Diego: the Immaculata. I used to shoot ceremonies there—in the days when I was foolish enough to photograph weddings (before I discovered there are easier ways to kill myself).

As quick as thought itself, I sprang into my trusty Honda, whizzed down to the campus, and parked illegally, which is the only way to park there without a permit (they don't seem to want to encourage visitors). I proceeded to sneak into the church, which appeared to be deserted. All the lights were off. I had never seen it so dark and thought to myself I had wasted my time as there was no way I could shoot in a gloom like the depths of some Acheronian forest. There fell upon my roseate lips a stygian hue, to paraphrase Wordsworth. But here I was, so I thought I might as well fire off a quick couple of snaps anyway.

I thought I could hear someone moving about in the dim hinterland at the far end of the church, so I crossed myself and tried to look suitably devout while putting up the old

INGREDIENTS
Camera: Fujifilm FinePix S3 Pro
Lens: Tamron SP AF 14mm
f/2.8 Aspherical (IF)
Memory Card: Lexar 512MB CF
Software: Adobe Photoshop
Computer: Apple Power Mac G5

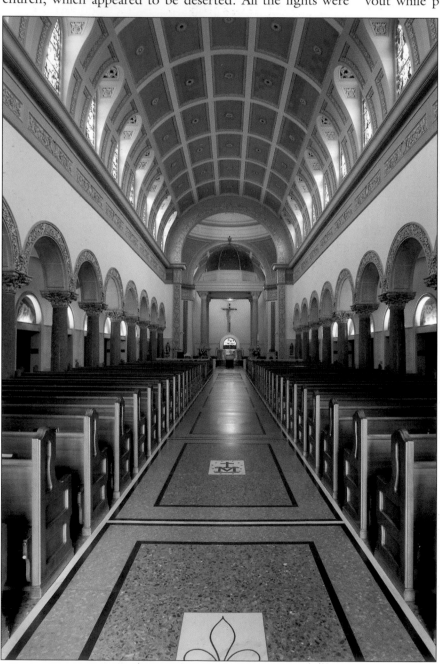

Gitzo and attaching my Tamron 14mm, frightfully wide-angle lens. It is a marvelous bit of technology. It looks like part of a fortune-teller's crystal ball mounted on a Nikon bayonet. Because of the curved shape, it can't use a regular lens cap and instead wears a sort of little soft hat like the ones falconers put on Peregrine falcons to make them think it's nighttime. I put the lens on the S3 camera and whipped off its hat. "Time to wake up!" I told it.

I had no time to do fancy exposure evaluation stuff, even if I had known what to do. Frankly, the whole thing looked like a nonstarter from the outset, but, like Napoleon, I can commence and persevere without hope of success.

I simply put the camera on Auto everything and pressed the shutter. Several seconds later I heard the soft "kerrchunk" of the mirror resetting, and I sensed something important was going on inside the camera. Suddenly a beautiful, clear, colorful image popped up—I could see so much more detail in the LCD than I could see squinting at the real thing! It was such fun I did it again, same thing: amazing.

Back at the ranch, I loaded the image into the G5 and found an amazing amount of detail—the light was all entering the church via little stained glass windows, and the S3 did a terrific job of keeping detail in the glass and the neighboring stonework as well as in the wooden pews.

Jerry Courvoisier: Using a Scanner as a Camera

With a previous career in horticulture, Jerry Courvoisier has a deep appreciation for the beauty of the natural world with all of its elegant shapes and contours.

In an effort to experiment with different ways to arrange and compose images for his photography and printmaking, Jerry uses the Epson Perfection 4870 flatbed scanner. The scanner is instrumental in helping him to try and develop a sense of how to arrange the forms within a standard frame of reference and to enhance the texture.

Using the scanner as one might use a Polaroid, Jerry can preview the images quickly and easily. This allows him to work with cut flowers as well as trimmings from bushes and tree branches and leaves in a variety of combinations and arrangements. This creative process leads him to view the scanner as a capture device for these natural 3-D objects. The scanner is used as a camera with only one very soft, directional, illumination source. Images created this way have a shallow depth of field and a soft, illuminated quality. This technique stands out as a special way to capture and exhibit form and texture, providing a closer look into this world.

INGREDIENTS

Scanner: Epson Perfection 4870
Computer: Apple Power Mac G5
Software: Epson Scan, Adobe Photoshop
Printer: Epson 4000 and 9600
Paper: Epson Ultra Smooth Matte and Epson Enhanced Matte

To emphasize the object placed on the scanner, Jerry discovered that if he left the scanner lid open and turned off the overhead lights, the result of the light falling off rapidly created a perfectly black background accentuating the natural object. To make the best use of the image capture, Jerry scans the objects at a high bit depth (16-bit), allowing for more color information.

The image file is then imported into Adobe Photoshop for some digital "darkroom" work. Jerry believes that for his horticulture captures, the computer should not be used for heavy adjustments, but only to eliminate any defects and to enhance the tone and color of the image. Jerry lists the key steps for this type of capture:

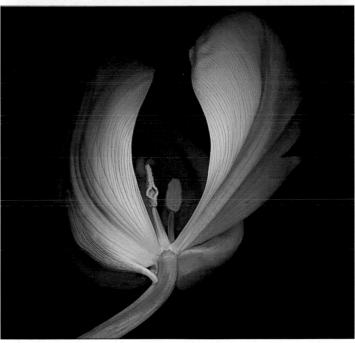

1. Keep the glass on the flatbed clean by wiping the top down with a lint-free cloth and a glass-cleaning solution.
2. Leave the lid open and turn the room lights off so the light falls off to pure black in the background.
3. Experiment by making multiple preview scans to fine-tune the arrangement of the natural objects on the scanner bed.
4. Set the scanner for 16-bit capture.
5. Scan the objects at 1600ppi.
6. Turn off the sharpening within the scanner capture interface.
7. Once the image is captured, the digital workflow in Adobe Photoshop is begun to hide any defects, such as stray pollen and broken or cracked leaves and stems.
8. Perform global tone and color correction.
9. The extent of sharpening will depend on which surface the image will be printed. Glossy and semigloss papers require less edge and detail enhancement than a watercolor fine-art surface. —*Harvey Goldstein*

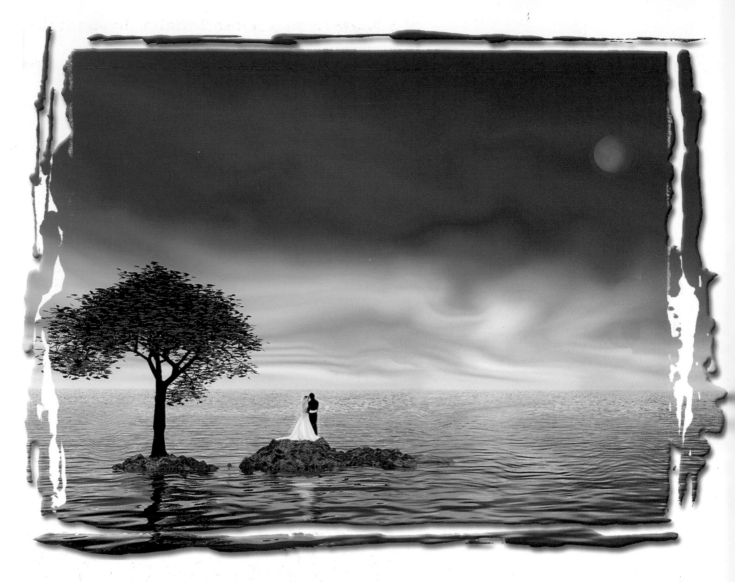

Robert Hughes' Visual Symbols

Many of the titles of Robert Hughes' images come from the subjects themselves. In this case, the bride once disclosed that life had not been easy for the couple. She added, "Into each life some rain must fall, but we'll be fine—we can weather the storm!" From this, the visual symbols for this image began to formulate. On the day of the wedding, Hughes created a backlit image of the couple. The resulting image, created on film, was designed to be scanned and used in conjunction with other elements to visually communicate the concept revealed by the bride.

The other "ingredients" in this image—sky, water, and rocks—were created in Bryce. The vegetation was created in Ray Dream. The moon image came from his stock supply of moons and was created with a Hasselblad CM (film) camera. The lens used to photograph the moon was a 350mm with a 2x teleconverter.

All of the elements were opened in Photoshop and placed as he had previsualized them, paying attention to reflections, direction of light, and composition.

The clouds above the horizon were manipulated with the Liquify filter in Photoshop. The edge effects were produced by Auto FX PhotoGraphic Edges.

The rain was created by using settings in the layer styles (see screen shot to the left). A drop shadow and slight bevel were added to the edges to produce a feeling of depth in the final presentation.

You can see more of Robert Hughes' images and a selection of his musings and articles on his web site: www.robert hughes.net. —*Harvey Goldstein*

INGREDIENTS
Camera (bride/groom): 35mm SLR
Camera (moon): Hasselblad CM
Lens: 350mm with 2x teleconverter
Film: Fujichrome 100D
Lighting: Ambient twilight; Speedotron flash
Software: Adobe Photoshop, Auto FX PhotoGraphic Edges, Bryce, Ray Dream

Jim Rode: Using Microsoft Digital Image Suite

When my daughter began performing in her high-school marching band, I found myself taking mundane snapshots equal to any other parents' photos. It was often difficult to get close—and with strict band discipline, she was not even allowed to make eye contact.

As a professional photographer, I'm normally in control of my subject. But what do you do when your subject ignores you, movement is limited, and you find yourself among thousands of fans? My answer was to get a "story shot" first and manipulate the file later. The result becomes as exciting as the performance. Even if she is not visible, the image captures the "magic" of the day.

This photograph was taken from the aisle at Texas Stadium. It is where the Dallas Cowboys play, and you may be familiar with the "hole" in the roof. The ambient light is a mixture of filtered natural light from the roof over the field, and sodium stadium lamps aimed toward the turf. I used a Nikon D70 shooting at f/3.5 at a shutter speed of $\frac{1}{125}$ second. The ISO was at 200 (lowest available setting with this camera). The 18–70mm lens was set wide open and the flash turned off. Camera blur is no problem and can provide interesting effects when the file is manipulated, but flash reflection minimizes the painterly quality I was trying to achieve.

After downloading the image to my laptop, I made a backup of the original and begin work on the JPEG image. JPEGs are universal, easy to work with and readily accepted where I post my art.

Using Microsoft Digital 9, I made an Automatic Levels fix to correct any contrast flatness. Going to Filters, I chose Metal: Chrome Chaotic, raising the transparency from 50 (a default setting) to 70 thereby lessening the chaotic effect and giving a more pleasing rendition.

It is important to change the hue and saturation levels. I never select a color when prompted, but simply change all colors with the inner-circle control. By experimenting with the control until the colors were boosted, I was able to make the photograph look more like the vivid colors of an oil painting. Lastly, I lowered the brightness of the image by about 15 percent.

INGREDIENTS

Camera: Nikon D70
Lens: AF-S Nikkor 18–70mm
Lighting: Ambient light in the stadium
Software: Microsoft Digital Image
Computer: Toshiba Satellite laptop

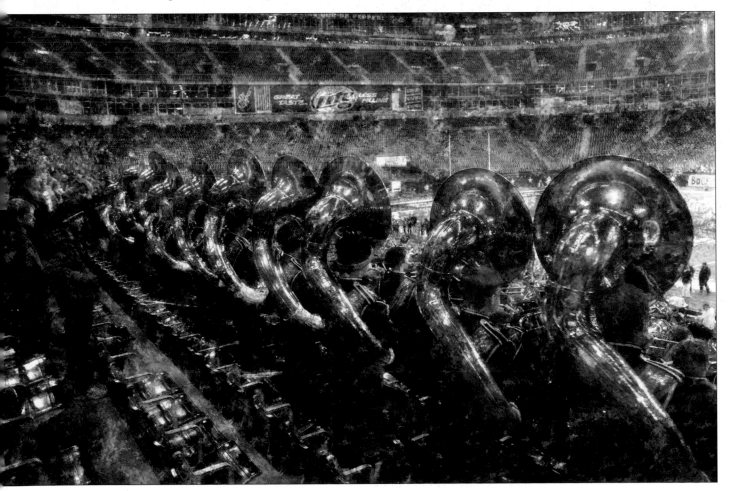

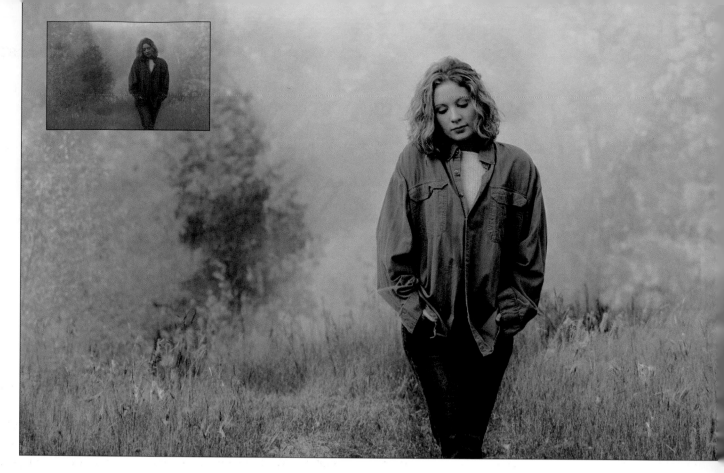

Fuzzy Duenkel: The Fuzzyfilter

Fuzzy and Shirley Duenkel operate Duenkel Portrait Art, a mom-and-pop studio in West Bend, Wisconsin. They began their business in the 1980s with weddings and have evolved into a low-volume studio creating custom portraits.

Fuzzy says, "Rather than study other portrait photographers' work for ideas, I've always tried to gain inspiration from TV and magazine ads. With large budgets, art directors, and the constant push to create a look that sells, commercial shooters have usually been more on the cutting edge of creativity than portrait photographers. Therefore, it's wise to keep a close eye on what's new in fashion magazines and other media, especially when a significant part of your business is high-school senior portraits.

INGREDIENTS

Camera: Canon EOS 1Ds
Lens: 70–200mm f/2.8 IS
Settings: 100 ISO, f/4 at $^1/_{125}$ second

"One photographic technique I've enjoyed in ads on television and in magazines is the use of high (luminosity) contrast, but relatively moderate color saturation. So I developed a simple, low saturation, high contrast technique that looks great (and sells like hotcakes). It works for an amazing variety of image types—and my clients love it! I call it the Fuzzyfilter." The following is the recipe for a Fuzzyfilter. Fuzzy suggests you make this a Photoshop action for quicker and easier access in the future.

1. Open an image in Photoshop and duplicate the background layer. Desaturate the duplicate layer (Image>Adjustments>Desaturate).
2. Open the Curves (Image>Adjustments>Curves).
3. In the dialog box, click on the center of the curve and drag the line about one-fourth of the way up.
4. Then click on the curve about one-eighth of the way from the bottom. Pull it down until just before the curve flattens against the bottom.
5. Click on the curve near the top, and pull it down until the curve isn't flattened against the top. At this point you'll have a light, high-contrast, black & white image.
6. Reduce the opacity of the top layer to about 45 percent.
7. If you wish, click on the History Brush and restore color to the cheeks, lips, and eyes at about 10-percent opacity.
8. Flatten the image and save it with a different name.

"This photograph was taken in the morning during fading fog. The sun was peaking over the horizon, providing enough of a low main light to create a lighting direction. The surrounding fog added fill lighting."

Fuzzy is a Master Photographer and Photographic Craftsman. You can check out more of Fuzzy and Shirley's work at www.duenkel.com. —*Bob Rose*

J.D. Wacker: Portrait of a Graphic Artist

J.D. Wacker is the product of four generations of professional photographers. With his photographer parents, Dave and Jean, he can trace his family's photographic roots back almost a hundred years. Their studio, Photography by J.D., specializes in seniors, portraiture, and special events.

The Graphic Artist was created for the subject, Steve Poole, a graffiti artist and the digital-assets manager at the Wackers' studio. The graffiti was part of a 8x16-foot mural Steve created for a local skateboard park. In Adobe Photoshop, J.D. combined an image of the mural with a portrait of Steve, which was photographed in the studio. To enhance the image, J.D. digitally metallicized Steve's portrait and added digital spray paint to the spray cans. The resulting image was selected for the Kodak Gallery Award for Portraiture in Wisconsin, the Burrell Award for the highest scoring image in the Wisconsin PPA competition, and the ASP Regional Medallion Award.

J.D. comments, "We particularly appreciate Steve's help during our conversion to digital imaging. He and I have worked very closely for several years, especially on developing and refining our workflow. It was rewarding to create an image that was meaningful to him and his family. Most of my award images have, to a degree, seemed to just happen. This image was different. We discussed the concept for several months before shooting it. So, receiving the top awards in our Wisconsin affiliated competition was extra special. Through the magic of Photoshop, I transformed Steve into an almost threatening figure, which isn't Steve at all. But, as an artist, he appreciated the mood that the image conveys. Recently, a local minister saw this image hanging in our studio and commented on how Steve must be a gang member. We told the minister that he actually works for us—but we keep him in the basement."

J.D. Wacker is a Master Photographer, Master of Electronic Imaging, and Photographic Craftsman. To learn more about the Wacker family and see a selection of their images, go to: www.photobyjd.com. —*Bob Rose*

INGREDIENTS

Camera: Kodak DCS 560
Lens: Canon 28–135mm f/3.5 IS
Settings: 1/50 second at f/11
Lighting: Norman flash head in 50-inch Westcott Apollo softbox
Fill Light: Two Norman flash heads in 64-inch home-made "Light Wacker" foam-board softbox styled after the old Photogenic Skylighter
Fill Reflector: 36-inch Bellypan reflector
Software: Adobe Photoshop

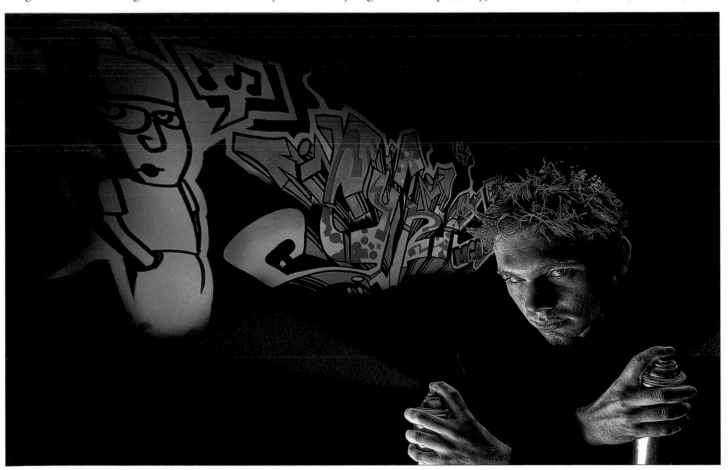

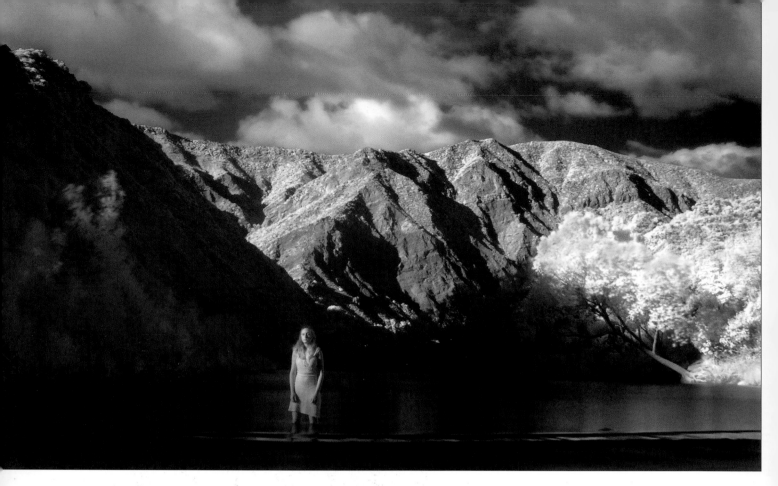

Jacob Rushing: Long Exposures for Digital Infrared

I was working on a project with fellow photographer Clayton McDermott when we stumbled onto this procedure. Under the instruction of Brooks Institute faculty member Rand Molnar, we were working with infrared film, experimenting with filters to achieve the most dramatic results. When McDermott suggested I try using the #87 filter, a visually opaque filter, on my D70, I thought he was crazy. "I think you'll be quite pleased with the results," he said.

We were in Yosemite National Park at the time, overlooking Bridal Veil Falls, and the results were breathtaking. The #87 filter is designed to transmit infrared light rays while blocking the rest of the visible spectrum. The CCD of a digital camera is equipped with a filter to block infrared light, but we found that with a long enough exposure, sufficient light reaches the chip to create an amazing outcome. Because the #87 filter is a red filter, the resulting image must be converted to a grayscale image in post-production.

Since discovering the technique, McDermott and I have continued to use it time and time again, mostly for landscapes. Taking this photo was the first time I employed the technique with a human subject in the shot.

It is said that humans are made up mostly of water and air, that biologically we are not all that different from our surroundings. This idea was on my mind when I created the shot. I knew I wanted to do it around sunset near Red Rock in the Santa Ynez Mountains, but I was waiting for the right weather at a time when my model was available. When we actually shot, I only had a one-hour window and the location was about a half-hour away. Needless to say, it was fast work when we actually got to the spot.

I needed the sun to hit the model directly for the infrared effects to be apparent in the image, and the sun was quickly dropping behind the tall mountains. Keeping in mind that each exposure was about 30 seconds in duration, so the model had to remain perfectly still in the frigid stream water. As a result, I only got two shots off before the sun dropped beyond the mountains and it was time to pack up and head back.

I converted the image to grayscale using the Channel Mixer in Photoshop. The clouds were added from a different image. Besides a slight contrast adjustment, no other digital alterations were made.

INGREDIENTS
Camera: Nikon D70
Lens: 24–85mm f/2.8–4D IF AF Zoom-Nikkor
Other: Bogen 3251 Tripod
Remote: Nikon ML-L3 remote
Filter: Lee #87 infrared filter
Software: Adobe Photoshop
Light: Sunlight

David Anthony Williams: *Papa Henri (Verdun, 1916)*

This man represents the forgotten soldier. I think of him as perhaps a schoolteacher in civilian life who is now seeing many of the generations he taught fed into the obscene mincer of relentless battle. The French alone lost over 500,000 men in the six-month Battle of Verdun during World War I; thousands were totally unidentifiable and never found. In many areas of the region, the topsoil is simply missing—vaporized by the strength and quantity of the bombardment. This photograph is an homage to an image of a U.S. Marine taken in Korea by (I believe) David Douglas Duncan. There is the same look of terror, shell shock, and complete, desperate sadness in the eyes. Sadly, that look has never, and will never change.

INGREDIENTS
Camera: Fujifilm FinePix S2
Lens: Sigma EX APO 70–200mm f/2.8
Lighting: Single studio flash
Exposure: ¹/₁₂₅ second at f/16
Printer: Epson Photo Stylus 1290 (U.S. model #1280)
Special Settings: black ink only at 2880dpi
Paper: English Permajet Portrait Classic 300gsm paper

The Epson Photo Stylus 1280 and 2200 printers are probably the greatest gifts photographers have been given in recent times. When you consider what these machines will do and what we had to pay previously for color darkrooms to produce the same size print, then these extraordinary machines really are amazing.

What power over the image we now have! I can use all of my darkroom knowledge to produce an image I probably couldn't make in the darkroom due to lack of materials. The choice available in inkjet papers alone is extraordinary and beautiful. My paper of choice is English PermaJet Portrait Classic 300 gsm, an acid-free, mould-made paper. To me, the paper gives the illusion of a beautiful gravure book illustration from years ago.

I was already firmly convinced of the capabilities of color images at 1440dpi resolution, but I did the tests and found little noticeable difference at 2880dpi. The difference *did* become noticeable, however—wonderful and totally necessary—when using the apparently little-known ability of the Epson 1280 to print at 2880dpi from the black ink cartridge *only*, producing stunning black & white prints.

This function is easily selected in the standard Epson print dialog boxes provided with the printing software. The only thing I would add is that if your Gamma check box in the printer software is set to 1.8, you may want to change it to 2.2. This will have the effect of printing a darker image. This is sometimes necessary, as prints at 1.8 can be a little light.

Having said that, I try to not to play with the printer offsets at all. One of the single biggest reasons for inconsistency with digital work is that the computer monitor is not profiled correctly. Comparing your screen to sample pictures is not enough. Do yourself the biggest favor ever and buy yourself a PhotoCAL Spyder monitor-profiling tool. (Or spread the cost around a few pals and share it!) Think of it as a light meter for your computer. It is the single best investment you can ever make in digital equipment.

Chasing color and density correction through multiple offsetting is the way to go mad quickly. What do I mean? Well, some folks change the screen, then adjust the printer, then adjust the screen, then adjust the printer . . . and they just end up so far out-of-plumb it's not funny. Just as the lab processes your film according to specs, you also need to work at known standards with digital.

4. LIGHTING TECHNIQUES

No other photographic technique is more important to master than lighting. Great photographs, more often than not, involve great lighting. Mastering the technical aspects of lighting is an acquired skill that often takes years of vigilant observation to learn. Learning to see light is learning to see the interplay of highlight and shadow, the elements that define shape and form. Lighting experts will tell you that wherever they go, they make it a habit to study how light and shadow affect the world and their perception of it. Like all complex skills, the more one knows, the more one discovers how much there is yet to be learned.

The unique blending of different light sources within the same scene often creates great and unusual photographs. How a photographer handles these blends, as well as the combinations of different light qualities, is a crucial factor in determining how well a photograph succeeds or fails.

It doesn't matter if you are adept at using five lights in harmony. Often the elegant photograph is made with a single light and reflector and nothing more. Simplicity of lighting technique creates greater control over the light and how it shapes the subject. And as far as taste in lighting is concerned, subtlety is always preferred over exaggerated lighting effects.

The articles in this chapter explore many different takes on lighting, from both classic and contemporary perspectives.

No other photographic technique is more important to master than lighting.

Gene Martin's Flash-Blur Mastery

Gene Martin's signature portrait of jazz pianist McCoy Tyner demonstrates his mastery of the "flash-blur" technique. This technique combines a burst of flash illumination at the start or end of the exposure (think of it as the "first photo") with a long exposure under hot lights (think of it as the "second photo"). The flash exposure on daylight film "freezes" a moment of time with the correct color balance. The color temperature of the hot-light exposure then causes the subject to turn amber on daylight film. Ghosting occurs when the subject or the camera moves during the exposure, and the background is allowed to record over the frozen flash picture (creating transparency) or is completely blocked by the subject (creating a black silhouette). Here's the procedure:

1. Martin taped red gels to McCoy Tyner's hands to create the strong color. He also put rings on his fingers, which created the amber-colored "flame tip" highlights due to the color shift from the tungsten light.

2. McCoy quickly moved his hands above the Lowel light positioned on the floor. The motion of his hands was parallel to the film plane, so they became extremely blurred during the ½-second exposure.

3. McCoy kept his torso and head relatively still, so they were recorded sharply during the exposure.

4. It would have been impossible to see the keys on a real piano from this perspective, so Martin set up a large electronic keyboard instead.

5. Several keys were taped down to create the illusion of the maestro commanding the keyboard.

6. A Lowel halogen light pointed straight up at the hands from beneath the keyboard and was goboed so that only the hands were illuminated.

7. A Speedotron 102 flash head in an umbrella was placed at camera left to illuminate the entire set. The flash was set at full power to produce the longest flash duration. This allowed him to avoid producing an image of razor-sharp hands mixed with the moving hands. Martin placed several Neutral Density (ND) lighting gels over the flash head to reduce flash output hitting the subject so he could shoot at f/11, matching the tungsten-balanced exposure. The final exposure was ½ second at f/11.

Equipment Notes: The most important equipment consideration in this type of photograph is the flash duration. A short (fast) flash duration is ideal for freezing motion, while a slow flash duration can produce blurred images. Short flash durations are achieved by reducing the flash output (power settings). The slower (blurring) flash durations require maximum power. —*Jen Bidner*

INGREDIENTS

Camera: Hasselblad 553-ELX
Lens: 50mm Zeiss Distagon lens
Flash: Speedotron 102 head mounted in 32-inch umbrella with 2400Ws pack
Filters: ND filters taped over flash reflector
Lighting: Lowel halogen lamp directed straight up at hands from floor
Background: Muslin background taped to jazz-club wall
Other: Red gels applied to McCoy's fingers

NyxoLyno Cangemi: Shrimp Boat at Dusk

I graduated from the Defense Information School at Ft. Meade, Maryland, and I am now working as a Coast Guard public affairs specialist in New Orleans. As a member of a federal law-enforcement agency, I am often on the forefront of the action. During a ten-day patrol in the Gulf of Mexico aboard the Coast Guard Cutter Valiant, I joined the crew as they boarded shrimp boats to ensure federal fishing, safety, and environmental regulations were being met.

On April 27, 2005, I decided to stay aboard the small boat that transported the boarding team from the Valiant, a 210-foot medium endurance cutter, to a shrimp boat. Inspections of shrimp boats, in some cases, can take several hours to complete; however, with the sun moving quickly beyond the horizon, I knew the quantity of light was diminishing and time was not a luxury I could afford.

My angle to the subject was not ideal for frontal lighting, so I decided to focus on the background and the water directly in front of the shrimp boat. Finding the proper exposure in this low-light situation was especially difficult since my subject and I were both constantly moving up and down in the water. Since I was already using the highest ISO allowed by my camera, I decided to compensate by using a wide-angle lens and a slower shutter speed. This enabled me to make a correct exposure without getting motion blur or camera shake.

In post-production, I used a Apple G4 laptop and Adobe Photoshop to further enhance the photograph. Personally, I am a firm believer that every digital photo can benefit from at least a small amount of sharpening. With that in mind, I adjusted levels independently to color correct the photo and applied the Unsharp Mask filter (Amount—30; Radius—3; Threshold—0).

INGREDIENTS

Camera: Nikon D1X (in-camera metering, pattern mode)

Lens: AF-S Nikkor 12–24mm, 1:4 G, DX SWM ED IF, with 77mm UV filter

Settings: 800 ISO, 1/30 second at f/3.2, –0.3 EV, manual mode, "cloudy" white balance setting

I thought it might be a good idea to produce a retro style in my next fashion series, so I started with an old Shure microphone, like the ones you see in movies from the 1950s. I remembered a location at Bellagio in Las Vegas where they have a cool lounge called the Fontana Bar. They also have an old drum set with an ornate "B" on the bass drum.

A model/actress friend of mine, Amanda Swisten, loves anything retro, so I asked if she would do this for me. As a photographer you have to make a lot of phone calls to orchestrate these "mini movies." The hair and makeup all had to be just right for this project, which ran as a sixteen-page spread and cover for *Las Vegas* magazine.

After I scouted and secured the location, I made a shot list with the editor to see what outfit looked best for each scene. That exercise took half a day. After making the selections, we had a fitting with Amanda to double-check the clothes.

I am all digital now, sporting Canon's 1Ds Mark II, and I don't remember how I ever lived before digital. The other day I was shooting an assignment for a client who wanted film. I kept looking down at the camera body to view the image I had just captured, but I couldn't because it was a film camera.

INGREDIENTS
Camera: Canon 1Ds Mark II
Exposure: 100 ISO at f/8, $^{1}/_{125}$ second
Light: Profoto strobe, flagged off with GatorBoard; other strobes covered with amber gels; Acute 2400 pack

With digital, I can quickly check my work when I am building a shot with lights—like the image of Amanda singing in front of the striking red curtains. I wanted to make sure I was getting shadows where I wanted them. I also wanted to keep light on the drum set and not fully on Amanda while shooting 100 ISO at f/8 and $^{1}/_{125}$ second; shooting digital allowed me to ensure these elements.

We made fine adjustments, flagged off the main Profoto strobe with some GatorBoard, and covered the other strobes with amber gels to give off some deeper colors. I only used three heads on this shot with an Acute 2400 pack.

Ken Cook: Illustrating a Lighting Concept

Ken Cook from Salinas, California, recently designed the Master's Brush for the F.J. Westcott Company. The Master's Brush is a self-feathering light in a 16x20 softbox. The company requested that Ken, a third-generation photography-studio owner with over fifty years of experience, photograph a signature portrait showing off the attributes of this new light modifier, which is designed to create a two-stop, self-feathering differential between the center of the light and the outer edges.

Ken selected a young woman with big, beautiful eyes and a wonderful facial structure. Photographing her with a Rembrandt broad-lighting pattern gave him the opportunity to show off the merits of the new product at its best.

The lighting pattern comes down to the face at a high 45-degree angle producing the signature triangle on the short (shadow) side of her face, thus allowing the fast falloff of the light modifier to place the exposed ear back into shadow. Ken only lit the "inner face," allowing the Master's Brush to produce the 360-degree, two-stop falloff.

Ken's objective is to capture everything on negative or digital capture and not to use Photoshop for burning or dodging. —*Harvey Goldstein*

INGREDIENTS

Camera: Mamiya RZ67
Lens: RB 150mm soft focus
Film: Kodak 160nc
Strobe: Photogenic 1250 Monolight with Master's Brush attachment
Flash Output: 50Ws
Retouching: Kodak dyes
Paper: Kodak Supra Endura E
Exposure: f/8
Vignette: Bottom dark vignette on camera
Negative: Scanned on an Imacon Flextight Photo Scanner, as a 5x7 at 300dpi
Software: Adobe Photoshop for minor retouching
Computer: Apple Power Mac G4
Printer: Epson Stylus 4000
Output Resolution: 2880dpi

Destiny was created with an AlienBees 1600 with a standard 7-inch reflector, fired into a Superior Arctic White seamless paper secured 10 feet forward on the floor with white duct tape. The main flash was 27 feet away from the background, with the center of the beam pointed to the farthest edge in order to light the surface evenly.

INGREDIENTS

Camera: Sigma SD-9
Lens: 50mm Sigma f/2.8 macro/portrait
Lighting: Alien Bees 800 with 7-inch reflector; Alien Bees 1600 with 7-inch reflector; two Bogen Lightform P-22 scrims
Metering: Minolta V incident flashmeter
Software: Adobe Photoshop

The subject stood in the front right corner of the seamless. The raw light path was interrupted by two Bogen Lightform P-22 scrims, both fitted with translucent rip-stop nylon and clipped together to form a slightly V-shaped, self-standing footprint about four feet away from the model. The power was adjusted to read f/5.6 on the subject's right cheek using a Minolta V incident flash meter. Two 4x8-foot white foam-core boards held together by white duct tape, also in a V-shaped footprint, placed four feet on the other side of the subject, provided fill light.

By placing the incident meter on the background surface with the dome aimed back at the raw light, the reading was between f/5.6.5 and f/5.6.8 at any point across the 9x9-foot area. Destiny's hair and white seamless floor were illuminated from an AlienBees 800 with a standard 7-inch reflector,

1. 7-inch flash head firing at main diffusion panel and background. **2.** Two Bogen P-22 (42x72-inch tall) panels clipped together with translucent nylon to serve as a main light. **3.** Subject. **4.** Two 4x8-foot white foam-core boards taped as an 8x8-foot reflector fill. **5.** 9-foot white seamless paper background, 8 feet high and 12 feet forward, taped to floor. **6.** 7-inch flash head bounced off ceiling to illuminate paper on floor and subject. **7.** Sigma SD-9 camera with 50mm macro/portrait lens set to $^{1}/_{125}$ second at f/5.6.

bounced into a 16-foot high white ceiling. The meter read f/4.0.8 at the top of her hair with the dome pointed at the ceiling.

The Sigma SD-9 digital camera was set to daylight color balance and fitted with a 50mm f/2.8 macro/portrait lens (twice the normal-lens focal length for that format). The exposure was $^{1}/_{125}$ second at f/5.6. The RAW image file was processed with Sigma's Photo Pro software to Adobe 1998 RGB color space, using medium sharpening (1.0), slight color saturation increase (0.3), and slight highlight increase (0.6) until the background read 255/255/255 (R/G/B).

The only retouching, done in Adobe Photoshop, was to remove a few stray hairs on the right side of the model. For painless high key by preventing imager overload in any digital camera, the secret is never to let the light on the background exceed the main-light reading/camera setting by more than 0.7 stops.

Jerry Ghionis: *Georgina*

Jerry Ghionis is an Australian photographer who, with his wife Georgina, brother Nick, and video partner John, owns and runs XSiGHT Photography and Video.

The image featured here is noteworthy for its extreme visual simplicity as well as its technical complexity. Ghionis says, "The shoot from which this image was created was for a fashion editorial to promote a local designer and the opening of my first international (and second) studio, XSiGHT, in Sacramento, California."

"The image is of my wife, Georgina, hence the title," Ghionis says. "I am very proud of, and emotionally attached to, this image because it is the only time I have had a chance to photograph my wife as a bride. It captures the way I see her as a beautiful, captivating woman with a little mystery."

The photograph was taken in the Freemason building in the heart of Sacramento. The image shows Georgina floating across the wooden floor of th[e] grand ballroom, angelically lifting both arms in the air whil[e] holding the veil of a beautiful wedding dre[ss] made by Miosa Couture. Ghionis used a[s] much ambient light as possible, using exist[t]ing tungsten lights and allowing the natura[l] light to filter through the back window[s]. "As a big fan of backlight," Ghionis says, "[I] wanted to add more drama to the photo[graph by creating two shadows of the figur[e] crossing each other in the foregroun[d] behind Georgina. I achieved this by placin[g] two 500-watt Lowel tungsten video light[s] in front of Georgina, pointed away from th[e] camera."

Ghionis finished the image in Photo[shop using the following steps:

1. Color correct the image with Levels.
2. Duplicate the background layer and change its blend mode to Soft Light. Then, desaturate the bottom layer.
3. Adjust the opacity of the top layer to 8[0] percent, then flatten the image.
4. Duplicate the background layer again and change the blend mode to Multiply to darken the image.
5. Delete any overly dark sections.
6. Adjust the opacity of top layer to approximately 60 percent, then flatten the image.
7. Add selective Gaussian Blur, vignetting and noise.

Jerry Ghionis can be contacted at XSiGH[T] via email at jerry@xsight.com.au or throug[h] his web site at www.xsight.com.au. —*Larr*[y] *Singer*

INGREDIENTS
Camera: Nikon D100
Lens: Nikkor 16mm f/2.8D fisheye lens
Software: Adobe Photoshop
Exposure: 1/30 second at f/5, 800 ISO
Light Meter: None
White Balance: Shade
Color Mode: RGB

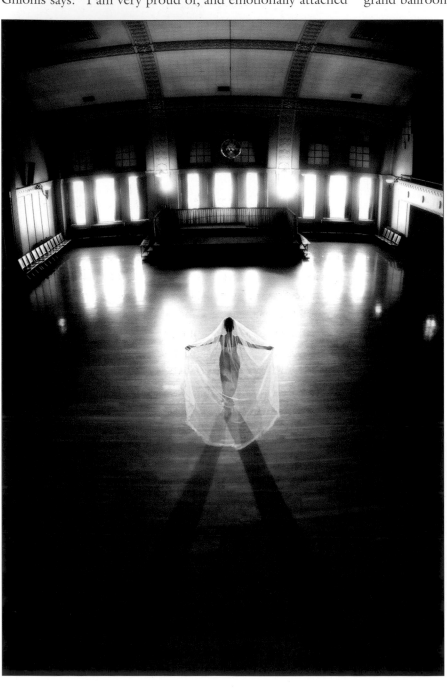

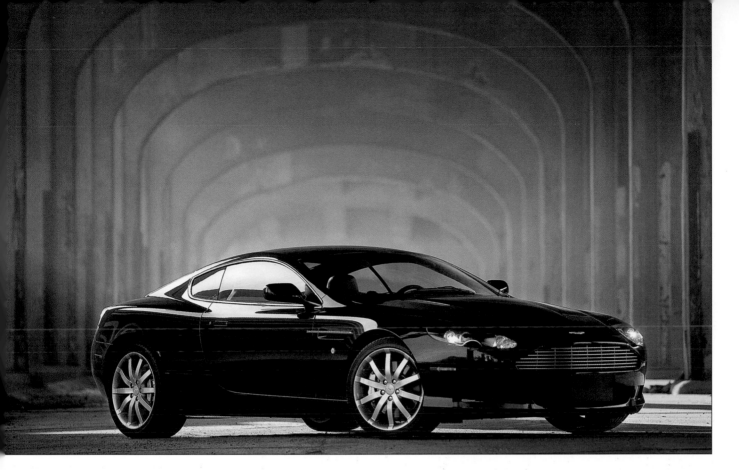

David Wendt: The Aston Martin DB9

I've lived in Cincinnati, Ohio, for twenty years, and I have spent much time scouting for locations suitable for shooting cars. I observed recently that I was beginning to use many of the locations I'd seen nearly two decades ago to solve graphic problems with today's new cars. This shot of the Aston Martin DB9, for example, was done at a location I used a long time ago. That older shot was terrible; it was shot at the wrong time of day. But the idea of that spot at the *right* time of day with the *right* car stuck with me.

INGREDIENTS

Camera: Canon EOS 1Ds Mark II
Lens: Canon 70–200mm f/2.8 at 200mm
Exposure: 1/160 second at f/2.8
File Format: RAW
Software: Adobe Photoshop

Locations and the time of day are chosen both for the lighting and for who is around at that hour. I like to work as simply as I can. I don't have budgets that allow me to hire crews to shut down roads or bridges. I've always found that being flexible about where and when to shoot the car has been to my advantage. As I've gotten to know this about my own town, I've found that the same goes for just about anywhere else. But most everywhere else I've worked with these cars, I've been able to find a place to do a shoot quickly, quietly, and conveniently without disruption to traffic or the owner's/driver's common sense.

I'm getting better at looking around now. I look at the space where a car may fit—where it can sit out of the way for a period of time, which is very important. I analyze what's behind the car and what the light will be like at sunrise or at different times of the year and on different days of the week. Sunday morning, for example, is a great time to shoot cars because no on else is usually around.

This shot is facing east at the end of May. I thought, "In late November, the light will be from the other side of the bridge. Would that be better? Would the owner get the car out in November or January? Will there be salt on the road? Will the car get the right reflections without having to set up numerous reflector panels that call attention to what I'm doing? Will I be able to park the car in a place that will allow me to feature it and the background so they work together and enhance each other?" This shot only took about ten to fifteen minutes. And I took my time.

Learning when and where great places are just takes time and observation. It's something you acquire if you have the interest. My job is to find spots where I can park a great car and make a good image. My job is to make the image like the DB9 here. I call myself lucky, and I am. But I also spend a lot of time looking for these kinds of places so I can be there when the luck is there with me.

5. PAINTER EFFECTS

*C*orel Painter is a very unusual software program. Not every photographer has the discipline required to learn it. But those who call themselves artists are compelled to master it, and it redefines how they do what they do.

We include four artists' techniques here. Fran Reisner uses Painter to blend and soften her images. The result is almost a photograph and almost a painting. Michael Campbell starts by photographing an image that he intends to convert to a painting. He pulls out all the stops in Painter and, with heavy reliance on the Sponge tool, creates an elegant masterpiece.

Marilyn Sholin's Painter technique is more illustrative than photographic. Her colors are unnatural in a poster-like fashion. Yet her subject matter and subject treatment is soft and evocative, like a dream.

Jeremy Sutton, like Marilyn Sholin, travels the country espousing the wonders of Painter. Jeremy's Painter style, often loud and blaring, is much more subdued in the image shown here. He reveals in great detail how he produced a ballet painting in the spirit of Degas.

Her subject matter and subject treatment is soft and evocative, like a dream.

Fran Reisner: Focused on Passion

When Texas photographer Fran Reisner was commissioned to create a portrait of three sisters, she gave it a lot of thought. Her goal was to create a storytelling image that showcased the relationship of the sisters at that age and moment in time.

During the initial consultation, Reisner learned that the girls would be wearing matching flower girl dresses from their uncle's wedding. They agreed on a dressing-room setting, and the mother was encouraged to bring heirloom props, such as an antique silver brush and hand mirror, along with a favorite doll.

Feeling that soft, natural light would produce the most appropriate look for this image, Fran relied on a large window with south-exposure natural light. Fill was provided by an unlit 4x6-foot Larson softbox, which she used only as a reflector. The table lamp in the background was left on, casting its own illumination for a warm, realistic effect.

The girls' time in front of the camera was under thirty minutes—just enough time to let each have a turn at the mirror, without being so long in duration that boredom set in. Reisner coached the basic pose, but then let the girls fall into the naturally occurring poses, such as the charming curled toes of the youngest, sitting on the chair.

The final image was scanned and brought into Corel Painter, where it was completely reworked to resemble a painting.

For information on Fran Reisner's *Focus on the Passion,* a twelve-hour DVD set, or *Dreams of Tomorrow,* a DVD that shows how some of her best images were created, visit www.franreisner.com. You can also view more of her images at the same site. —*Jen Bidner*

INGREDIENTS
Camera: Mamiya RZ67
Lens: Mamiya 180mm
Film: Kodak Portra 400 VC
Lighting: Window light
Light Modifier: Unlit 4x6-foot Larson softbox
Final Treatment: Corel Painter

Michael Campbell: Making an Oil Painting

I photographed the energetic, cooperative, and multitalented Tasha using three Photogenic lights in softboxes of different sizes, the smallest (a Westcott Masters Brush softbox) being used for the main or modeling light. The fill light was twice the size to provide soft shadows. The third light was placed behind and above on the opposite side from the main light to give some light on the hair.

The background was a gray wall. In Photoshop, I adjusted the Levels and Curves for good tonal range and contrast. I then removed the background using the Background Eraser tool. I did this on a duplicate layer, of course—let's call it layer B. After getting a fairly quick but not-very-precise

result, I held down the Command key (Mac) and clicked on the layer to make a selection. I then selected the original layer (layer A) and clicked on the Layer Mask icon, which created a mask based on the active selection. I then dragged layer B to the trash. It was now easy to refine the mask using the Brush tool, painting with either black or white into the layer mask.

INGREDIENTS
Camera: Fujifilm FinePix S3
Lens: Tamron 28–105mm f/2.8 AF Zoom
Lighting: Photogenic in Westcott softboxes
Computer: Apple Power Mac G5
Graphics Tablet: 9x12-inch Wacom Intuos3
Printer: Epson 2200
Software: Adobe Photoshop and Corel Painter

I cropped the image to improve the composition but left a little more around the image than was necessary so I could crop it more after the painting stage was completed.

Next, I created a new layer (C) underneath the image layer. I selected two colors from the violin, one light and one a dark brown. With the Gradient tool, I then created a diagonal gradient of the two browns in layer C. I used the Hue/Saturation command to make a few adjustments to this until I got an approximate idea of the background I wanted to produce in Painter. I saved the image with Layer A and Layer C still separate and then opened the file in Painter.

Using the Square Chalk, I added other colors to the layer C, notably some blue and cyan to contrast with the warm brown of the skin and the wood of the violin. I then used the Smeary Wet Sponge to slosh (a technical term!) the colors about so they were blended but not totally mixed into mud.

The next step was to flatten the image and make a clone.

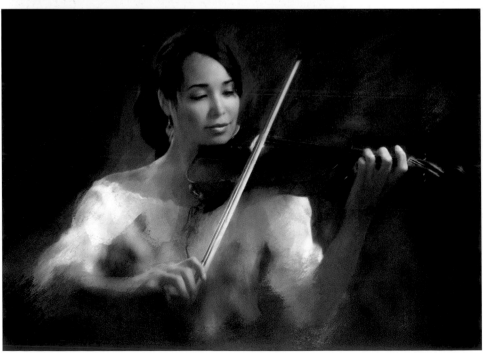

To create a canvas to paint on, I used the same sponge technique to slosh the colors of the clone into a discombobulated mish-mashed hodgepodge (another technical term!).

Switching back to the chalk and clicking on the Cloning icon in the Color palette, I started bringing back the image into the clone. I had the paper set on a coarse texture and the grain control turned down to about eight so the texture was applied with the paint.

I finished by refining the more detailed areas with the Oil Brush clone tool. Finally I seasoned to taste in Photoshop for printing with an Epson 2200 printer on matte paper.

Marilyn Sholin: *Remember When Your Brother Was Your Best Friend?*

For the past 25 years, Miami's own Master Craftsman and portrait artist Marilyn Sholin has constantly and creatively set and raised the bar for other professional photographic artists. Marilyn, the well-known baby, children, and family portrait photographer, has evolved into Marilyn, the portrait artist and Painter expert.

Marilyn says, "Capturing moments between brothers and sisters is a specialty of mine. I love to delve into their relationships and capture their feelings. The trademarks of my paintings are my vibrant and saturated colors, but those are not for every client. I also paint portraits from photographs for clients in the actual colors depicted in the film, just as a traditional oil portrait artist does."

This image is one Marilyn remembers well. "We went to a beach at sunrise for the shoot. Although the client commissioned photographic portraits, I always photograph with the intent of tempting them to upgrade to a painting. As soon as I saw the lighting at sunrise and the warm relationship the twins shared, I knew I would probably get my portrait to paint.

"I began the session with the typical photography that clients expect to receive—with the children both posed formally and also casually smiling at the camera. Gradually, as they became more comfortable with the camera and me, I asked them to interact with each other. I captured giggling and tickling and laughing, and finally when the moment was right, I asked the sister to hug her brother. The spontaneity with which she hugged him from behind, and the way he responded made for an instant that I knew was going to be the painting.

"After the film was processed and edited, I sent the negative out for a high-resolution scan and opened it in Adobe Photoshop. I then color corrected it, not for a photograph to

be printed, but with rich saturated colors as the first step of a plan to use Corel Painter.

"In Painter, using cloning brushes, sponges, wet sponges, and acrylics, I added color and blended in the warmth and softness that I knew would enhance the painting. I chose the colors for the image. It was extremely important to add highlights to retain the feeling and to add detail in the eyes and faces. Had I left out these details, it would have looked too much like a photograph and not enough like a painting."

The image was created on a PC with Photoshop and Painter using a Wacom Intuos Tablet. Marilyn printed the image on canvas and hand-embellished the surface with acrylic paint for the final look.

Visit Marilyn at www.marilynsholin.com to see more of her work. —*Bob Rose*

INGREDIENTS
Camera: Hasselblad 500C
Lens: Zeiss 150mm f/4
Film: Kodak 400NC
Lighting: Existing light, Vivitar 285, reflector
Software: Adobe Photoshop and Corel Painter
Graphics Tablet: Wacom Intuos

Jeremy Sutton: Creating Painterly Images With Corel Painter

Painter offers such a vast array of brush looks that almost anything is possible. Your only limit is your imagination! Here I'll focus on transforming an image of a ballerina taken by David Taylor. This introduces the basic principles of working on photographs in Painter.

1. Select your source image. Resize it and crop if necessary, and make any necessary adjustments to the image using Photoshop or Painter.

2. Before making a clone (duplicate) of your original image (File>Clone), decide on the look you want. If you are seeking a watercolor or oil effect, I recommend using Canvas>Canvas Size to add a white border to your image. This will allow you to roughen and smear the image edge by hand. For a pastel look, as in this image, there is no need to add a border. After making a clone, just select a suitable paper color from the Colors Palette, and fill your clone canvas with that color (Cmd/Ctrl-F).

Original Photograph by David Taylor.

INGREDIENTS
Computer: Mac or Windows
Graphics Tablet: 6x8-inch Wacom Intuos2
Software: Corel Painter
Photo by: David Taylor

Next, choose a brush by selecting the Brush Category in the Brush Selector and then the specific brush within that category. You have three main choices: brushes that add color taken from the original source image; those brushes that add the color selected in the Color Picker; and those that smear or blend color already on the canvas.

3. For this image, I decided to fill the clone with beige, then use the Large Chalk variant in the Chalks Brush category to brush in the details of the figure. The Chalk Brushes reflect the currently selected Paper Texture, in this case, French Watercolor Paper. To turn the Large Chalk into a clone brush that takes color from the original image rather than the Color Picker, I clicked on the Clone Color (rubber stamp) icon just below the hue wheel in the Colors Palette.

4. After mapping out the basic forms of the figure with the Large Chalk using clone color, click on the Clone Color icon so it is inactive. Then select colors in the Color Picker to add to your image. (*Note:* You can always clone back the original image if you go too far with adding your own colors.)

5. To softly smear some of the chalky brush strokes, especially at the edge, select the Just Add Water variant in the Blenders category, lower the opacity, and apply gently with light pressure. Other good variants in the Blenders are Grainy Water, Smear, and Runny.

6. As a final touch, use a little of the Soft Clones variant (Cloners category) with low opacity and light pressure to subtly mix in some of the original image. Here, I applied the Soft Clones around the face, eyes and hair and some of the detailing of the dress. By saving sequentially numbered versions as you work, you can always clone from an earlier version back into the current working image, giving you great flexibility.

There is much more Painter advice I would like to share with you—how to make the most of the Custom Palettes and how to get wonderful watercolor and oil effects from the many other great brushes. Since this space is limited, though, I recommend that you visit my web site www.paintercreativity .com. There, you will find illustrated step-by-step tutorials, information and links regarding educational resources (books, DVDs, and classes) that will help you master the wonderful world of Painter. Happy painting!

6. PHOTOSHOP EFFECTS

*a*dobe Photoshop is the ultimate creative tool. Richly detailed in its effects and flexible almost beyond comprehension, no one can truly master all of the areas of Photoshop. It's simply too vast.

The Photoshop techniques presented here are as varied as the program is diverse. Here's a short synopsis of what's covered in this chapter.

Bambi Cantrell is a well-known portrait and wedding specialist. Here, she dissects the differences in cross-processing techniques. She produces both the effect of processing transparency film in color-negative chemistry and the opposite effect of processing color-negative film in transparency chemistry. Bambi illustrates one technique traditionally, and one digitally. She also discussed the making of an enigmatic portrait titled *Gypsy*.

Todd Morrison, with the help of a Wacom Intuos graphics tablet, produces beautiful, painterly images of children worthy of gallery display.

Michael Campbell describes the procedure used to create an incredible black & white fine-art piece that has almost no equivalent in reality.

Stephen Dantzig describes a simple Photoshop toning technique, while Deborah Lynn Ferro details the technique of combining black & white and color in the same image. Deborah also talks about the simple pleasures of using Photoshop's Lab color mode for various effects.

Robert Kunesh, Jim DiVitale, and Julieanne Kost describe the start-to-finish techniques involved in creating one-of-a-kind masterpieces, all drastically different.

Lastly, David Wendt discusses two incredibly different rare automobile photos. One, a limited-production Ferrari, was photographed on ten different frames, painting the light with strobe differently in each frame. Then the individual exposures were made into layers where an extensive blending process produced an impossible "day for night" effect. Wendt, in another shot of a classic Chevelle, discusses the beauty of layers for extensive highlight and shadow manipulation.

The Photoshop techniques presented here are as varied as the program is diverse.

Bambi Cantrell's Cross-Processing Artistry

Bambi Cantrell offers her clients fresh, spirited portraits using the cross-processing technique. One or two of these shots can add an artistic flair to any album.

Cross-processing is a technique in which color transparency film is processed in C-41 negative chemistry to produce a negative with altered tones and contrast, or color negative film is developed in E-6 transparency chemistry to produce a positive image. Usually, Cantrell uses Kodak Ektachrome 100VS film because its high saturation yields very exaggerated colors.

In the cable-car photo shown here (left), Cantrell used Ektachrome 100SW developed in C-41 chemistry—even though she isn't thrilled that this warmer film tends to make the flesh tones greener.

"Cross-processing is exciting to shoot, because it is unpredictable—and I love that," says Cantrell. Even so, she has recently begun doing more digital imitations of the technique (right).

Through experimentation, Cantrell has found that she can digitally manipulate images to quickly imitate the cross-processing effect. She begins by scanning an image, or shooting an original digital photo with her Canon EOS 1D digital camera. She then uses the Brightness/Contrast controls in Adobe Photoshop to bump up the contrast about 50 percent and then makes minor color adjustments.

Be forewarned, however, that this causes all the shadows to go very black. Faces therefore must be relatively shadowless (turned toward the sun or filled with flash), or the eye sockets and other shadowed areas will become ugly black slashes.

For more examples of her photographs, visit Bambi Cantrell's website at www.cantrell portrait.com. —*Jen Bidner*

INGREDIENTS

Digital Camera: Canon EOS 1D with EF 70–200mm f/2.8L lens
Film Camera: Hasselblad 503W with 100mm lens
Flash: None
Film (Cable Car Shot): Kodak Ektachrome 100SW

Todd Morrison: Painterly Portraits

Todd Morrison has seamlessly integrated his traditional portrait images with the artistry of a painter and the wizardry of a digital master. The result is a portraiture style that is very much in demand from his clients.

Todd's portraiture usually starts with very simple, open lighting. The main light is a 6-foot octagonal Photoflex softbox with a Photogenic flash unit. This is positioned at a 45-degree angle to camera left. A 6-foot collapsible reflector provides the fill. He captures the image with a Kodak DCS 760 digital camera and a Nikkor 50mm f/1.8 lens (for a 35mm equivalent of approximately 65mm).

He acquires the RAW-format image and converts it to a 16-bit TIFF. After making basic color, contrast, and Levels corrections, and adding a white border, he begins to "paint" the image in Photoshop. In this case, he used the Art History Brush (using the Tight Short style with a tolerance of zero). He then worked on the background with the Watercolor 3 brush from the Natural Brushes 2 category.

He begins this kind of alteration with large brushes and works down to small brushes for the details. His finishing touch is to copy and modify a light skin tone and use this to paint in some highlights. Morrison stresses that the control cannot be achieved without a Wacom Intuos graphics tablet for painterly control of the brushes.

The entire process takes about two hours, but the final product is well worth it, invariably leading to increased sales.

To see more of Morrison's photographs visit www.morrison photography.com. He offers on-site consulting services for helping photographers set up or reorganize their studio and business. He also has a video training series available through www.software-cinema.com. —*Jen Bidner*

INGREDIENTS
Camera: Kodak 760 and Nikkor 50mm f/1.8 lens
Lighting: Photoflex Octagon with Photogenic flash unit, collapsible 6-foot Photoflex reflector
Software: Adobe Photoshop
Graphics Tablet: Wacom Intuos

Martin Schembri: Both Soft and Sharp

An abandoned power station made the perfect backdrop for a portrait taken by Australian photographer Martin Schembri. The facility featured massive corridors and idle turbine engines. Late afternoon sunlight created a natural light source in an outer corridor, and fill was added with a collapsible reflector.

A little bit of Photoshop wizardry created an interesting effect. The image was doubled up using layers. One layer's opacity was altered, and the Diffuse Glow filter was applied. Then, select parts of the layer were erased away to create an image that is both sharp and diffused. Then the technique was re-applied, but this time the Gaussian Blur filter was used to give the image an overall softness, which helps take away the sharp edges around the subject's face.

INGREDIENTS
Camera: Nikon D1X
Lens: Nikkor 28–35mm f/2.8 zoom
Lighting: Natural with a reflector
Software: Adobe Photoshop, including Gaussian Blur and Diffuse Glow filters

Schembri took several variations of the original image, and worked in different parts of the facility. It is a trademark of Schembri's photography to shoot sequentially because he enjoys creating a series of images that tell a story. As a result, he often sells wedding albums that showcase multiple images from a sequence on one page.

To facilitate this type of album creation, and to help photographers do the same, he has created a digital template software called You Select It (YSI). Simple to learn and easy to use, the software lets the photographer simply select one of hundreds of designs and then "drop" their digital photos into the layout. The finished layout can be saved into any high-resolution format (including PSD) or exported directly into Photoshop for further image enhancement or customization. All templates can be resized to fit any album format or portrait enlargement.

For more examples of Schembri's work, check out his web site at www.martinschembri.com.au. Or go to www.youselectit.com for information or a demo copy of his template software. —*Jen Bidner*

Michael Campbell: Photographing Something That Can't Be Photographed

How can we photograph a feeling or an emotion? On the way back from La Jolla, CA, one day, I stopped in a park near the 52 Freeway. I noticed a fallen tree that lay like some huge fossilized beast and seemed to be a metaphor for the struggle of all organic life. I thought about how these struggles fail in death, and how the forms that remain tell us some of their story.

I decided to use the tree as a symbol and a visual metaphor for my feelings about this struggle between life and death; I thought about how to communicate visually the thoughts the tree had inspired. I wanted to express a feeling—not the feeling I had for the tree itself, but rather, the feeling the tree evoked.

In the essay "Equivalence: The Perennial Trend," photographer Minor White asserted that the creative photographer "recognize[s] an object or series of forms that, when photographed, will yield an image with specific suggestive powers that can direct the viewer into a specific and known feeling, state or place within himself."

I wanted to do just that—to use concrete images and forms to convey abstract feelings and ideas. However, I thought the raw photograph was too literal and too recognizable, so I set out to change it.

I first converted the image to black & white in Photoshop using the Channel Mixer; I also increased the contrast. Next I made a new layer and set the Blend Mode to Multiply. I painted black strokes on this layer in areas where I wanted to remove certain details. I made a duplicate of the log layer and flipped it vertically and horizontally, and then altered its size. I selected Lighten as the Blend Mode for this layer, and I repositioned it in the lower part of the image. I merged the visible layers, duplicated the new layer, and then applied the Poster Edges filter. Finally, I reduced the opacity of this layer and flattened the image.

INGREDIENTS

Camera: Fujifilm FinePix S2
Lens: Tamron 28–300mm f/3.5–6.3 XR DI
CF Card: Lexar 48X WA 1GB
Software: Adobe Photoshop
Computer: Apple Power Mac G5
Graphics Tablet: Wacom Intuos 9x12
Printer: Epson 2200 Photo Stylus

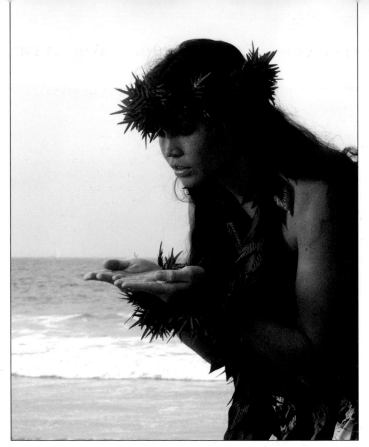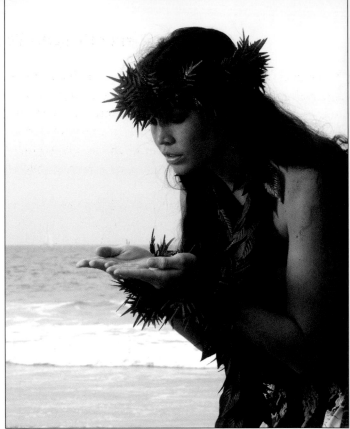

Stephen Dantzig: A Simple Toning Technique

There are many ways to tone your images in Photoshop. I stumbled upon this incredibly simple technique as I was trying to remember how to use some of the more complicated methods (such as the Channel Mixer adjustment layer technique).

I started playing around with other possibilities because the book that details the channel method was 3000 miles away in my office. I knew that I wanted to work with layers and the layer blending options to create the effect, but the methods I was using were still too convoluted. I was looking for a sepia-tone look to add an old-time Hawaii feel to the image of Sanna Dioso wearing a traditional hula outfit.

I started by selecting a dark brown color swatch as my foreground color. Then I created a new document that was the same size as the image of Sanna. I selected the paint bucket tool and dumped dark brown into my new document. I dragged the brown image on top of the image of Sanna while holding the Shift key to center the new layer. I changed the Blend Mode to Color and was done.

INGREDIENTS
Camera: Olympus E-20N Digital Camera
Media Card: CompactFlash
Light: Sunpack Strobe
Software: Adobe Photoshop
Other: Homemade scrim

The idea of having to create a new document to match the size of each image I wanted to tone seemed ridiculous, so I kept playing. I went back to the original document and made a duplicate layer by pressing Cmd-J (Ctrl-J on a PC). I then dumped the foreground color onto the top layer by using the paint bucket tool and changed the Blend Mode to Color. This also worked, but I found an even easier way to do it.

1. Open the image you wish to tone.
2. Select the toning color from the Color or Swatches palette, or use the Color Picker dialog box, and set your choice as your foreground color.
3. Go to the Layer drop-down menu and select New Fill Layer>Solid Color.
4. Accept the default name or change the name and click OK. You will have a solid color as your image.
5. Go to the Layers palette and change the blend mode to Color. (The blend modes are in a drop-down menu on the upper left corner of the palette.)
6. Lowering the opacity of the fill layer will allow the colors in the original layer to show through. Lower the opacity of the fill layer until you get the exact mixture of tones you desire.
7. If you want to change the color of the tone, simply double click the fill layer icon in the Layers Palette and choose a new color with the Color Picker. It really is that easy!

Deborah Lynn Ferro: Color and Black & White in One Image

Sometimes the candid approach to photographing a mother and child is preferable to structured posing. Such a mind-set will enable you to capture those rare moments that exist between them. It is often at the end of a portrait session that you get that one special moment when the child is either relaxed and you have earned their trust, or when the child is just plain exhausted.

This image was taken on location with ambient natural light and fill flash to soften shadows and brighten up the skin tones. The image was captured on Fuji NPH 400 film with the Canon EOS 3. A zoom lens with a long focal length and wide lens aperture (70–200mm f/2.8) was used to isolate the subjects from the background. The negative was then scanned with a Nikon 2000 scanner and brought into Photoshop.

My first step in manipulating any image after scanning is to color-correct the image because there is always a color shift that occurs when scanning, even when they are drum-scanned. I alternate between Levels and Curves depending on the image, but I find that Curves generally gives me more control over my adjustment. The second step is to retouch the image to remove any undesirable blemishes or dark lines.

I use a wide variety of methods when retouching images. With a Wacom tablet and pen I dodge any dark lines or shadows on the face using the Dodge tool set at 5- to 10 percent opacity. My brush is always sized smaller than the area I am dodging. Then, I use the Clone Stamp tool set at 20- to 25-percent opacity to remove any imperfections on the face. You must constantly resample the area so that the face does not appear flat.

Next, I add a softening and a glow to the face. This is done by the use of the Airbrush tool set in the Color mode and at 2- to 5-percent opacity. With the Eyedropper tool, select a color from the face. As you move over the face with the Airbrush tool, you will need to resample the color again so it is consistent with the area you are airbrushing. I will often add a soft red color and airbrush over the cheeks, nose, chin, and forehead for a rosy glow.

To render this image in both black & white and color, I desaturated a new copy of the retouched image. In the Layers palette, I lowered the opacity to bring back a hint of color to the mother. To get the child in color I erased back to the retouched color image. Soft focus was then applied to the image using the Gaussian Blur filter in Photoshop and erasing around the areas that I wanted to keep sharp in the image (eyes, mouth, nostrils, etc.).

For me, photography is an art, not just a technique. Photoshop enables me to artistically express the creative vision I have for a subject—a vision that I am not always able to capture completely with just my camera. I do not take a picture; I prefer to create art that visually captures the love, feelings, emotion, and spirit of the subject.

INGREDIENTS
Camera: Canon EOS 3
Lens: Canon 70–200mm f/2.8 L
Film: Fuji NPH 400
Lighting: Ambient light and fill flash
Software: Adobe Photoshop
Other: Nikon 2000 scanner, Epson 1280 printer, and 9x12-inch Wacom tablet

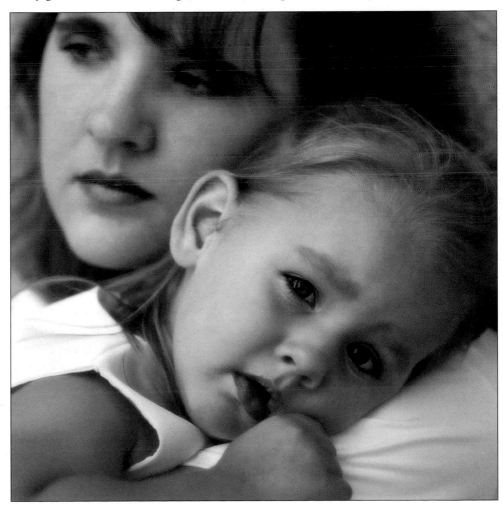

Deborah Lynn Ferro: Lab-Color Conversion

As photographers, what better subjects are we privileged to photograph than children, who have the joy of innocence and playfulness that so many adults have trouble relating to? I like to capture "life moments" between a mother and child—images that reflect the love and emotion shared by them.

In the image shown here, I filled up the frame with the mother and child so you are drawn to their faces. This image was taken on location using natural ambient light. A zoom lens with a long focal length and wide aperture (f/2.8) was used to isolate the subjects from the background.

The image was captured digitally and converted to black & white using the Lab color method in Photoshop (see below). After it was converted, a filter was applied to add grain to the image so that it would appear similar to an 1600 ISO film image. The final step was to add an edge effect around the image with Extensis Photoframe, a plug-in filter for Photoshop.

INGREDIENTS
Camera: Canon EOS 1D
Lens: Canon 70–200mm f/2.8 L
Lighting: Ambient light and fill flash
Digital Equipment: Epson 2000P printer, 9x12-inch Wacom tablet
Software: Adobe Photoshop, Extensis Photoframe

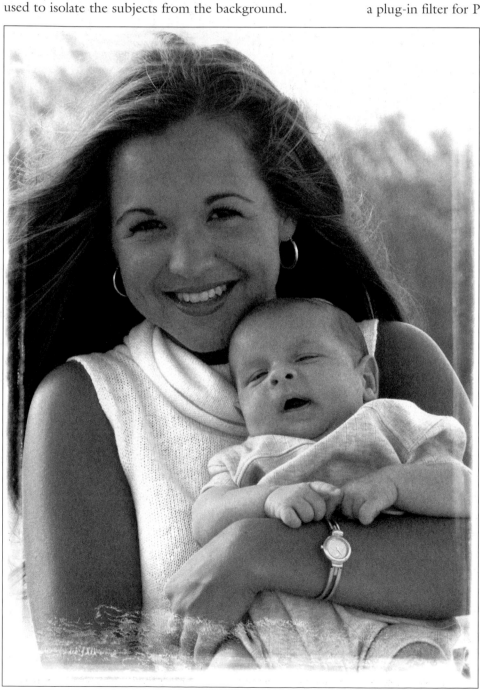

There are several ways in Photoshop to convert a color image to black & white. I like to use the Lab color method, because it produces a sharp black & white image with increased contrast and little or no grain. Here's how to do it:

1. Make sure you are working with a flattened, color-corrected image.
2. Go to Image>Mode>Lab Color.
3. Go to the Channels palette and click on the Lightness channel. This will turn your image to black & white.
4. Drag the A channel to the trash can at the bottom of the Channels palette.
5. If more contrast is needed, go to Image>Adjustments>Levels to make your adjustment.
6. Go to Image>Mode>Grayscale.
7. Go to Image>Mode>RGB to complete the conversion and give you an image that is ready to print.

I suggest you try other methods of black & white conversion (i.e., converting a color image directly to grayscale or using the Desaturate command) and compare them to the Lab color method. I think you will see a remarkable difference.

Bob Kunesh: *The Computer Bug*

Bob Kunesh is an art teacher and photographer who is in the process of digitally exploring the combination of both. Bob started out in art but really wanted to be a photographer. On his way to becoming a Master of Photography, Bob stumbled into Photoshop.

A retired teacher who continues to educate, Bob is co-owner of Studio K Photography and SKP Photo Lab in Willoughby, OH. He simply feels fulfilled when he is photographing people and things or playing on his new toy—the computer. Continuing in educator mode, he wants to share with as many people as possible the wonderful and exciting world of creativity. He mainly focuses on how and why we must live in the creative mode—why creativity is the oxygen of our life, not just in photographic endeavors, but also in everyday existence. He has even come up with a name for his style of photography. He calls it "Photographic Digital Jazz."

About *The Computer Bug*, Bob says, "This image started off as a snapshot of a handful of blue balloons that I photographed at a wedding. I had no idea why I took the photo except that I have a philosophy that keeps me aware of any image that calls to me. I don't ask questions; if it calls, I shoot it. I chalk it up to some higher awareness that finds me easy to latch on to. It's probably artists who have passed on but want to dabble in digital. Anyway, my *modus operandi* is to play with an image until it tells me what it wants to be. I pulled this image into Photoshop and began to experiment with it, eventually using Levels and several Distort filters, including Polar Coordinates to achieve the final effect."

After thinking about it, Bob felt obliged to pass along this thought, "How can you connect a bug, images of computer symbols and a balloon? If I only had the technical knowledge to work all the bugs out."

Bob Kunesh is a Master Photographer and Photographic Craftsman. To see more of his work go to www.portfolios.com/bobkunesh. —*Bob Rose*

INGREDIENTS
Camera: Bronica SQA
Lens: 80mm, f/2.8
Scanner: Epson 2450 Photo
Computer: Intel Pentium 4 1.6GHz, Windows XP
Printer: Epson 2000P, Epson Premium Semi-gloss photo paper

Bambi Cantrell: *Gypsy*

The work of nationally known Northern California wedding and portrait photographer Bambi Cantrell has been featured in such diverse publications as *Martha Stewart Living, American Photo,* and *Ebony* magazines.

Cantrell's technically complex image, which she has titled *Gypsy,* received its initial spark of life from a telephone conversation. "I got a call from my favorite hairdresser saying she was competing in a styling competition," Bambi recalls, "and she wanted me to photograph her subjects. Hairdressers are a lot like photographers in that they wait until the last minute to enter a competition. So, with only a moment's notice, I arranged with her to do the shoot in my studio.

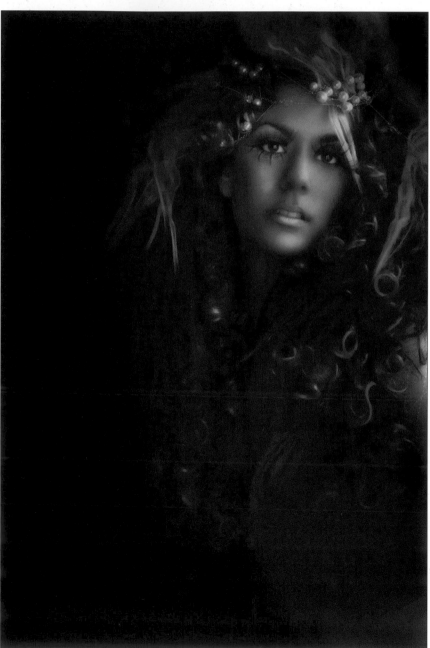

"This particular photograph was taken using window light and an Oriental screen as a backdrop. I chose that particular screen because the scrollwork seemed to flow with and complement the curl of her hair. The theme of the competition was texture, so to bring out the curl, the eyes, and the lips, I first made three layers of the image, then applied the Nik Software Midnight filter to the top layer. I filled in the entire scene with the filtration and erased the face, a portion of the hair, and the chest. I applied the Diffuse Glow filter to the middle layer, applied a layer mask to the top layer, and gently erased about 10 percent of the eyes, lips and curls around the face.

"I've been working with this particular hairdresser (Lori from Wild Orchids) for the past three years," Cantrell continues. "We have an arrangement whereby we get together about every three months to work on new techniques. She gets to try new styles in hair design, makeup, and fashion, and I get to experiment with new lighting, posing, and computer techniques. Because we both get to experiment with new creative techniques, no money ever changes hands. This jointly advantageous agreement has allowed me to grow as a photographer.

"The main reason I enjoy and embrace this type of photo shoot, although I am primarily a wedding photographer, is because to me these two seemingly unrelated categories of photography have much in common.

"The same creative concepts apply whether I am photographing a bride, a high-school senior, or a woman in street clothes. To me, a bride is basically a woman wearing a fancy white dress. While most brides may not be wearing such an outrageous hair style, some little idea will spring into my head that has been inspired by one of these mutually beneficial shooting sessions."

Bambi Cantrell can be contacted at www.cantrellportrait.com. —*Larry Singer*

INGREDIENTS
Camera: Canon EOS 1D Mark II
Lens: Canon 28–70mm f/2.8 L
Exposure: 1/125 second at f/2.8 at 200 ISO
Lighting: Window light
Software: Nik Software Midnight filter, Diffuse Glow filter

Jim DiVitale: *Radio Wars*

Digital-imaging and Photoshop wizard Jim DiVitale has been an Atlanta commercial advertising photographer and instructor for over 25 years. He has lectured before audiences at Photoshop World, MAC Design, Imaging USA, and the World Council of Professional Photographers. As a member of NAPP's Instructor Dream Team since 2000, Jim also writes a monthly column on digital capture for *Photoshop User.*

Radio Wars perfectly demonstrates his mastery of digital manipulation. DiVitale says, "The most important talent to develop for an illustrative photographer in the digital age is previsualization. Being able to see images in mutable layers takes this creative process to the next level.

"While on a Photoshop lecture tour this fall, I had the chance to stay a few nights on the Queen Mary in Long Beach, California. While wandering around on the ship with my camera, I found a display room with antique radios.

"The room was very dark, and I didn't have a tripod with me, so I raised the ISO to 800 and set the white balance for tungsten light. I pressed the lens right up to the glass window to brace the camera and shot one-second exposures of the different radios in the room as RAW files. The files were then processed in Adobe Camera Raw.

"Using the old telephone-line switchboard as a background anchor layer, I outlined each radio with the Pen tool, turned them into selections and brought them into the image as layers, one image at a time. I then blended the different radio images together using different layer blend modes and opacities. Some of the layers were duplicated a few times with different combinations of blend modes to get the translucent effect. Additional grid lines and type were added with different blend modes for additional depth.

"Practicing on these types of composites prepares me for client assignments with tight deadlines," DiVitale explains.

More of DiVitale's work can be seen at www.DiVitale Photo.com/. —*Larry Singer*

INGREDIENTS

Camera: Fujifilm Finepix S2 Pro
Lens: Nikkor 18–35mm f/3.5–4.5D ED-IF AF zoom
Exposure: 1 second at f/3.5
Software: Adobe Photoshop
Computer: Apple Power Mac G5
Monitor: LaCie Monitors

Julieanne Kost: *Levity*

Julieanne Kost's *Levity* conjures feelings of alleviating self-doubt and tackling something without worrying about failure. "The figure," she says, "has been given the freedom to ascend. Knowing she will be protected with the gift of flight, and, wrapped physically by the cocoon around the lower body, she can accomplish the impossible."

After creating a number of test sketches, Kost decided on the most pleasing composition, assembled the individual elements, and photographed them. The images of the ocean, waves, butterfly wings, doll enveloped with string, and clouds (which make up the steam rising from the water) were captured with the Nikon D100. The image of the figure's back and hair were two separate photographs—both shot on film then scanned with the Imacon Flextight scanner. The stained tea bag, which creates the gauze pattern, was scanned using the Epson Perfection 4870 photo scanner.

To produce the composite image, Kost created a new document 22x22 inches at 360ppi in Adobe Photoshop. Before beginning, each individual element had any necessary tonal or color corrections applied. Kost also set the Image Interpolation to Bicubic Smoother in the General Preferences. This assured she would achieve the best results when up-sampling the images to the correct size.

To create the steam, Kost selected half an image of a wispy cloud and copied it to a new layer. Using Free Transform, she flipped the copied layer horizontally to make a mirror image and then merged the two images together. Kost then used a layer mask to hide the clouds in the lower half of the image and used blend modes to composite the cloud and water layers with the wave layer. To keep the Layers palette tidy, Kost placed the background elements into their own layer set.

The hair, legs, and back were isolated using layer masks in their individual files and then brought in to the composite with the masks applied to minimize the file size in the large image. The legs were then blended with the back using a layer mask. An additional mask was added to fade the legs into the water.

The wing was outlined with the pen tool, then the path was converted to a selection and the background deleted. A small part of the wing was absent, so Kost created the missing piece using the Brush and Clone Stamp tools. The first wing was duplicated and flipped to create the second one, then merged down with the first wing. Then, a drop shadow was added using Layer Styles.

Because Kost didn't want the drop shadow to appear on the background, she separated the style from the layer and used a layer mask to hide it where necessary. Kost then duplicated the wings, blurred them slightly to add motion, and placed the blurred copy under the original.

INGREDIENTS
Camera: Nikon D100 (ocean, wings, doll, cloud)
Scanners: Imacon Flextight scanner (figure's back and hair images), Epson Perfection 4870 photo scanner (for tea bag)
Software: Adobe Photoshop

To wrap the entire image in a gauzy texture, Kost added the scan of a used tea bag to the top of the layer stack and set its blend mode to Screen. This setting also minimized any visual dissimilarities due to the different sources of image components.

Finally, Kost added a Curves adjustment layer and used the layer mask to selectively darken down just the edges of the image.

Julieanne Kost and her husband Daniel Brown can be reached through their web site at www.adobeevangelists.com. —*Larry Singer*

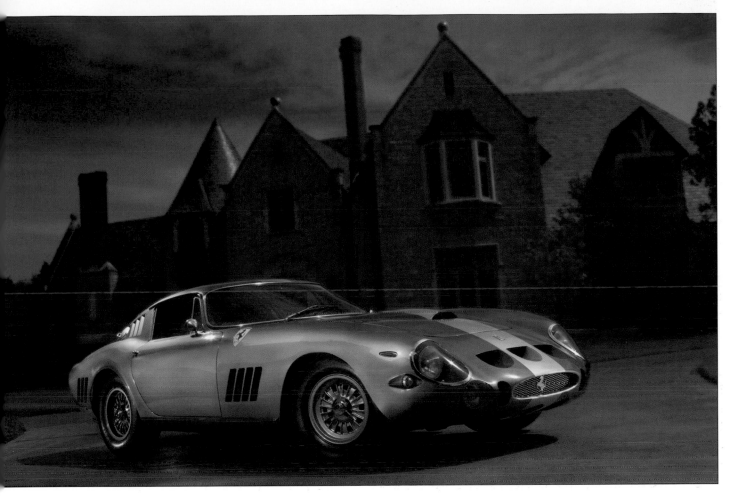

David Wendt: "Layers" With Light

To photograph an ultra-rare silver 1965 Ferrari 275 GTB/C in front of a massive English manor, David Wendt traveled to Dallas, TX.

Although the shot appears to have been taken early in the morning or shortly before sunset, it was really made at noon on a sunny day. To get the moody lighting effect, Wendt took nine separate exposures that he would later sandwich as layers to produce the final image.

First he positioned the car in front of the building. Then he locked his Canon EOS 1Ds (with 50mm lens set to f/22) into place on a sturdy tripod. Then, he used a PocketWizard remote-control device to trigger identical exposures of ½50 second. Wendt first exposed the car with available light. Then, he walked around the Ferrari and "painted" the car eight times with a 400 Watt-second light from his battery-powered Lumedyne flash unit. Firing his flash at different parts of the car from various distances illuminated the vehicle and gave it a dramatic shape.

Next, Wendt downloaded the images to his computer and placed each one on a layer in Photoshop, which resulted in a sandwich of nine different lighting layers.

After the sandwich was complete, Wendt realized he had missed lighting a few spots on the front fender. He retouched those problem areas by creating new layers and sampling existing colors, which he then painted onto the car. To work on each portion of the car Wendt needed to retouch, he used the Pen tool to create an additional five to ten smaller layers.

Because this was his first try at this particular technique, it took Wendt several eight-hour days at a computer to put this image together. Wendt says he could now produce the same results in two or three hours. It simply involves the desire to experiment and repeated practice with the technology.

To see more of Wendt's photography, and learn how he shoots a variety of different vehicles, visit www.wendtworldwide.com. —*Larry Singer*

INGREDIENTS
Camera: Canon EOS 1Ds
Lens: Canon EF 50mm f/2.8
Exposures: Nine shots at ½50 second at f/22
Lighting: Lumedyne 400Ws battery-powered flash unit
Software: Adobe Photoshop
Printer: Epson Photo Stylus 1280
Paper: Epson Matte Heavyweight and Premium Glossy

David Wendt: The Classic 1970 Chevelle

One of my favorite cars is the 1970 Chevelle. For this image, I wanted to convey the feel of the old ads from back when these cars were new. I wish you could have heard this thing as it pulled in. The light was just what we ordered; all we had to do was wait for the sun to go down. Shooting with the Canon EOS 1Ds, I snapped away with just a few adjustments here and there. Everything looked good, so that was that. The shoot took just about an hour.

I processed the RAW file in Phase One's Capture One software to get a good high-resolution base image, but the file just didn't have the snap of the original scene. So how did I get that feeling back? In Photoshop I built layer upon layer of enhancing colors and contrasts. This let me bring up brightness in the reflections and take down areas of shadow to make the car pop. This shot, at last count, had 21 layers.

Usually I work on the sky first. It always has room for better, richer color. Here, I selected the sky using the Color Range command, then added some color by making a new layer and using the Gradient tool.

There is a lot more to this, but a good rule of thumb to work by is this: Always make a new layer to do your work on. Very rarely should you make any changes to the base image.

I always copy the car and the foreground as a new layer. I also copy the background, so as to always preserve the base image.

For this image I used the Pen tool to make a very accurate and very quick outline of the car itself. This tool has been around for some time now, and most people who use Photoshop probably know what it does and how it works. It is "the way" to get smooth selections of any organic shapes in the image. I also feathered the selection to soften the edge of the selected area, since you can see the hard edge more than you might think later on in the finished version.

Once this was done, I started creating more contrasts through applying blurring techniques and the layer-blending modes. This is where it gets complicated to write about, but when you play with the blending of layers and colors using the overlay, screen, multiply, and darken modes, you can start to build levels of contrast that bring about the "snap" that makes the shot look so much better than the original RAW file.

INGREDIENTS

Camera: Canon EOS 1Ds
Lens: EF 20-35mm f/3.5–4.5 USM
Exposure: 1/40 second at f/3.5
File Format: RAW
Software: Phase One Capture One and Adobe Photoshop

7. PORTRAIT LIGHTING

The interplay of highlight and shadow on the human face is infinitely variable.

*L*ike traditional portrait posing, portrait lighting has given way to softer, less rigid forms, complementing the more spontaneous, casual portrait style that has evolved in recent years. Deliberate modes of portrait lighting are necessary, however, to define not only the shape and physical features of the subject, but also to reveal character. The interplay of highlight and shadow on the human face is infinitely variable, but the expert portrait artist will quickly discern the optimal lighting for a specific face.

In this chapter we will cover a myriad of different lighting styles, starting with Don Ayotte's outdoor portrait assignment. Don, an instructor at Hallmark Institute of Photography, uses what he calls "tree line" light to produce a delicate rim light around the portrait subject and lovely facial modeling.

Celebrity portrait artist Matthew Jordan Smith created a classic portrait of legendary photographer Gordon Parks in his home in New York City for Smith's book, *Sepia Dreams* (St. Martin's Press, 2001).

Master photographer William S. McIntosh provides two examples of outdoor portrait lighting with barebulb flash. McIntosh has perfected the use of barebulb flash for fill and explains every nuance of the technique.

Norman Phillips discusses an available-light portrait of a young boy in which Norman interpolates the information given him by the light meter. Great portrait photographers are aware that their experience and intuition often provide the difference between a passable portrait and a great one.

Louise and Joseph Simone, legendary Canadian portrait photographers, talk about one of their classic family portraits made with parabolics.

Tim Walden presents a beautiful character portrait called *The Hands of Time*, in which shadow detail and highlight brilliance abound.

Lastly, Monte Zucker presents a simple way to harness backlight outdoors as a high-key portrait lighting.

Don Ayotte: Teaching Natural Lighting

A typical day for Don Ayotte, director of education and an instructor at the Hallmark Institute of Photography in western Massachusetts, is to take his students into the field for some real-world scenarios.

Since the digital era has come to photography, such live demonstrations have become much easier and provide a great learning opportunity. Moments after taking the image with a Mamiya 645 AFD camera and a Leaf Valeo 17MP digital back, students can view the finished product on an HP iPAQ, a handheld portable computer with Bluetooth wireless technology. The students can instantly see how the lighting ratios look in a two-dimensional image, and how decisions such as aperture or fill light affect the final product.

The assignment for this day was to learn how to take "tree-line" and rim-lit portraits in natural light. In the first image (left), the model was placed in the open shade. The photographer stood with his shoulders parallel to the tree line. The open sky to camera left was the main light source on the face, producing diffused light on the left side of the model's face. A branch held in the foreground by one of Ayotte's students was thrown out of focus through the use of aperture selection (approximately f/4 at with the 110mm lens setting).

In the second image (right), the assignment was to create the illusion of depth through aperture selection. The secondary aspect was to learn how to balance rim light from direct sun with an open-shade exposure. —*Jen Bidner*

INGREDIENTS

Camera: Mamiya 645 AFD with Leaf Valeo 17MP digital back

Lens: 55–110mm zoom set to about 100mm

Other: HP iPAQ portable solution with Bluetooth wireless technology

Lighting: Natural

Software: Adobe Photoshop

Matthew Jordan Smith: Gordon Parks for *Sepia Dreams*

Several years ago, celebrity/beauty photographer Matthew Jordan Smith set out on a personal project—to photograph fifty African-American celebrities and discover how they made their dreams come true. The result is an inspirational book combining sepia-toned and color photographs with insightful quotes, entitled *Sepia Dreams* (St. Martin's Press, 2001).

INGREDIENTS
Camera: Mamiya RZ67
Lens: Mamiya 100mm lens
Flash: Profoto power packs with Octa Bank softbox and Magnum reflector
Film: Kodak Plus-X 120
Tripod: Gitzo

Among these images is one of photographer Gordon Parks, taken at his home in New York City. After listening to Parks play the piano for him, Smith positioned Parks in front of a shoji screen. He set up two Profoto flash units for the photograph. The main light was from a 2400Ws power pack with an Octa Bank softbox about eight feet from him. The background and rim light was on a separate Profoto power pack with a Magnum reflector. A 4x8-foot reflector added fill light to the scene, while a flag blocked backlight from hitting the camera.

The image was then captured on Kodak Plus X film with a Mamiya RZ67 camera and a 110mm lens. The camera was set up on a Gitzo tripod. The flash units were slaved to the camera with wireless remote. "When I'm shooting, I don't like to be tethered to the lights by a cord," Smith explains. The film was then processed and printed by L&I Labs in on West 17th Street in New York City.

Smith says that he is "working towards digital." Although he currently uses Canon EOS digital SLRs for his personal work, he still relies on film when creating his professional work.

After the shoot, Smith stayed to interview Parks for the book. "The journalistic side of *Sepia Dreams* was new to me," says Smith. He found the interviewing process very rewarding and was pleased to share the insights of these successful individuals with his readers. In addition to Parks, Smith photographed and interviewed Samuel L. Jackson, Vanessa Williams, Halle Berry, and Gregory Hines to name just a few.

Signed copies of Smith's book are available at www.sepiadreams.com. More examples of his photography can be seen on his website: www.matthewjordansmith.com. —*Jen Bidner*

William S. McIntosh: The Environmental Family Portrait

The portraits that bring in the most profit for my portrait sessions today are family groups. Up until about 1970 most of my groups were made in the studio. Although I still offer studio portraits, today most group sessions are conducted either outdoors or in the family's home.

I began making family portraits in gardens and on the Atlantic oceanfront in 1964. I offered them as wall-sized portraits mounted on canvas to be sold as premium, custom-made portraits. In the '60s, color negative film was slow and a far cry from the quality of film today. To get good-quality backlit portraits or portraits made just before the sun went down, you had to use blue flashbulbs to supplement the light, or else the shadows would turn blue. A serious drawback, however, was that most battery-powered strobes were not powerful enough, and those that were did not recycle very fast.

I made these types of portraits to create a new market for my studio. I kept them on display continuously. It still took five or six years before customers began to see their value. It was the early 1980s before the environmental portraits began to overtake the volume studio portraits. Today about 60 percent of my portrait business is of family groups made outdoors. My technique is very much the same as it was in the '60s, except the film today is far superior and so are the battery-powered strobes and cameras.

INGREDIENTS
Camera: Mamiya RZ67
Lenses: Mamiya 90mm and 110mm
Strobe: Lumedyne barebulb flash set to f/8 for both exposures
Film: Fuji NHG II 800 and NPH 400 films
Exposure: 1/30 second at f/8 (roses); 1/60 second at f/8 (oceanfront)

Fine portraits can be made outdoors in the shade when you can find the right scenery and conditions. Equally, fine portraits can be made right after the sun comes up and just before it goes down.

In either situation, the portraits can be made using reflectors to fill in the faces of your subjects. However, it takes a big reflector to cover a group of six or so, plus even a slight wind makes it hard to handle. Therefore, I prefer to use a barebulb strobe to fill in backlit subjects or to add a little punch to sunlit subjects when the sun is very low, early in the morning or at sunset.

No matter how good your artistic and photographic skills are, though, there is one more element required to make a great group family portrait: color harmony. Spend time before the sitting discussing the style of clothing (formal or casual) and advising clients of particular colors that they feel happy with and that will also create a harmonious portrait.

The garden family portrait (top) was taken with the last rays of the sun behind the family. You can see the light on their hair. The exposure of the ambient light was 1/30 second at f/8. I set the strobe at an f/8 output and the shutter speed at 1/30, thus matching the daylight exposure. This gave a good lighting pattern to their faces and added catchlights to their eyes. Without the strobe, their faces would be in the shade and their eyes would be lifeless.

After the sun has just gone down, the oceanfront sky is very dramatic (bottom image). The light on the family, however, is frequently flat and lacks contrast. I use a Lumedyne barebulb strobe to make the people stand out. The exposure for the sky is 1/30 second at f/8. I set the strobe for f/8 and the shutter for 1/60, thus underexposing the sky by one f-stop to make it deeper and more dramatic.

Norman Phillips: The Evolution of Evan

An award-winning photographer from "the other side of the pond," Norman Phillips came to Chicagoland from London in 1980. In 1983 he opened Norman Phillips of London studio, in the North Shore suburb of Highland Park. He specializes in portraits of children, families, weddings, and bar mitzvahs.

Norman's approach to photography is direct: "I am on an ongoing mission to produce something different, exciting, and emotional. I don't want my images to be just technically beautiful. They must be a commentary of what I see in my subjects. People tell me my portraits appear to be talking to them. Communication between me and the use of lighting techniques are the defining difference."

About this portrait Norman says, "I have been photographing Evan since he was one year old. For the first four years, all the portraits were made in his home. Each year I seek to create something different to show how he is evolving as a little boy. I have created images with him outdoors, and in different locations in the house—each to show another side of him. One, titled *Evan's Hall* placed him in the hall where three of his previous portraits hang. This latest image shows his growing interest in learning and in books in particular. We scheduled the morning so I could use the light from two windows in the family living room, one at the left of the camera as my main light, and one to the right of the camera and behind Evan. The light to the left of the camera was sweeping across the front of the boy's face to create modeling, and the book was positioned so that the same light could be reflected from the book onto his face as a fill light. Light coming from behind was used to create separation in the shot. The composition was designed to create a line that runs through the image from wherever you begin your analysis.

"The exposure was calculated from the highlight side and then an additional ½ stop was added to compensate for the shadow side in order to balance the exposure across the image. This ½ stop did not overexpose the highlight side and therefore did not require custom printing. Many would have added a full stop, but this would have tended to burn out the highlights a little and create an unbalanced exposure. The only modification in the finished image was to damp down the reflection on the leather couch behind the boy, which would have been a distraction."

Norman is a British Master Photographer. More of his work and information on his resources can be found at www.normanphillipsoflondon.com. —*Bob Rose*

INGREDIENTS
Camera: Pentax 645N
Lens: Pentax 150mm f/2.8
Settings: 1/30 second at f/5.6
Film: Kodak Portra 400VC
Light Meter: Sekonic L-508 Zoom Master

Louise and Joseph Simone: Parabolics for Portraits

Louise and Joseph Simone have been a couple and a team since 1975, when they established their studio, Simone Portrait, in Montreal, Canada. Since then, they've never stopped investing in their profession and continue to be excited about their work. As Joseph puts it, "We consider the portrait a sacred art. The love and passion that we invest in our profession is reflected in each image because a subject who feels respected, loved and valued will disclose his or her complete authenticity."

Louise says, "We consider ourselves portrait specialists whose satisfaction depends on our clients' satisfaction. We are truly concerned with all of the components surrounding a high-quality image; refinement and exclusivity are key to creating powerful and timeless images."

About *Family & Baby* the Simones say, "This shot was taken during a week-long seminar at one of our lectures in South Carolina. These people are not professional models; they were invited to be there for the students. So this is a real family that we didn't know at all. The parents had decided they wanted a beautiful portrait of their family, and the children were their focus. But, after seeing them all together, we really felt that the baby boy had to be the center of attraction

for the photograph. So we posed them to look at the baby, not the camera.

"Lighting was tricky. We use parabolic reflectors for better control. This is important as it's very hard to light something like this with a softbox. We had to consider the split of the two planes of the family and the fact that the father and baby were both posed in profile. We slowly rolled in a main light on the left side to find the right point for balance on the daughters, the father and the mother. Then a hair light was positioned to provide background separation for everyone, but most of all it was the primary light on the baby's face. Finally, we brought in an umbrella for soft, overall fill.

"We captured a beautiful memory. You can see the contact they're making together with that baby. It's something that we were all feeling during the shoot, and the family was delighted when they saw the final results."

Louise and Joseph are both Master Photographers in the U.S. and Canada. To see more of their work, go to www .simoneportrait.com. —*Bob Rose*

INGREDIENTS
Camera: 6x6 medium format
Lens: 120mm, f/4
Settings: f/16 at $^1/_{125}$ second
Film: Kodak Portra 400BW
Lighting: Photogenic

Tim Walden: *Hands of Time*

Tim Walden created *Hands of Time* about six years ago for the family of this well-seasoned, wise gentleman, who was lovingly known as "Poppy." Poppy had an amazing career starting in World War II as a communications specialist where his quick fingers tapped out messages while aboard one of the many ships approaching the Normandy beach on D-Day. His hands continued to provide a vital service to many throughout the years, and they would often be callused, cut, and bruised by the end of each day.

Tim knew, when he first faced this grand character, that probably hundreds of images had been previously created of Poppy with his great face and wonderful smile. But it was not Poppy's face he wanted to photograph. Tim was attracted to the deeper story to be told by his well worn hands, marred by hard work and a long life. Tim says, "After spending time with Poppy, I knew that the best way to portray this proud, but gentle man—veteran, husband, father, grandfather, great-grandfather, and friend to many—was through his hands. They represent this humble man who is always willing to help others before himself."

When Poppy arrived at the studio, Tim immediately envisioned the simple lighting setup he needed to provide. A 4x6-foot softbox was positioned as the main light, and a white reflector used as a fill. He then brought in a soft accent in the form of a strip light, which skimmed across the top of the hands to produce a specular highlight. Finally, an overhead light coming from behind the background introduced that last bit of separation between Poppy's features. Closing in for a tight shot with a 150mm lens on his Hasselblad, Tim shot *Hands of Time* at ⅟₆₀ second at f/16.

Visit Tim and Beverly Walden's web site at www.waldens photography.com. —*Bob Rose*

INGREDIENTS
Camera: Hasselblad 501CM
Lens: Zeiss 150mm f/4
Lighting: 4x6-foot softbox with white reflector; striplight for specular highlights; overhead backlight
Film: Kodak T-MAX 400
Exposure: ⅟₆₀ at f/16

Monte Zucker: *The Touch*

For this image, Monte Zucker wanted to create a high-key portrait outdoors with simple props. In order to do so, the first thing he looked for was a covered area with strong backlighting. The perfect setting was under a covered porch with no light coming in from above. To get the backlighting, he waited for the afternoon sun, then used a Westcott translucent panel directly behind the couple to diffuse the backlight.

The camera was a Canon EOS 10D loaded with a 640MB Delkin memory card. The ISO was adjusted to 200. Monte says, "I used aperture priority with the lens set at f/5.6. The internal exposure meter saw a lot of white behind them and stopped down too much, so the figures were underexposed. I had to override the in-camera meter by a stop and a half to get the correct exposure on their faces.

"Heads were positioned for profiles of both, with my normal lighting pattern for profiles coming thru the Westcott translucent panel. In addition, they were lying on a Westcott Black/White 4x6-foot panel.

"I used a 27-inch silver reflector as a kicker to help brighten the image. The reflector (Westcott's Monte Illuminator) was tipped upward to catch light coming over the top of the translucent panel. This opened up the shadows slightly without overpowering the main light coming through behind them."

Very little was done in Photoshop, except to remove a few minor blemishes from their skin.

"The couple in the picture were high-school friends. They came to pose for one of my workshops. They got more and more into my photographing them when they saw how much fun we were having. They originally told me that they didn't like posed photos, but as we took more pictures and they looked at the LCD screen, they got more enthusiastic. They said, 'These aren't what we meant when we said we didn't like posed pictures. These are fun!' They said they've never looked this good in photographs."

About photography, Monte says, "It's exciting to see how far you can take it and nail it every time! I believe in it completely and teach it with love and with passion."

Visit Monte at www.montezucker.com. —*Bob Rose*

INGREDIENTS
Camera: Canon EOS 10D
Lens: Canon 28–135mm f/4 IS Zoom
Memory Card: Delkin 640MB
White Balance: ExpoDisc
Light Control: Westcott 4x6-foot panel, Translucent panel and 27-inch silver reflector (Monte Illuminator)

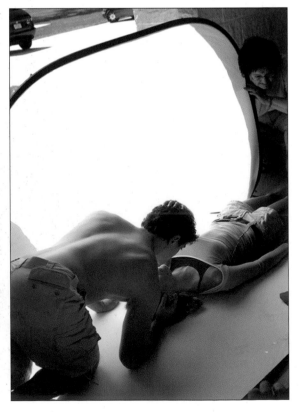

8. PORTRAIT POSING

The way photographers reveal the human form has given way to a love of naturalness.

*I*n the early days of photographic portraiture, posing was an absolute necessity. With extremely slow films, equally slow lenses, and a lack of artificial light sources, time dictated long exposures. The headrest was the "immobilizer," giving photographers the ability to record their subjects at long exposure times—several minutes long—without subject movement. The poses were stiff and unnatural and the expressions ranged from pained to grim.

All that has changed, by virtue of vastly improved technology that has allowed photographers to work freely and to record spontaneity in their portraits. But also gone is the almost rigid framework of poses that developed over the centuries. The way photographers reveal the human form has given way to a love of naturalness—unposed, softly lit, and often without that delicate expertise that inspires the viewer's imagination.

This chapter presents examples of both formal and informal posing. Brian Shindle's portrait of a little girl with her matching doll is a good example of employing the posing traditions of the past to reveal character. Randy Brister, aside from being an expert sports photographer, does large groups well. Such large group portraits depend on repetition and simple posing. Randy reveals how to expertly pose and light 250 kids in one photo. Mike Colón uses a relaxed posing style for his informal engagement portrait. If a portrait photographer's goal is to reveal character with style, then Australian Mercury Megaloudis has succeeded in his portrait of Molly the dog, whose "self" is exposed in one sleepy eye. Lastly, Darton Drake created a self-portrait to e-mail home. Although casual in style, the lighting and pose make this a portrait a classic example of fine posing.

As these images show, the great portrait photographers of today have not lost sight of the posing rules but have chosen to incorporate them into a freer framework of informality. That is to say, they haven't lost the fundamentals of good posing but now interpret those rules less rigidly.

The Shindles' Clients for Life

Judith and Brian Shindle have created their photography business with a long-term goal—get your first client, and then make sure they still love you when it comes time to photograph their grandchildren. The little lady shown here is proof that the Shindles' philosophy and techniques work for their Creative Moments Gallery, established in 1986 in Westerville, OH.

This image is the second of nine image creations that have been presold (and prepaid!) to the girl's grandmother. The Shindles were the portrait photographers for the older generation. After that, the decision was made for the pair to create a canvas art portrait of each of the nine grandchildren when they reached the age of five. Each child will be photographed in the house or garden. When the series is complete, the custom-framed images will hang in a gallery that stretches along the home's yellow hallway (visible in the background of the image shown here).

After a consultation with the Shindles, the client invested in the matching outfits for the little girl and the doll. Brian then worked to create a classic image through a combination of pose, lighting and location. Soft window light from a huge bank of windows lit the girl from a distance of about ten feet. A large white reflector was placed on the opposite side for fill light.

In general, Brian uses subtle direction to pose children, while still allowing them to "be themselves." His young clientele are comfortable and trusting of him, letting him refine their poses with age-appropriate directions. The final image was one of many taken as they explored different parts of the grandmother's house and garden.

The image was created digitally with a Fujifilm S2 camera and a 35–70mm f/2.8 lens. The exposure was $\frac{1}{90}$ second at f/4.8 using the 400 ISO equivalent setting. The camera was mounted on a Bogen tripod, and the exposure was checked with a Sekonic meter. It was then retouched and perfected using Adobe Photoshop.

Contact the Shindles by email at bts_jks@msn.com. —*Jen Bidner*

INGREDIENTS

Camera: Fujifilm Finepix S2 Pro
Lens: Nikkor 35–70mm f/2.8
Meter: Sekonic
Tripod: Bogen
Software: Adobe Photoshop

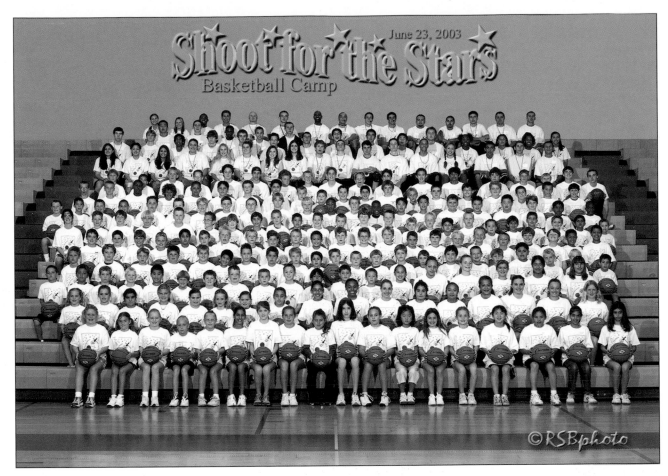

Randy Brister: Shooting Large Groups

Each year we photograph sports groups in a variety of locations, but most are smaller than the basketball camp in this photograph with 250 kids. At this camp, each player gets a brand new basketball and an 8x10 group photograph. I am allowed fifteen minutes to pose and photograph them, and I must return three days later with 250 prints.

For several years, I had photographed the basketball camp groups with a Mamiya RB67. Then I would send the film out to be processed and then scanned. This was not the best scenario when working on a tight schedule. So this year I photographed them with a Canon EOS 1Ds; the digital capture streamlined the entire process dramatically.

The gymnasium where this group was photographed has some skylights. In a typical high-school gym, skylights can add about two stops to the ambient light exposure. The natural light from the skylights also helps to neutralize the color cast from the sodium-vapor lights of the gym. I used a pair of Norman 400B strobes, mounted on two 13-foot Bogen heavy-duty light stands. The lights were placed about twenty feet from the group and about twenty feet apart, with the stands extended to about twelve feet. The Normans were set at full power and the heads were feathered up slightly, which gave a fairly even f/11 at 400 ISO across the entire group. I mounted a PocketWizard MultiMAX to the camera and the strobes, which eliminated the need for sync cords.

I used a 28–70mm f/2.8L Canon lens set at about 40mm. The camera was mounted to a Bogen tripod with a Bogen grip head and was placed at my eye level about 35 feet from the group. The exposure was ¹⁄₆₀ second at f/11, and the camera was set to auto white balance and RAW.

The RAW file was converted in Adobe Camera Raw. I tweaked the white balance and moved exposure +⅕ stop. In Photoshop, I cloned out a painting on the wall that interfered with the graphic above the group. I then applied a small amount of Unsharp Mask and added the graphics. Within three hours of capture, the file was at my lab (transferred via FTP) and I had the 250 prints one day early.

INGREDIENTS

Camera: Canon EOS 1Ds
Lens: Canon 28–70mm f/2.8
Lighting: Two Norman 400B strobes
Exposure: ¹⁄₆₀ at f/11, 400 ISO
Radio Slaves: Pocket Wizard Multi Max
Stands: Bogen 13-foot, heavy duty
Tripod: Bogen 3021 with Bogen grip head
Software: Adobe Camera RAW, Adobe Photoshop
Media: Lexar 1GB CF card
Camera Settings: RAW, AWB

Mike Colón: Alternate Engagement Portraits

I have been a professional photographer based in Southern California for almost ten years. With a background in professional fight and sports photography, I appreciate the challenges of working under pressure that is involved in this type of photography.

Today, I focus nearly all of my attention on wedding and portrait photography. Just like sports photography, there is no such thing as a retake in wedding photography. When you have just one chance and such a huge responsibility, there is great satisfaction in a successful outcome.

I have been commissioned to photograph weddings throughout the United States and abroad and recently photographed the NBC television show, *Race to the Altar.* My work has also been featured in numerous publications, including *Wedding Style Magazine, Modern Bride, The Knot, Studio Photography & Design, WPPI Monthly,* and *The Orange County Register.* I also lecture internationally.

When I created this image, I was actually getting a little tired of photographing the same old half-hour engagement sessions on the beach right before sunset, so it was a nice change to find a couple that wanted to try something different. Amy and Yves are fun and adventurous. For their engagement portraits, they were willing to trust me and try

anything. It was actually their idea to photograph in the streets of Hollywood, and I turned the session into a five-hour marathon. We had so much fun running around finding cool spots that it was dark before we knew it.

I was using my new 70–200mm AF-S VR (vibration reduction) Nikkor lens, and I was anxious to try it out at night. I had Amy and Yves hold still while I photographed them, handheld, at shutter speeds down to ¼ second. With the vibration-reducing stabilizer in the lens, I could get sharp images without the hassle of a tripod, while moving cars in the background streaked by. I took this image using only available light, which consisted mainly of streetlights and car headlights.

I really like the movement in the images caused by the slow shutter speeds. It added a dimension of time to my images. Since this assignment, I have become increasingly attracted to movement in my images. In fact, I have begun to allow what I previously regarded as imperfection to become a regular part of my work.

INGREDIENTS
Camera: Nikon D1X
Lens: Nikkor 70–200mm f/2.8 AF-S VR
Software: Adobe Photoshop
Computer: Apple Power Mac G5

Mercury Megaloudis: Getting Inside Your Subject's Head

Mercury Megaloudis first experienced photography in the darkroom over thirty years ago, and his passion has never faded. He always wanted to be a sports photographer but found he could actually earn a living by photographing weddings and shooting portraits, pets, and nudes. After working in Melbourne, Australia's highest-profile wedding and portrait studio in the 1980s, he went out and set up his own shop, Megagraphics Photography, in the suburb of Strathmore.

Of his approach to photography Mercury says, "I like to inspire photographers to pick up their camera and take pictures . . . and teach photographers how to see. Asking a photographer to take your picture usually means feeling awkward and self-conscious. When asked to pose, it's often difficult to feel relaxed. Now, imagine a photographer who is able to capture you as you are and, better still, to capture that special part of you that allows you to look at ease. I just love taking photographs—it's a passion, and I get paid for it."

Mercury tells the story of Molly: "Once a year I go down to Tasmania and spend a bit of time with Robbie Burnett, who is probably Australia's leading commercial photographer. After this particular hectic weekend of shooting and conferences, we went back to his house to chill out. After a couple of drinks, I looked at his dog, Molly, and decided that's exactly how I felt. So I sat there and stared back at this Boxer and found an interesting angle. I looked into her eyes and saw so much of Rob Burnett and myself at that moment. I love dogs, and I love how their personalities remind me of their owner's personalities. The timing was right, and I just started taking photos.

"I know, to some degree, I was thinking about what I was doing, but I simply felt the personality of the dog more than anything. I had to wonder what the dog was thinking, 'This guy is sticking this strange thing in my face . . .' Everything said, this is a shot that I just absolutely adore."

INGREDIENTS
Camera: Canon EOS 10D
Lens: EOS 100mm f/4 macro
Lighting: Available tungsten room lighting

This original file was color, but Mercury saw it as a black & white image with a dash of sepia. In Photoshop, he converted to Lab color and deleted the "a" and "b" channels. He touched the lightness, converted to grayscale, adjusted the contrast, converted back to RGB, and added some warmth to the image.

Mercury is a Master Photographer, and you can see more of his work at www.mega.com.au. —*Bob Rose*

Darton Drake: Self Portrait

Darton Drake, whose professional photography career began in 1971, is an innovative portrait photographer based in Baraboo, Wisconsin. During his career he spent two years working with Frank Scherschel from *Life* magazine and has been named Wisconsin Photographer of the Year five times. Drake currently has 27 National Loan Collection prints, and he lectures at a variety of state conventions and photography schools. Drake has an associate degree in commercial art and bachelor's degree from Layton School of Fine Art in Milwaukee.

"My wife Carolyn and I own a small studio." Drake says. "We photograph about 150 high-school seniors, twenty families, and about thirty children a year. Another part of our business," Drake continues, "is called the Signature Collection. This is an incorporated business separate from our Baraboo business, where we travel to various cities in the country and make children's portraits. The income for this part of our business far exceeds our Baraboo income.

"This image is a self-portrait and scored a 98 at the Wisconsin state convention in 2004. It was not meant to be a competition print. It was taken for my wife, Carolyn, with whom I'm totally in love. When I travel and teach at five-day schools, I make a self-portrait every night and e-mail it to her with a little note telling her my feelings for her at the moment. In the morning when she comes to work, there I am in her mail box. That's the reason for this portrait.

"I would not have chosen this image for competition. Carolyn wanted me to submit it for this cookbook. It was taken at MAIPP School of Photography, in Iowa, during lunch hour. Usually I take the portrait at night in my hotel room. But after teaching all day I was mentally exhausted and couldn't come up with anything I felt was good enough for her. For this image I used the Canon 10D on a tripod with the camera on self-timer mode.

INGREDIENTS
Camera: Canon EOS 10D on a SLIK Pro 700 DX tripod
Lens: Canon 28–135mm IS zoom
Exposure: $^1/_{100}$ at f/11 at 100 ISO
Lighting: 4x6-foot Larson softbox, 3½x7-foot Larson bright silver reflector

"To the right of the image, about ten inches from my hand, is a light stand on which I pre-focused. The camera was set to 100 ISO, $^1/_{100}$ second, and f/11. It took about ten exposures to get the one I liked. This is almost the full image area recorded on the chip. The final print size was 20x24 inches, including the digital border. Some of the left side of the full image was cropped off.

"The lighting was one 4x6-foot Larson (horizontal) softbox on the left and one 3½x7-foot Larson bright silver reflector behind and to the right. The background was a brown Les Brandt 'Quixote' about two feet behind me.

"Inspired by the movie *Saving Private Ryan,* I wanted the image to be in color, but also have a timeless flavor, so I

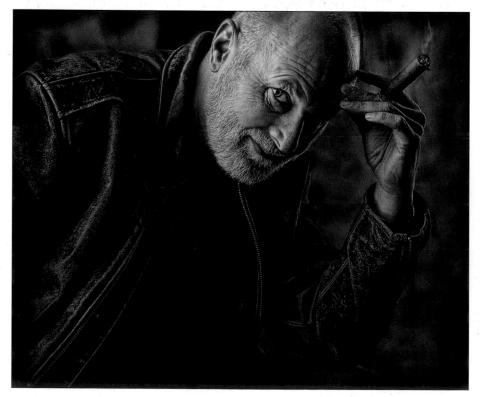

desaturated it in Photoshop about 60 percent. A duplicate layer was made and a Gaussian Blur of 9 pixels was applied to the bottom layer. The Eraser tool was pllied at 100 percent to remove only the background on the top layer to make it softer, creating more depth in the image. No retouching was done on my face.

"I then applied a Photoshop plug-in called LucisArt on sculpture mode at about 10 percent. This filter makes everything more three-dimensional. Since I was in the school, I couldn't actually light the cigar, so I used the Dodge tool on the end of the cigar and added a small amount of red with the Brush tool. The smoke was added with the Airbrush. Finally, the border was added with the Outer Glow layer style in Photoshop."

To see more, visit www.dartondrake.com. —*Larry Singer*

9. HIGH-SCHOOL SENIOR PORTRAIT PHOTOGRAPHY

> Senior photography is one of the fastest growing areas of professional photography.

 enior photography is one of the fastest growing and most profitable areas of professional photography. The level of creativity, spurred by imaginative teens and higher-than-ever budgets for senior pictures, knows no limits. As a result, many photographers from other disciplines now happily call themselves senior photographers—and in this chapter, we have some of the finest in the country.

Tim Kelly has won practically every award a professional portrait photographer can win. In his portrait *The Debutante*, which was an accident by design, he talks about his goals for portraiture and the ability to optimize his subject's experience. He also talks about the fairly ambitious lighting of this remarkable portrait.

Craig Kienast loves photographing seniors because they encourage him to be even more creative. His Fantasia series of portraits are special effects masterpieces.

Robert L. Williams loves the honesty and straightforwardness of his senior portrait entitled *Hoop Dreams*. His philosophy on seniors is illuminating.

Jim Schmelzer loves colors and patterns in his senior portraits. He likes the concept and result to be edgy—and that's just what his senior customers want, too.

Jennifer George-Walker describes the creation of a striking, multilayered image entitled *Mario's Resolve*. The image demonstrates both technical ability and the impact of good storytelling.

Miami-based photographer Robert Lino makes his living photographing teenagers and does so using the classical lighting and posing techniques that give his subjects an old-world elegance.

Ellie Vayo photographs only seniors, and her studio is devoted to providing the very best results for her subjects. From wild to subdued, the customer gets what they ask for, because Ellie knows that word of mouth is the best means of advertising she has at her disposal.

Ten Ingredients for a Great Tim Kelly Portrait: *The Debutante*

Every Tim Kelly portrait varies, but a keen eye can pick out his strong style from each. One of his most well-known images is *The Debutante,* which showcases Tim's ten main ingredients for success.

1. Kelly carefully chooses props that are timeless and minimalist, such as a neutral-colored stool or a simple chair. Otherwise, props can become crutches for the photographer and possible distractions for the viewer.

2. The smaller of two softboxes (3x4 feet) becomes Kelly's main sculpting light. He uses it to bring out the three-dimensionality of the subject.

3. His largest softbox, this time placed on the right, fills in the shadows created by the main light. The 4x6-foot softbox is large enough and placed close enough to produce extremely diffuse, subtle fill light.

4. Kelly's background light never seems to be in the same place twice. It is strategically placed to offset the main sculpting light or separate a dark portion of the subject, such as hair. Here, he used a gridded spotlight.

5. A 10x30-inch strip light with louvers gives Kelly fine control over the placement of his hair light. Hair lights should be subtle or they will draw the eye from the face.

According to Kelly, "The viewer does not want to see the lighting—they need to see the subject."

6. Kelly is amazed at how little thought some photographers give to the background they choose, even though it is such an important element. He has his own design custom painted by a background artist. The beauty of this background is that it works well for both high-key and low-key portraits. (This background is so popular that artist David Maheu now sells it as a Kelly Signature Background. Contact him at www.backgroundsbymaheu.com.)

7. The more form the photographer shows in the picture, the greater the difficulty in balancing the overall image. However, Kelly believes it's worth the work because these portraits help show off the essence of the person through their body posture.

8. Kelly suggests you get subjects "into the zone" by coaching their positions but letting them go from there. This allows him to capture a more natural feeling. He pays special attention to the moments during and after film changes or breaks in the shooting because he is often able to catch "candid" images on the set (such as this debutante relaxing).

9. Before delivering his portraits, Kelly digitally optimizes them. "I polish and perfect every image," he explains.

10. This is one of Tim Kelly's last film portraits, taken before his studio went all digital. "I didn't go digital to save money, because it was actually more expensive to get quality digital at the time. I did it to improve my creative control," he explains.

This print was professionally canvassed without laminates. Hand lacquering added the artistic flair of brush strokes. Light oil enhancement also improved the flesh tones and highlighted the subject's key features. —*Jen Bidner*

INGREDIENTS

Camera: Hasselblad with 150mm f/4 lens (set at f/8.5)

Film: Kodak Vericolor VPS III

Main Light: Photogenic Powerlight in a Larson 3x4-foot softbox

Fill Light: Photogenic Powerlight in a Larson 4x6-foot softbox

Hair Light: Photogenic Powerlight in a Larson 10x30-inch strip softbox with louvers

Background Light: Gridded Photogenic Powerlight spot

Background: Kelly Signature Background painted by David Maheu

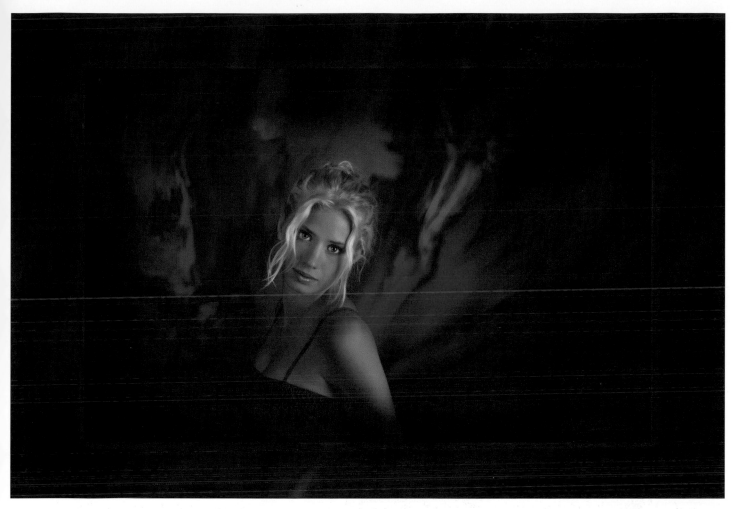

Craig Kienast: Fantasia Portrait Art

Craig Kienast offers his senior portrait clients a special Fantasia portrait package that combines a photographic image with an artistic representation straight from his imagination. "I consider capturing the spirit of another human being a privilege," explains Kienast. "I try to make each portrait more than a still life by capturing emotion."

The senior pictured here was a referral client who traveled a long distance for the shoot. The session included prom-dress images, classic portraits, and even a few shots with the family's pet raccoon.

The lighting setup was fairly simple. The main light was a Photogenic flash head with a Larson 6x8-foot softbox. A Larson 72-inch Reflectasol was placed about three feet from the subject for fill light. The background was a Photo Showcase Blue Abstract canvas, which was turned red by gelling it with a Photogenic flash head. The image was shot digitally with a Canon 1Ds and an EOS 28–105mm lens.

The photographer then used Photoshop to manipulate the background and perfect the image. The Liquid Smear feature of Corel Painter was also applied. The outer frame was also created using Photoshop, picking up colors from the background.

Kienast uses the Canon Zoom Browser software to create proof sheets for his clients. He also offers the incentive of a 5-percent discount if they select soft viewing (no printed proofs). The increased sales due to soft viewing more than offsets the 5-percent discount. "People buy on emotion," he explains, "and their emotion is highest when they initially view the images at the studio."

Craig Kienast's studio is in Clear Lake, Iowa, however he services clients in New York, Nashville, and other cities across the U.S.

Kienast's images can be viewed on his web site at www .photock.com. He also sells products to help train professional photographers, including an educational CD on lighting entitled *Seeing the Light. — Jen Bidner*

INGREDIENTS
Camera: Canon EOS 1Ds
Lens: EOS 28–105mm
Lighting: Photogenic heads, Larson softboxes and reflectors
Software: Adobe Photoshop and Corel Painter
Background: Photo Showcase Blue Abstract

Robert L. Williams: *Hoop Dreams*

When Robert Williams of Tallmadge, Ohio, was asked to submit a signature or most challenging image for a special assignment, he had a difficult decision. He had so many favorites that he narrowed it down from three of his favorite black & white portraits. He loves to create images that have a special effect that cannot be recorded in color.

Hoop Dreams was captured with a Hasselblad using Kodak Plus-X Pan film. Robert used a 180mm lens at $1/125$ second at f/5.6. The lighting was a 70-inch softbox with a 5-foot reflector fill. The background light, along with the hair light, was set on the lowest power setting. The image was printed as a monochrome print— a black & white negative printed on color paper by Buckeye Color lab. The sepia tone was added in printing. Robert felt that adding the sepia color added dimension to the photograph.

Williams says, "Although I have created thousands of color images, black & white photography and digital photography have recharged my love of this profession. I enjoy photography even more now than when I was processing and printing my first images in school. I cannot imagine any other profession that touches so many lives today and for generations to come."

William's studio is "full-service," photographing children, families, high-school seniors, weddings, and corporate clients. Among his list of clients are Ohio Edison, General Tire, Xerox, and Holiday Inn.

To see a broad selection of Robert Williams' work, visit his web site: www.robertwilliamsstudio.com.
—*Harvey Goldstein*

INGREDIENTS

Camera: Hasselblad
Lens: 180mm
Exposure: $1/125$ second at f/5.6
Film: Kodak Plus-X 120
Lighting: 70-inch softbox, 5-foot reflector fill
Background and Hair Lights: Lowest power setting
Printing: Black & white

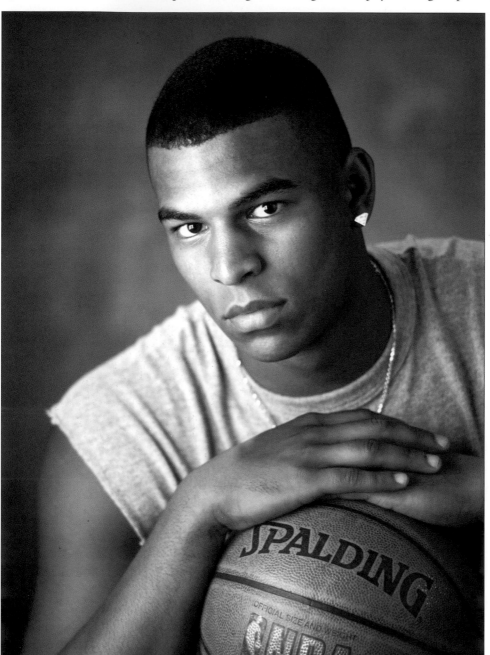

James Schmelzer: Senior Portrait Fun

Jim Schmelzer has been practicing the craft of photography for over three decades. In that time, he has earned an enviable reputation as someone at the top of his game. He has garnered more awards than he has wall space to display. He has built a wedding clientele that has taken him to all points of the globe and he has earned the respect of his peers, which is no mean feat in such a highly competitive field.

Jim has a niche market that focuses on Greek and Italian wedding clients. They have large families and are very close-knit. Big families buy many pictures and because of that, are great sources of referral business. He attributes his success to good prices, honesty, and the fact that he was one of the first photographers to retouch his wedding photos.

But weddings are weekend work. During the rest of the week Jim focuses on high-school seniors. Jim likes to use high-speed telephoto lenses, like his 85mm f/1.2. He needs to shoot fast, so he pushes his EOS-1D Mark II to the limit. By choosing a lens like the 85mm f/1.2, he's able to throw the background way out of focus when he shoots wide open.

One of Jim's pet peeves is "raccoon eyes"—when eyes are dropped into shadow by an overhead light. He usually tries to photograph his clients outdoors under an overhang to eliminate that. If no overhang is available, such as in this shot, a black gobo is employed to cut back the light, and a Westcott silver reflector is used to bounce in some fill. In addition, since it was raining during this shoot, the gobo helped keep the rain off his subject. The simplicity of his light control can be seen in the shot of the complete setup (left).

Jim says, "Don't get stuck in a rut. Use a quirky camera angle, give the camera a slight tilt, add spice to your shot. The first part of a senior portrait shoot is the traditional stuff, but the second part is where you break the rules, where both you and your subject cut loose and have fun." See Jim Schmelzer's work at www.elitefoto.com. —*Bob Rose*

INGREDIENTS
Camera: Canon EOS-1D Mark II
Lens: Canon 85mm f/1.2
Light Control: Westcott black gobo, white reflectors

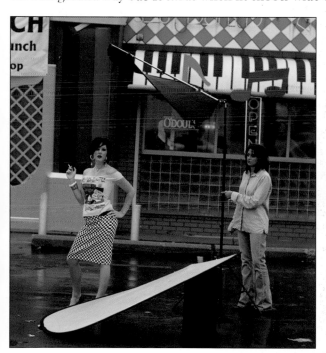

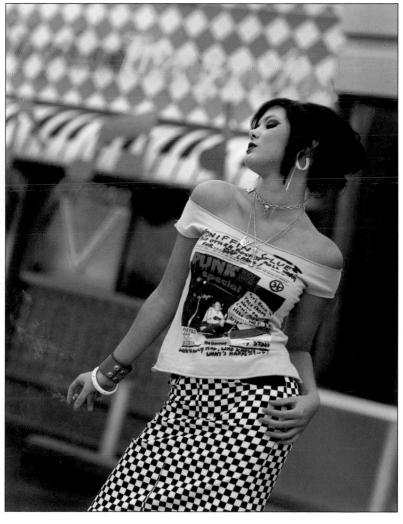

Jennifer George-Walker: *Mario's Resolve*

Always seeking new ways to tell the stories of her clients, Jennifer George-Walker is known for photographing her subjects from angles and perspectives that urge the viewer to evaluate and draw meaning from the entire photograph.

The multilayered and multidimensional image-within-an-image that Jennifer picked to be featured here displays her storytelling talents. The image shows a woman behind a young man with a goatee and chillingly cool blue eyes. The title, *Mario's Resolve,* Jennifer says, came to her because the man in the picture looks like his mind is made up about something, and the lady in the background looks sad that his decision is so final.

"I just go with my first gut feeling," she says, "and sometimes other people don't read the same thing in the image. My goal is just to get people thinking. If an image causes you to stop and pause, even for a second, it has achieved something more than documenting a person or thing. It provokes the viewer to think or have an emotional response, whatever that may be."

The image was made using late-afternoon daylight in downtown San Diego. Jennifer had actually discovered the graffiti-covered wall shown in the background some time before using it to create this photograph—she was just waiting for for the right couple to pose in front of it. Drawing on the success and popularity of this portrait, she has now pho-

tographed other subjects in the same spot—including a wedding couple who fell in love with the shot when they saw it at her studio.

To capture *Mario's Resolve,* Jennifer first waited for the sun to go behind building across the street, then used a Fuji S2 Finepix Pro and a Tamron 28–300mm zoom lens. For maximum resolution, she set the camera to capture a high-resolution JPEG file. Using only indirect, late-afternoon light with no additional illumination, Jennifer exposed the scene for approximately 45 seconds at f/6.5.

INGREDIENTS
Camera: Fujifilm S2 Finepix Pro
Lens: Tamron 28–300mm zoom
Exposure: ¹⁄₆₀ at f/4.5
Lighting: Afternoon light

After the image was in the camera, Jennifer brewed up a little post-production magic to create the final photograph. First, she converted a duplicate layer to black & white. Then, she placed a mask over the layer and restored the color from the layer below it. She made sure to paint back the color in the blue eyes, because she felt the young man's eyes were so striking. She then desaturated the color layer to ensure the colors would not compete with Mario's image.

The elements for the mat of the finished image were cut from a copy of the image and pasted onto a new canvas. After Jennifer spent time adjusting the position of the elements, she chose to alternate the layers to create the illusion of depth in the image. A stroke was then placed on each visible layer, and the final image area was placed a bit off center for tension.

"Although *Mario's Resolve* is not at the top of the list of my favorite works," Jennifer says, "I thought it would be perfect for this book because it appears to be more technically complex than it really is. When all is said and done, while technique is important, it is the image and the story that matter." —*Larry Singer*

Miami-based photographer Robert Lino started his own business in 1986, specializing in fine portraiture and social events. His style of photography follows the lines of formal and elegant classical portraiture. While Lino is recognized for his ability to direct and pose clients, he says capturing the feeling within every subject is his main objective.

Lino has been awarded Photographic Master and Craftsman Degrees, the Professional Photographer Certification from PPA and the ASP Fellowship. He has also earned the Accolades of Photographic Mastery, Outstanding Photographic Achievement and Exceptional Photographic Achievement from WPPI.

Lino's articles and images, have appeared in Amphoto's *The Business of Wedding Photography*, featuring thirty of the world's best wedding photographers. His first book, *Wedding Poses* (Image Publishing Corp., 1997) was published in English and Spanish. In 1996, he was awarded "Best Latin American Photographer" by *Foto Imagen* magazine.

The portrait Lino chose for this book was created for Aileen as part of her fifteenth birthday celebration, known in the Hispanic community as her *quinceañera*. "I chose this image because I think it captures Aileen's beauty, emphasizing her hair, eyes, lips, and beautiful hand.

"Starting with the formal portrait session, prior to the event," Lino explains, "I chose to capture all these images with my Bronica because I trust the quality of the image when large prints will be made. Using film also gives me the option to make straight prints or scan and manipulate the image digitally.

"Aileen was seated, her face turned into the main light, her hair brushed to one side in textured waves. I chose a high camera angle, tilting my Bronica almost diagonally to create the illusion of windblown hair and a feeling of motion within the image.

"Once I had a perfectly exposed, nicely posed, and well-lit image, I could then be creative. The original photo was scanned, and changes were made in order of priorities. I conceived of this as a black & white portrait, resembling the old Hollywood glamour images but with a modern twist, so my first step was desaturating the image.

"I then proceeded to take care of her truncated right arm, by having it disappear into black. I cropped the image to emphasize her hair and create negative space in the image. I then flipped the image horizontally to make it more pleasant to the eye and read right into her face. I softened the skin but kept eyes, hair, and nails sharp. Some enhancements were made to the eyes and hair texture with selective burning.

"This image was used in a full-page magazine advertisement for my studio, with only the studio name and phone number added to the image in the ad." For more, visit www.robertlino.com. —*Larry Singer*

INGREDIENTS

Camera: Bronica SQ-Ai
Lens: 150 mm f/4 lens
Film: Kodak Portra 160NC
Exposure: $^1/_{125}$ second at f/8
Main Light: Speedotron Force 10 with a Beauty Light reflector and barn doors
Fill Light: Norman P808 bounced into ceiling

Ellie Vayo: *Chris*

Over the years, the outstanding images created by Ohio senior photographer Ellie Vayo (Master Photographer, PPA certified, CR., CPP and API) have won numerous print exhibit awards, including the J. Anthony Bill Award for the most outstanding portrait in Ohio. Three of her images are Loan Collection prints and were published in the Loan Collection book. In 2004, Ellie won first place in the All-Ohio Folio Competition.

Sharing her creative ideas and business methods with fellow photographers in seminars and workshops is just one way Vayo gives back to this industry. Vayo is also the author of *The Art and Business of High-School Senior Portrait Photography* (Amherst Media, 2003).

Currently, Ellie is photographing second-generation high-school seniors, having taken their parents' pictures two decades ago.

Ellie Vayo's 5600-square-foot studio houses three camera rooms, two sales rooms, three dressing areas, a makeup room, production and framing space, and offices.

The image called *Chris* was created late in the summer of 2004. This photograph was one of 24 previews printed to be selected for this young man's senior portraits.

"What makes this image so unique," Vayo says, "is that Chris didn't look anything like this image when he came in. He was somewhat apprehensive about posing for a portrait, which is understandable, considering he had a mouth full of braces. Throughout the session I used strong masculine poses. I was a little apprehensive using a 'no smile' technique, but he couldn't get his braces removed until later in the year, and his mother wanted the portraits completed so she could give them to family and friends.

"The one thing he definitely communicated to me was that he wanted these pictures to be something that didn't look like the standard senior portrait, so I told him to trust my judgment in the posing and lighting. What we got were some striking images."

The original picture was shot as color, but Vayo transformed it into three distinctly different images. One was printed with minimal adjustment. The second was altered in Photoshop, and the third was sepia-toned, also in Photoshop. Vayo gave him previews of all three images and presented them in an "Ellie Vayo General Products Album." He was overjoyed at seeing his senior portraits.

You can view a selection of Ellie Vayo's images at her web site: www.evayo.com. —*Larry Singer*

INGREDIENTS

Camera: Fujifilm Finepix S2 Pro
Lens: Tamron SP AF 28–105mm lens
Exposure: $1/125$ second at f/11
Software: Auto FX and Adobe Photoshop
Lighting: Studio Master lights with Photogenic Power lights; one 4x6-foot Larson Soff Box used as the key light; one Larson 40-inch silver reflector on a stand as a fill light; one Larson 9x24-inch Soff Strip for hair light
Album: Ellie Vayo General Products album

10. SHOOTING TECHNIQUES

*T*his chapter is a catch-all for unusual shooting techniques that defy categorization. Although some could fit into the section on wedding photography, and some in lighting, they seem really to belong together, because each represents an unusual or out-of-the-ordinary shooting procedure that defines the success of the photograph. Here's a taste of the techniques you'll find:

Philadelphia wedding photographer Cliff Mautner relates how he incorporated Hurricane Ivan into an award-winning wedding image.

Capturing an image of lighting is a very difficult and potentially dangerous proposition. Jake Butler relates his game plan and how he achieved success in Costa Rica. Jake also talks about ultra-long exposures of Arenal, one of Central America's most beautiful waterfalls. The cotton-candy effect of the moving water and the lush shadow detail make this shot amazing.

NyxoLyno Cangemi talks about photographing a moment of downtime when the Coast Guard cutter *Valiant's* crew was out jumping waves at sunset in the cutter's small boat.

Scott Mansfield takes a ghoulish trip to the old boneyard to make a long exposure of tombstones at midnight . . . not for the faint of heart.

Monte Zucker, normally known for his portrait and wedding images, describes how a monument, the Holocaust Memorial, so moved him that he created an amazing photograph to rival the intensity of his emotion.

Automotive specialist David Wendt talks about two unique shooting challenges: shooting a 1970 Dodge Challenger amidst a sea of yellow school buses, and shooting a yellow Ferrari 360 on a deserted blue expansion bridge. The self-assigned goal in each was to achieve maximum color contrast and impact.

Peter Skinner talks about a favorite piscatorial portrait of a lionfish, a difficult subject to photograph under even the best of circumstances.

Nature photographer and author Tony Sweet dissects three of his well-known shots, all with differing shooting techniques.

Each represents an unusual procedure that defines the success of the photograph.

Cliff Mautner: Great Shots in Bad Weather

Most photographers can get a great shot in perfect conditions, but it takes mastery to consistently pull off dynamic images on miserable days. When Hurricane Ivan intruded upon a wedding, Cliff Mautner came up with a creative solution for some stunning images.

En route to the reception, Mautner noticed a brief clearing in the clouds and had the limo driver stop at a small lake for some pictures. Though the location was nothing special, he knew this was his chance. "I took some nice portraits, and then looked up to see the sky turning ominous enough to make the Addams family feel right at home," recalls Mautner.

Instead of calling it quits, he quickly developed a plan to utilize the dramatic sky. He lay down in the wet grass with his Nikon F5 and a Nikkor 17–35mm f/2.8 lens. He had his assistant point a Nikon SB-800 flash up at the bride for fill light at about 90 degrees. It was TTL synchronized with the camera via a Nikon SC-29 TTL cord, and he played with the shutter speed between exposures.

"The bride was an incredibly statuesque, poised, and exuberant woman," explains Mautner. "She was one of those brides who 'gets it' and enjoys being photographed. With me lying on the ground soaking wet, she and her husband just goofed around for 25 or 30 frames.

"The decisive moment came when she threw both arms up while holding her veil, thus helping me create a dramatic diagonal composition," he adds.

The final image was shot at f/5.6 using Ilford XP-2 Super black & white film. Shutter speeds on the series ranged from $1/30$ to $1/125$ second in an attempt to underexpose the sky a bit and let the TTL flash from the SB-800 light the bride from the side. A vignette was added with Photoshop. The only other changes were a little dodging on the side of her face and, finally, sepia toning.

Despite being soaking wet for the rest of the reception, Mautner had no complaints. He knew he'd just made a special series of photographs. To see more examples of Cliff Mautner's images, visit his web site at www.cmphotography.com. —*Jen Bidner*

INGREDIENTS
Camera: Nikon F5
Lens: Nikkor 17–35mm f/2.8
Flash: Nikon SB-800 with a Nikon SC-29 TTL cord
Film: Ilford XP-2 Super black & white
Software: Adobe Photoshop

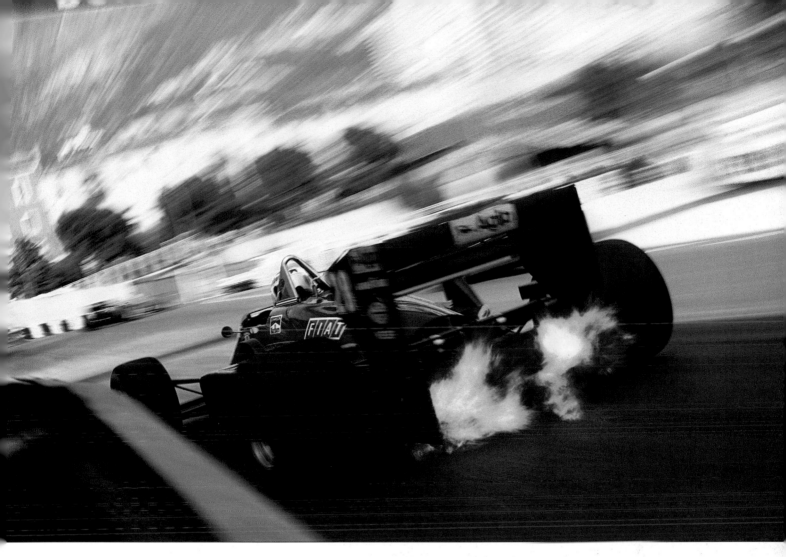

The Height of Action with Rainer Schlegelmilch

Rainer W. Schlegelmilch has been photographing the high-speed world of Formula 1 auto racing for over forty years. His body of work includes revealing candids of the drivers, action-stopping drama, and artistic images like the one shown here.

He considers this image of Stefan Johansson, taken at the Grand Prix in Monaco in 1985, one of the very best action shots he has ever taken. Johansson is a Swedish Ferrari driver who scored 49 Formula 1 World Championship points in 1985 and 1986 before leaving to drive in the American Indy series. The image shows off Schlegelmilch's specialty: converting the movement and speed of racing cars into a fascinating and adventurous display of color and excitement.

To create this image, which he calls *Ferrari Turbo*, Schlegelmilch utilized three techniques simultaneously.

First, he set his f-stop to a small aperture, between f/11 and f/16, and selected a slow shutter speed of 1/60 second with Kodachrome film. Second, he then followed the car in the viewfinder with a smooth pan. This caused the background

to blur, while the driver and car frame remained relatively still (and thus relatively unblurred) in the viewfinder. The wheels spinning, however, are extremely blurred, which helps create the heightened feeling of speed. Finally, simultaneous with the panning action, Schlegelmilch zoomed his 43–86mm Nikkor Zoom lens. This caused an "explosion" type of blur that complemented the feeling of speed he was trying to convey.

Schlegelmilch modestly describes the burst of fire as "just plain luck." Although he could not have planned the perfect flame, he was ready when it came, and he got the shot.

To see more of Rainer Schlegelmilch's images, information on his books, or a peek at Formula 1 racing highlights from the past several years, visit his website at www.schlegelmilch.com. —*Jen Bidner*

INGREDIENTS

Camera: Nikon 35mm SLR
Lens: 43–86mm Nikkor zoom
Film: Kodachrome
Shutter Speed: 1/60 second
Aperture: between f/11 and f/16

Jake Butler: Capturing Lightning in Costa Rica

Never have I seen the evolution of a thunderhead so clearly as on the beaches of the northwestern coast of Costa Rica. That day, the tropical winter provided one of those perfect combinations of place and time for this type of experience. The beauty of the elements was gripping.

I started out on a late afternoon hike with gear in tow up to my favorite sunset peak. Halfway up the slope, I felt the cool gusty winds calling for the rains to come. I continued on toward the summit. With a waterproof cover to protect my camera pack and an umbrella keeping the tripod head dry, I huddled by the tree line on the cliff overlooking Tamarindo Bay and watched the display as the rain drenched me.

The meager light from what was supposed to be yet another beautiful sunset quickly faded, but my attention was held as lightning began flashing in the clouds behind the northern tip of Playa Grande. Almost twenty minutes passed with the diffuse purple glow behind the rain illuminating the scene like clockwork. I began to count the pulse interval between the flashes.

The storm moved away from the land and out to sea. I wrung out my shirt, grabbed my gear, and headed for the shores. With a fresh coat of insect repellent applied, I arrived on the beach just in time for the light display. I set up my tripod and was ready to strap on the umbrella that I'd learned to have with me at all times—but then I realized it wasn't even sprinkling where I was standing. The storm was holding just off shore in a very concentrated manner.

I set up my Pentax 645, attaching the wide-angle 33–55mm zoom lens to the body. The sand was still wet from the storm and receding tide. Sheets of rain moved about in a dance on the horizon. The lightning struck both in front of and behind the natural diffusion as the reflections gleamed off of the wet beach in front of me. With my cable release I was able to try a variety of long shutter speeds, while keeping the aperture at f/8 for maximum sharpness throughout the frame.

Out of the sequence, this single strike is by far the most powerful image.

INGREDIENTS

Camera: Pentax 645 N II
Lens: 33–55mm Pentax zoom at 33mm setting
Film: Kodak E 100s
Exposure: 74 seconds at f/8
Tripod: Manfrotto carbon fiber 3443 tripod

Jake Butler: Costa Rica's Arenal Waterfall

The rainy season brings out vibrant life in the jungles of Central America. The air fills with enough humidity to transform the normally invisible gas into a rolling fog. The mist lingers in the valleys. It hangs in the treetops as a companion to the howler monkeys. The forest is filled with the vibrations of its countless inhabitants; species of life exist there that are found nowhere else in the world.

In the afternoon, the streams and rivers swell with the daily downpours that arrive like clockwork. The ground seems an animate sponge that gives under footfall, only to fold in on itself and rejuvenate the depression. There is no better time to venture into the rain forests of Costa Rica.

Monte Verde and the cloud forest are some of the most verdant places on earth. Volcano Arenal looms majestically in the distance, occasionally giving off the rumble that serves as a reminder of its potent wrath. The waterfalls are world class, and at the height of the season, their full potential is breathtaking. The jungle falls of Costa Rica, surrounded by the lush greenery of the canopy, make for excellent photography.

The water that flows here is pristine. Although you wouldn't want to drink it without refining first, the clear, cool, refreshing quality of it is undeniably inviting. An afternoon swim should be prescribed to everyone who visits.

This shot was taken during midday, but the mist was diffusing the light fairly evenly. Even stopping down to f/32 wasn't cutting it for the exposure I wanted. I added four stops of neutral density filtration to the front of my lens and was able to obtain the desired effect of the blurred water at 1½ seconds.

Crawling out to the rock I shot this from wasn't an easy feat. Most everyone else who had ventured on the hike stood on the bank closest to the trail, but the composition there wasn't as good. I used my tripod as a brace and treaded very lightly to the center of the stream at the bottom of the falls. Only there did I find what I was looking for. I composed with as much flowing water as I could fit in the frame and, using my mid-range telephoto, made two shots. I didn't change my exposure for the second one; I simply snapped it as a safety.

Weeks later, back in the U.S., when I developed nearly forty rolls of film, I found that the first image taken had a very strange blue light leak at the frame's lower edge. Although Photoshop might have been able to help, major Clone-tool work would have been needed to salvage the shot. The second shot, however, was flawless. The lesson I learned was that, even after all the painstaking care and precision taken to shoot fine outdoor photography (especially in foreign countries), one can never know what may accidentally happen to the film during shooting or processing. A safety shot and/or bracketing exposures isn't a bad idea when you think the image in the viewfinder could possibly be a real beauty.

INGREDIENTS

Camera: Pentax 645 N II
Lens: Pentax smc P-FA 645 75mm f/2.8
Film: Kodak E 100VS
Exposure: 1½ seconds at f/19
Filters: 3-stops neutral density
Tripod: Manfrotto Carbon Fiber 3443 tripod with 3030 head

Mike Colón: Shooting With Lens Flare

Mike Colón enjoys photographing children because they are always finding creative ways to entertain themselves. He was inspired to create this portrait by a postcard he received from friends. It was a shot they had taken of themselves in the desert with a strong backlight and lens flare.

Here, the flower girls were holding hands in a circle and diving under each other's arms until they were all knotted up. Mike made this shot while down on one knee with his Nikon D1X and 17–35mm AF-S Nikkor lens, positioned about fifteen inches from the girl's face, and zoomed out to 17mm.

He positioned the sun peeking halfway into the corner of the frame to create lens flare. Mike states, "I've found the trick to getting a decent exposure while shooting with lens flare is to set your exposure compensation to +0.7 or +1.0 (sometimes more) while in aperture-priority mode." Mike was aiming for the shaded side of his subject; therefore, he set his white balance to the shade preset. Lens flare from the sun usually creates a yellow color cast in the image and flattens out the contrast. To enhance the depth in the image, Mike brought back a small amount of contrast using the Curves in Photoshop. By cropping the image to a square format, he was able to pull the viewer into the tight space of tangled arms. —*Harvey Goldstein*

INGREDIENTS

Camera: Nikon D1X

Lens: 17–35mm f/2.8 at 17mm

Computer: Apple Power Mac G5

Software: Adobe Photoshop, iView Media Pro

Exposure: $^1/_{1250}$ second, f/2.8, 400 ISO

Exposure compensation: +0.7

White balance: Shade

NyxoLyno Cangemi: Wave Jumping at Sunset

I'm in a privileged profession through which I get to experience numerous types of Coast Guard operations. I once had the honor of spending ten days aboard the Coast Guard cutter *Valiant*, home-ported in Miami. The crew of the *Valiant* was assigned to the Eighth Coast Guard District to conduct a living marine resource patrol in the Gulf of Mexico. After spending three days with the crew, I had amassed a wealth of photographs showcasing the crew's activities.

To build better relationships with the crewmembers, I would leave my laptop in common areas and play looped slideshows of photos I had taken during my stay. When I returned, I would often find an interested crowd gathered around the laptop. The crewmembers could see the work I was doing, and through my photography, I was able to boost their level of pride and accomplishment in what they do. It didn't take long before I was at a point where I didn't have to "look" for action—the crewmembers would tell me where to be, and they would include me in everything they did.

On one such occasion, I was editing some photos I had taken earlier that day when I received a call from someone in the pilothouse of the *Valiant*. I was told to go outside with my camera.

I quickly grabbed my gear and ran outside, thinking there was something of great importance happening. When I got outside, I looked around and saw nothing! Not knowing what to do, what to look for, or if someone was playing a joke on me, I decided to simply wait. After a minute or two, I heard faint screams of joy in the distance as the cutter's small boat started approaching me. At that point, I realized I was called out to take pictures of the boat crew jumping waves. With little time to react, I quickly exposed for the sun and waited for two things to happen: the boat to leap into the air, and for the boat crew to be positioned in the sun's glare across the water. Tracking the boat, I triggered the shutter once I saw both elements come together.

For more, please visit www.NyxCangemi.com.

INGREDIENTS

Camera: Nikon D1X (in-camera metering, pattern mode)

Lens: AF Nikkor 24-85mm 1:2.8–4 D with 72mm UV filter

Exposure: 125 ISO, 1/3200 second at f/4, +0.3 EV, manual mode, AWB

Post Production: Apple Power Mac G4, Adobe Photoshop (adjusted Levels, applied Unsharp Mask)

Claude Jodoin: Straightening Fisheyes With Image Align

The photograph to the right was made with a single exposure using a Sigma 8mm EX Fisheye lens on a Canon 10D digital camera. A Minolta Flashmeter V determined exposure in ambient-light mode. The exposure was one second at f/5.6.

A custom white balance was achieved using the amazing Wallace Expo Disc. Putting this device over the lens and exposing it at the working aperture (f/5.6) and time (1 second) produced a gray frame. The resultant spike in the histogram appeared exactly where it should be (for those who double-check exposure with histograms). As a result, the only color correction made to this image was the custom white balance from the "incandescent gray" frame created by the Expo Disc.

The curvilinear "barrel" distortion created by the fisheye was partially corrected with the Image Align program from Grasshopper software, which can function either as a plug-in for Photoshop or as a stand-alone program. Image Align allows you to correct pincushion and barrel distortion using sliders instead of complicated math. You can see what is happening in the image preview as you slide the controls. When it looks like you want it to look, you then render it, and it applies changes to your image file. In this case, a 120-degree correction was all that was needed to make a full-frame image from the original.

The final image (below) was cropped as a 24x12-inch panoramic by using the Crop tool in Photoshop. It was then printed on an Epson 7600 with Semi Matte paper and the corresponding Atkinson Profile at 2880dpi.

This image shows off the elaborate reception decorations from the exact viewpoint of the bride and groom, standing behind their chairs. It took less than three minutes to capture this image, as the meter reading was taken while walking toward the bridal table. After the shoot, it took about five minutes to finish in the computer as outlined above.

While the shot was quick and simple to produce, it's a dramatic image that looks much more complicated.

INGREDIENTS

Camera: Canon EOS 10D
Lens: Sigma 8mm EX Fisheye lens
Meter: Minolta FlashMeter V
Other: Wallace Expo Disc
Lighting: Ambient twilight; Speedotron flash
Software: Image Align, Adobe Photoshop
Exposure: $\frac{1}{15}$ or $\frac{1}{30}$ second at f/2.8

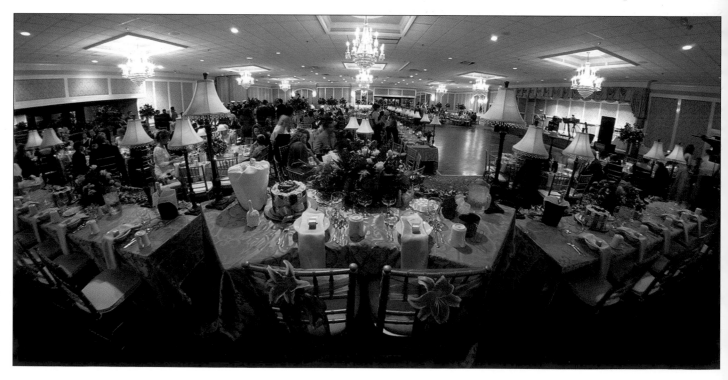

I'm sure I looked a little strange walking around this little coastal New England cemetery at midnight with a large backpack and equally large tripod tucked under my arm. Not a soul seemed to be wandering—except for the four seemingly innocent skunks that decided to make their evening rounds in the one place that looked utterly amazing in an apparently deserted town.

The sign at the entrance was a dilapidated ceremonial plaque dedicated in 1934 for the 300th anniversary of the cemetery. That alone made me pause, but as I stood there, I started to see an image that had been in my mind for years. This small plot of land sitting by the ocean had several small hills with headstones jutting out at all angles. Some were crumbling and unreadable, others newer with textured wear.

As I wandered into the cemetery the uniqueness of the light instantly became apparent. Surrounding this colonial cemetery were groves of hardwood trees. Behind these trees, streetlamps of all color temperatures poured light into the place, creating mysterious shadows and mischievous highlights. Some of the headstones were completely lost in shadow, while others lit up in wonderful greens and blues. The sky overhead was a mixed bag, combining subtly illuminated, drifting white clouds and the starry blackness of night.

I had my camera in my hand and had already set up my tripod without thinking. I set up slowly, methodically searching the angles and placing the shadows where I wanted them. I knew it was going to be a long exposure, so hurrying was not an issue. With my eye pressed against the viewfinder I saw it, the subject of the image, the thing that this whole scene was supporting: a simple colonial house lit by an unseen light. The house stood out quietly, and it was, in my West Coast eye, the New England I had envisioned all my life.

With my shutter open and locked, I figured I had about an hour or so to kill. There was nobody around, and I was tucked in a dark corner of the cemetery, so I figured the camera was safe. I turned to leave and walk a little more around town, and that's when I saw the skunks, all four of them. Staring at me with beady little eyes illuminated by the magical streetlamps was the one small creature that makes any grown man stop dead in his tracks. They all stared directly at me. Not really sure what to do, I simply didn't move. We stared at each other a few moments until they got bored and resumed their midnight feeding. Intrigued, I decided to stay in the cemetery for the length of the exposure, I mean, why not?

Photography is, for me, a solitary endeavor. With my camera in hand, I feel at home anyplace in this world. In New England, my scene was being lit by dozens of mixed, modern streetlamps, but I felt as if I was transported back in time.

To see more, visit www.scottmansfield.com.

INGREDIENTS

Camera: Hasselblad 501
Film: Kodak 160NC, EI: 160
Exposure: f/11 at 1 hour, 15 minutes
Lens: 50mm
Light: Streetlamps and moonlight

Scott Mansfield: The Road Not Taken

I arrive at images in different ways. I often find myself roaming with no preconceived idea of the image I am seeking. I simply explore, hunting the landscape for a scene. Some trips, though, are deliberate. The destination is known, and the images I seek are somewhat, if not completely, defined.

Then there is the imagery that is always with me. Pictures created in my psyche and pieced together with bits of other scenes and built into finished products. Studio photographers use an array of tools, from models and artificial lights to manufactured backgrounds and costumes, to recreate the images in their heads—but commercial photographers aren't the only ones plagued by these preconceived images. As a landscape photographer, I'm constantly haunted by scenes that are completely created in my mind, and I am forced to search for them in reality. This image is one of those.

It was the last few days of a week-long trip to southern Utah. Several days earlier I had stumbled onto a fantastic shot of a herd of bison wandering through a field. It was one of those moments where everything comes together: light, composition, time, art. Now, near the end of my journey, I was happy and satisfied; I had gotten my trip-defining image. I shot many other scenes over the week, though none with the same magic as the bison—until I came around a 90-degree bend in the road.

The scene unfolded in front of me, and, before I knew it, I had pulled off the road into the dirt. For months, I had envisioned this exact scene—a diminishing road with spotty clouds. Not an original idea, it was just one I wanted for myself. As I got out of my truck I remembered I wasn't the only one on the highway. For the next two hours I played chicken with cars, eighteen-wheelers and motor homes. I waited for clouds that kept building and withdrawing and for the shadows that kept dancing this way and that. It was early afternoon, so the light let me take my time and wait for the scene to fully develop. Between cars whizzing by, I ventured into the middle of the road to compose. I wanted to shoot from as low to the ground as the hyperfocal distance would allow (about three feet). I threw on a polarizer to separate the clouds and a 2-stop split neutral-density filter to bring down the sky and cut the brightness of the distant mountains.

I could only get off a few exposures between the cars approaching from behind or popping up in the distance. After a few hours, though, I had a couple rolls of film and felt content I had gotten what I wanted. It was a good trip.

To see more, visit www.scottmansfield.com.

INGREDIENTS

Camera: Hasselblad 501
Film: Fujifilm Velvia 50; E.I. 25
Exposure: ⅛ second at f/16
Lens: 50mm
Light: Natural
Filter: Polarizer, 2-stop split ND filter

As a public affairs specialist in the Coast Guard, I get a lot of unique shooting opportunities. The Coast Guard also furnishes us photographers with some great gear. The result: being in neat places with the right tools.

This shot was taken at the Portsmouth Naval Shipyard in Kittery, Maine, where a Coast Guard cutter was scheduled to return home. I was assigned to photograph the event. As family and friends waited on the pier, I anticipated what types of shots I could get. I planned (or rather, hoped) to get that sunny picture of the big kiss, or the little boy waving a flag, dad with the kids, tears of joy, and all the usual emotions evoked by families being reunited.

It wasn't long before the 270-foot cutter rounded the river bend and everyone started waving and cheering. By this time, I had already snapped a few exposure checks on my Nikon D1X and had set the white balance to shade, which tends to produce nice, warm results. There were still a few hours of daylight left and before the cutter was in full view. I began shooting the crowd's excited reaction.

The boat was rigged to tie up with its starboard (right) side to the pier, but as it made the approach, the river's current spun it around, and the cutter was forced to tie with the port (left) side to the pier.

One has to imagine the size of the stairs and ramp used to offload crew and their equipment. The setup is huge and can only be moved with a forklift—a *big* forklift. Furthermore, one would have to imagine the time it takes to reconfigure and move the colossal setup when things don't go according to the plan, as was the case.

The crew and their dockside family and friends had to wait an additional two hours before they could be reunited. For me this meant losing precious daylight. The sun was now slowly slipping toward the horizon and the crew was still aboard the cutter. I worried that once it was dark, I probably wouldn't get the shots I hoped for. I figured that in the meantime, I could try to get some facial shots of the crew waiting up on the deck of the boat.

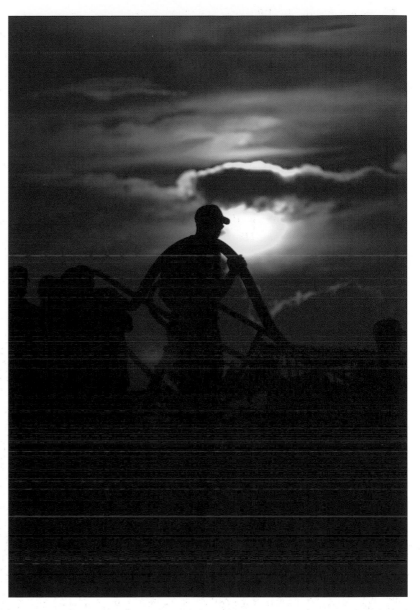

Even though the lens, a Nikkor 80–200mm, got me in close enough to the crew, it was difficult to capture their expressions as the sun was now behind them. I shot some, but I had pretty much relin-quished all hope of getting any of the images I wanted and was pretty disappointed.

Not long after that, the stairs were finally rigged and the crews had started to come off the boat. As they hauled the power cord across the deck and down the stairs, I looked up to see a great opportunity. I had only a few moments before the sun passed down below the other side of the boat. I had to run about fifty yards along the length of the boat and then scale a small wall to get the crewman and the sun to stack up in the viewfinder. I shot it at $\frac{1}{3200}$ second at f/4.5. I adjusted the levels and saturated the color in Photoshop.

Lesson learned: I allowed tunnel vision to set in and almost missed this shot because of it. It's especially true of photography that when one door closes another is surely opening behind you.

INGREDIENTS
Camera: Nikon D1X
Lens: Nikkor 80–200mm
Software: Adobe Photoshop
Exposure: $\frac{1}{3200}$, f/4.5

Monte Zucker Adds Dramatic Background Effects

Monte Zucker—photographer, businessman, teacher, philosopher, lover of life and of living—is considered one of the more influential and prolific teachers of photographic portraiture today.

With his talents, Monte has the ability to reach into the hearts of his subjects and reveal their inner emotions as few photographers can. Often, he creates unexpected images. As a result, few people know who Monte is today. He keeps reinventing himself. He is unconventional, to say the least.

He is sometimes brilliant, always moving. Of course, the fact that he's spent over fifty years as a professional photographer and teacher, studying and perfecting his photographic technique, may have something to do with his success.

When asked about this image, Monte says, "The Holocaust was happening on the other side of the ocean. I was aware of it, but had no concept of the horror of it all. I was too young to fully comprehend what was going on.

INGREDIENTS
Camera: Canon EOS 10D
Lens: Canon 28–135mm f/3.5 IS
Software: Abode Photoshop

"I visited the Holocaust Memorial by chance one day while in Miami. I spent several hours engrossed in the story, mesmerized by the memorial and all that it stood for. I photographed the hand against a beautiful blue sky . . . feeling all the while that the contrast of the horror depicted on the bronze and the beautiful blue sky behind it would be a dramatic statement of contrasts. I was wrong; the picture was merely a snapshot of the bronze.

"Fortunately, I had just photographed a cloudy sunset. In Photoshop, I started to adjust the Levels. With a few sliders, I transformed the peaceful sky into a stormy rage. Then, with the original image of the bronze hand on my computer screen, I selected the Color Range controls. With a few more clicks I was able to isolate the blue sky and delete it. Then it was a simple matter to merge the two separate images together, placing the bronze hand into the storm.

"When it was done I was overwhelmed with emotion. I had made a statement that was far greater than anything that I could have done in any other medium. Now, with this image I feel that in my very small way I have at last done something of lasting value for humanity. Through digital imaging I feel that I have finally made my contribution."

Monte says he's got just about every photographic degree that exists. Find out more about Monte at: www.montezucker .com. —*Bob Rose*

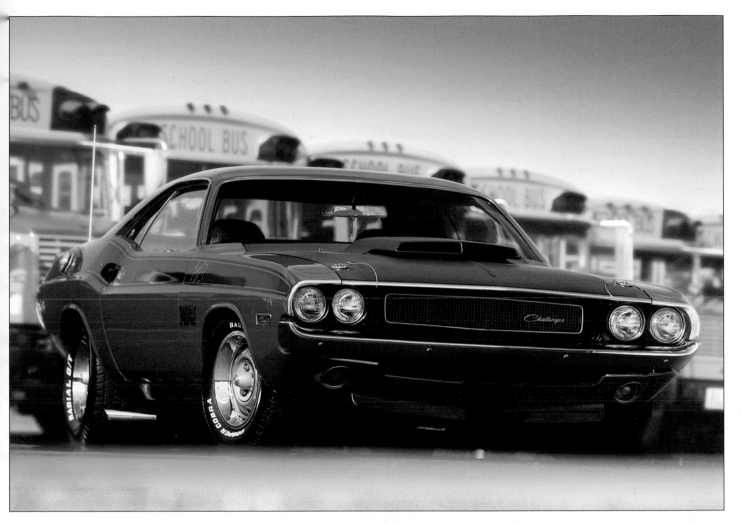

David Wendt Meets the Challenger Challenge

To get his shot of a 1970 Dodge Challenger T/A, for an *Xtreme Muscle Cars* calendar, vehicle photographer David Wendt needed a location that provided a bright, colorful, and contrasting color scheme. The photograph, which Wendt describes as fairly simple, conveys a subtle message aimed at every guy who ever lusted after a sexy muscle car in high school but had to use a far less glamorous form of institutional transportation.

Wendt had to shoot the car near where it is permanently housed in Cincinnati, OH. He was fortunate to find the ideal location within five miles of the owner's home—a parking lot containing a number of bright yellow school buses. He chose the buses for a background because he wanted a colorful backdrop that was interesting, but not so interesting it pulled attention away from the vehicle.

To photographically preserve the perfectly purring machine, Wendt used a 70–200mm lens on his handheld Canon EOS-1Ds. The exposure of 1/800 second at f/5.6 was 2/3-stop underexposed. The picture was taken around 5:00PM.

In addition to natural sunlight, Wendt used only one Flexfill reflector disc for fill to keep the shoot as simple as possible.

To get the yellow speed bump in the foreground that matches the buses, Wendt positioned himself flat on his stomach on the hot blacktop.

After the final image of the car was in his camera, Wendt used the Color Range selection under Select in Photoshop to tweak the school-bus colors and darken the upper corner of the sky. "When you activate the Color Range selection tool," Wendt says, "a dialog box comes up. The creative things I can do with this box has changed the way I use Photoshop forever."

To see more of Wendt's photography, and learn how he shoots a variety of vehicles, including big trucks and trains, visit his website: www.wendtworldwide.com. —*Larry Singer*

INGREDIENTS
Camera: Canon EOS-1Ds
Lens: Canon Zoom Lens EF 70–200mm, f/2.8
Lighting: Daylight at 5:00PM, Flexfill reflector disc
Meter: Internal camera metering and bracketing
Software: Adobe Photoshop

Peter Skinner: A Piscatorial Portrait

Usually fish portraits are made by underwater photographers who often feed their subjects to bring them into close range. It's a good technique and one I have used myself. On this occasion, however, my assignment was to create a "character study" of pterois volitans, better known as the common lionfish, in an aquarium where he could not be tempted into view by any tidbit. So, it was a sit, wait and hope he'd cooperate situation.

Dubbing it a "character study" might be a bit of a stretch because fish tend to be somewhat expressionless, but the lionfish's thrusting jaw line and "Don't mess with me!" attitude made it easy to conjure up the similarity with the pugnacious visage of Winston Churchill as portrayed by the peerless Yousuf Karsh. Perhaps, however, the slightly curious look on the lionfish makes him more approachable than Churchill!

The ideal way to photograph aquarium creatures is in a specially set-up and reasonably small tank with lighting access from above, as well as through clear (and clean) glass from the front and sides. My location, however, was a public aquarium with thick Plexiglas® with an unknown color cast and no overhead lighting capability. Back scatter, created when light strikes suspended particles of various matter in the water, and the possibility of scratches or other imperfections on the surface of the Plexiglas were also problems.

A portrait of any subject—person or animal—involves much the same approach. I decided to use a Nikon D1X camera on a Gitzo monopod, a 105mm f/2.8D Nikon lens because of its ideal focal length for head-shots and its macro focusing capability that facilitated a tight composition of the relatively small subject.

Lighting was with a single Nikon SB80DX flash set on TTL and held against the aquarium glass, slightly higher than the subject and at an angle so as not to throw any reflection of glass or backscatter particles into the lens. At such a close distance, the depth of field is shallow. While I wanted critical elements, such as the eyes, to be sharp, I also wanted the background to be indistinct, so I set the camera on aperture priority and selected f/8. Autofocusing is a great feature most of the time, but in this situation manual pre-focusing was more practical. To avoid any color shift issues, I shot in RAW mode, confident that color correction and cleaning up other imperfections could be done in Photoshop.

I selected a small area of the tank that the fish liked to swim through as he did his rounds, pre-focused on the spot where he would be framed quite tightly, and waited until pterois volitans swam into range. Holding the flash with one hand while moving the camera on the monopod forward and backward slightly to fine-tune the focus was a bit like the one-armed paper hanger analogy, but it worked. It took only a few shots—but quite a long time and considerable patience—to get what I wanted. Being able to check the results immediately was a bonus. So, while this fishing trip was only photographic in nature, I was quite happy when my lionfish was in the bag!

INGREDIENTS
Camera: Nikon D1X, RAW
Lens: Nikon Macro 105mm, f/2.8D
Exposure: 1/60 second at f/8, 125 ISO
Lighting: Nikon SB80DX
Monopod: Gitzo
Computer: Apple PowerBook G4
Software: Adobe Photoshop

In the bright, late morning light, I wanted to capture some backlit dewdrops. A friend of mine was shooting this scene. Upon looking through her finder, I quickly began shooting a similar subject in the same area.

This is remarkable in its openness and backlighting. It was the beginning of a bloom, with only the "sticks" upon which the flower will grow in the coming week. In fact, upon returning the following week, this scene didn't exist; the flower filled in the lines, which were now no longer visible. As John Shaw says, "Shoot it when you see it."

Because the sunlight was getting hotter and changing angles by the minute, we only had a few minutes to get this image. The hub was placed in the upper third area in the frame at a location where the most and brightest highlights are visible in the frame. The round highlights are a direct result of shooting at the widest lens aperture. I had to hold my hand in front of the lens in order to shield it against the bright sun and to avoid lens flare.

INGREDIENTS
Lens: Nikkor 300mm f/4
Filter: 81B multi-coated warming filter

Tony Sweet: Repetition

What I wanted to do here was to have two "repeating" subjects and a wash of color.

On the East Coast, the state highway administration plants large patches of colorful wildflowers on the median strips and exit ramps of major interstate highways. If a safe and secluded enough area can be found and photographed without the photographer being asked to leave, it is a true photographic mecca. The numerous close colors of these flower fields are ripe for creative photography. Basically, I had a 300mm f/4.5 lens and just started pointing it into the area of flowers, trying different points of focus to see what presented itself. Still, I definitely had a previsualized idea of what I wanted. I found a nice repeating pattern of poppies.

Playing around with depth of field, I decided to use f/8 to show some detail in the background poppy. I adjusted the camera height in order to get the background poppy to appear to be rising out of the sea of muted red tonality.

At somewhat shallow depths of field, like f/8, point of focus is important. The main point of focus is the center of the foreground pink poppy. This lets everything else go soft for visual contrast and to get a color "wash" to further attract attention to the foreground poppy.

INGREDIENTS
Lens: Nikkor 300mm f/4 lens with 27.5mm extension tube
Filter: 81B multi-coated warming filter

Tony Sweet: Waterlily—Shooting Multiple Exposures

What I wanted to achieve on this image was a sort of twirling effect while keeping the center of the flower relatively sharp.

The bright sun and black pond are the conditions for this pre-visualized image, shot at the National Arboretum in Washington, D.C. Notice how the colors pop with the black background. While leaving the camera on the tripod, eight exposures were calculated by shooting on matrix metering and aperture priority and setting the exposure compensation to –3. The image was made on one piece of film while twist-ing the camera on the lens tripod in very small increments for nine exposures. Although this is prop-er metering for eight exposures, I shot one more (nine) for a little more luminosity.

The center of the flower is the point of focus and appears to have sharpness, despite the many overlapping exposures. In terms of composition, it was placed at the bottom and center part of the frame for visual weight.

INGREDIENTS

Lens: Nikkor 300mm f/4 lens

Filter: 81C multi-coated warming filter

David Wendt: Ferrari 360

Each time I get to go out and shoot a car, I have to consider the color of the car and what kind of background I can use to make it show up the best. A long time ago in art school, I was taught about color and what each color does next to another color. For example, yellow and blue are about as far apart on the color wheel as I could get for this shot—and that means maximum contrast.

But color isn't the only important contrast. The contrast of texture and the focus of an image can also direct the eye around the shot. The eye naturally seeks what is sharp in an image. Even though the car is smooth and sleek, it's in focus; the bridge, on the other hand, has a rough structure that, even out of focus, contrasts with the car. If the whole shot was in focus, it would not work as well because the eye would busy itself trying to separate the two subjects.

The contrast of lights and darks also plays out well here and helps make this image better. The only real darks are in the car, as are the brightest spots (the headlights). The way the light comes across everything in the shot helped define the shapes, textures, and colors.

I took this shot right after sunrise because of the light and one other big reason: at 6:45AM on a Sunday, nobody is out driving on this bridge except for an occasional bus. This allowed me to do what I wanted without having to get the police involved to block traffic.

There are more details to take into account for a shot like this, but the regular use of these basic ideas can help define how we see our work and how well it is received by the viewers and our clients.

Not all my images win on each count like this one does. But for the work involved and the time spent on it, I'd say I scored pretty well with this shot. I hope I can do as well next time, since a tremendous part of what I do comes down to a lot of good luck and a little bit of experience with the basics of contrasts.

INGREDIENTS

Camera: Canon EOS 1Ds Mark II
File Format: RAW file processed through Adobe Photoshop
Exposure: 1/400 second at f/4.5, 100 ISO
Lens: EF 70–200mm f/4L USM at 150mm
Lighting: Sunrise, 7:00AM, mid-May
Meter: Internal meter set on auto, –1/2 stop
White Balance: Auto

11. WEDDING PHOTOGRAPHY

Divergent styles have collided with changing attitudes to produce the finest imagery this genre has known.

*W*e live in the midst of a great renaissance of wedding photography. It is a time when divergent styles have collided with changing attitudes to produce the finest imagery this genre has known. At no other time since photographers began recording the wedding ceremony to preserve its history has the style and artistic merit of wedding photography been so remarkable.

You will see by the diversity of styles and techniques in this chapter that the skill set of the contemporary wedding photographer is extensive. Wedding photographers must be social directors, photojournalists, master portrait photographers, lighting wizards, and tireless observers who are both attuned to the subtle nuances of the events of the day and skilled enough to capture them in an instant.

Here are just a few highlights to look for in this chapter.

Ohio native Patrick Rice presents the lowdown on digital infrared portraits. His formal portrait of the bride and groom outdoors in digital infrared is gorgeous.

Southern Californian Gigi Clark recreates a very ambitious project that she started in Australia. It is a tapestry reminiscent of the 15th century French tapestries that would document or celebrate important events like the wedding day.

Englishman Dennis Orchard talks about the one that got away . . . or almost got away. Being a diplomat and restaging a perfect moment, Orchard was able to recreate a purely spontaneous scene, much to the delight of all concerned.

Parker Pfister reveals how a magical moment was created. The mystery comes from a bride's veil that seems to float on air.

Robert T. Williams presents a marvelous moving portrait (which almost caused him to be run over by oncoming traffic) of the bride and groom zooming down the street in a '57 T-bird.

Joe Buissink is one of this country's finest wedding photographers, but even he just gets lucky sometimes—as he did one afternoon in Mexico. The result is the serendipitous *Between Two Walls*.

Finally, Australian Ryan Schembri examines his award-winning image, *Kiss Now*, a truly unique expression of love and romance.

Roy Madearis: Instant Backgrounds

Roy Madearis of Arlington, Texas, no longer worries about bad weather or curious tourists complicating a location shoot. Instead, he shoots his background images ahead of time, and relies on projected backgrounds to set the location for his studio portraiture.

The image here was photographed with a 2x2-foot softbox and Norman flash units. The model was posed standing in front of a Virtual Backgrounds projection screen. The fill illumination was light bounced off the white walls of the studio with two Norman heads.

A slide taken by Madearis was placed into the front-screen projector and the image was projected at the model and screen. Because the screen is made of a highly reflective material, a very faint amount of light is needed to make it show up clearly. This projected light is insignificant, however, compared to the flash illumination, and thus the projected slide is not visible on the model—only on the background.

Being able to change backgrounds simply by changing slides is just one of the advantages of a virtual background system. It's also a great time-saver. The image shown here is of the gorgeous columns of Texas A&M University—a four-hour drive from Madearis' studio. The system also ensures perfect weather every time. The only trick is to make sure the studio lighting is harmonious with the background slide.

In this case, the studio image was captured with a Kodak DCS Pro SLR/n digital camera and a Tamron 28–105mm lens. The lens was set to f/8. The final digital image was then outsourced to Full Color Lab in Dallas, Texas, for printing (www.full color.com).

For more about Roy Madearis, visit his web site at www.madearis .com. He also offers a wide variety of educational materials designed to help professional photographers improve their marketing skills and promoting capabilities. —*Jen Bidner*

INGREDIENTS
Camera: Kodak DCS Pro SLR/n
Lens: Tamron 28–105mm
Flash Units: Norman Photo Control
Lighting: Light bounced off white studio walls
Background System: Virtual Backgrounds projection

Since Kodak first introduced infrared film to the scientific community, fine art and other photographers have been fascinated by its aesthetic qualities. However, infrared film was always difficult to handle, process, and print, making it difficult at best and unpredictable at worst.

Photographer Patrick Rice has left that far behind, becoming a leader in the use of digital infrared photography. Many digital cameras are infrared sensitive and can be converted by the use of deep red (nearly opaque) filters, or even permanent customization.

In addition to conventional wedding photography, Rice offers digital infrared portraits. He uses Nikon Coolpix 950, 990 and 995 cameras and Canon D30 cameras that have been converted to infrared-only by Pro Camera and Video in Cleveland, Ohio.

In conventional infrared photography, a nearly opaque filter must be placed over the lens to screen out other non-infrared wavelengths of light. However, this makes composing and focusing through TTL viewfinders difficult. On the converted camera, the filter is not in the path of the viewfinder, and therefore does not interfere with it. As a result, normal viewing is possible.

Rice has done a lot of experimenting with digital infrared and is the author of two books on the subject: *Digital Infrared Photography: Professional Techniques & Images* and *Professional Digital Imaging for Wedding & Portrait Photographers* (from Amherst Media).

INGREDIENTS
Camera: Modified Nikon Coolpix 950 digital camera

The image shown here was a pivotal image for Rice's infrared photography. "It changed the way I thought about infrared," he explains. "It was my first foray into close-up infrared portraits." While most infrared photographers tend to concentrate on scenics, or on distant portraits, Rice now prefers to zoom in close on his subjects, as he did in this image.

"Infrared photography tends to make skin tones look immaculate, creating bigger-than-life portraits," he explains. "It's the closest thing I've found to emulating the golden age of Hollywood glamour, and especially the work of one of my favorite photographers, George Hurrell," Rice says.

To view more of Patrick Rice's images, visit www.ricephoto.com. —*Jen Bidner*

Gigi Clark: *Remains of the Day*

Iwas recently in Canberra, Australia, shooting a wedding. On a walkabout with the couple, the bride kept commenting on the beauty of the city of her youth. I thought the fall colors reflected the color scheme found in medieval tapestries. Historically, these tapestries reveal details surrounding an event, along with creatures found nearby. I decided to include the textures and techniques of 15th-century French tapestries, complete with rough sections that would show wear and tear. For the project, I spent the better part of two weeks in Australia, documenting native animals such as kangaroos and koalas, and kept on the lookout for "special events," such as the crimson rosellas—birds who mate for life—which showed up every time the couple appeared.

First, I scanned a kitchen towel that had a weave much like that of the tapestries, and I did a bit of "stitching" in Photoshop to create a larger area. For the outer border, I used the sculpted white marble twisting columns from the front of the Duomo in Florence, Italy, and filled the empty spaces between the spirals with red Japanese maple leaves that were photographed in Canberra, near the bridal site.

The center image was cleaned up and manipulated lightly using Photoshop filters, including Fresco, Poster Edges, and Rough Pastels, to give the subjects definition. A displacement map was then applied to the couple, adding edges to the figures so they would seem woven, rather than photographic. A blue sky with clouds was created, since the main image was photographed after sunset, yielding a blank sky.

The inner frame is a composite of balls and gold border, created using the Spherize tool and Lighting Effects. The other elements were cut out and placed on top of the burgundy border, using the blending layers in Multiply mode.

Lastly, the towel scans were added, with opacity adjustment as well as blending enhancements. The animals became "tapestry." As the towel was medium beige, tending to dampen the saturation, final adjustments to brightness and contrast allowed the tapestry to be seen in its splendor.

David Bentley of Frontenac, Missouri, states that in a time when the focus (and he enjoyed the pun) of wedding photography seems to be primarily on the details, the most important detail to the groom is still the bride. The groom is in love with this girl, and while David is making her portraits, so is he. He stresses that nothing but the best posing, lighting and post-capture enhancements will do. The finished image should take the groom's breath away.

This portrait of the bride, called *A Simple Statement of Love*, was made on her wedding day in the hallway of the country club. David came in for a tight shot with his Canon D60 digital camera and 28–135mm zoom lens. He photographed the bride at 100 ISO at the largest JPEG file format setting.

David says he does not photograph in RAW mode because his memory cards hold too few files in this mode, and he would rather not spend the time in post-capture manipulation. He believes that with the correct exposure and white balance, he will get a printable proof file right out of the camera.

To make the bride's slightly narrow face appear more oval in the portrait, David portrayed her in a two-thirds view. He brought the flowers just up to her lips, but did not cover them. Because he wanted her eyes to photograph as large as possible, he did not want her to smile. He positioned her eyes a third down from the top of the composition and her lips a third up from the bottom.

The bride was lit with a Bogen monolight at low power into a Larson 27-inch softbox with a silver reflector positioned to the right of the camera. A barebulb Quantum Q-flash illuminated her veil and gave the bride a nice separation from the background. He synched both strobes to the camera with a Quantum radio link.

The post-capture manipulation on the image was performed using Photoshop and involved cropping, normal portrait retouching, and burning in the bottom of the print.
—*Harvey Goldstein*

INGREDIENTS

Camera: Canon D60 with 28–135mm zoom lens
Lighting: Bogen monolight at low power into a Larson 27-inch softbox with silver reflector, barebulb Quantum Q-flash
Sync: Quantum Radio Link
Software: Adobe Photoshop

Charles Maring's Wedding Dance

According to Charles Maring, one of his most challenging images is one he took at a wedding in 2002. During the couple's first dance, Charles decided to step outside. He saw that there was enough illumination to capture the couple without using a flash. So Charles stepped outside and waited in the rain. The couple danced back and forth, but rarely in the center of the windows.

Charles says, "I kept thinking of the moments I was missing inside, but my heart told me just to be patient. Then suddenly it happened. The couple moved towards the center of the dance floor and I was able to make two exposures, one vertical, the second horizontal."

As Charles puts it, "Stepping outside of your own comfort zone to make unique photographs that the couple expects to see can sometimes be magical." Waiting for this special image to emerge was worth it. The final exposure was made at ⅛ second at f/2.8 handheld and the results were tack sharp.

Charles and Jennifer Maring are two of the world's leading experts on the subject of digital wedding photography. Their digitally mastered images are changing the face of wedding photojournalism by imbuing it with a more artistic vision. Although photojournalistic in style, their designer photographs convey the feeling of the moment with a cinematic mood that expresses a formal message.

Being on the cutting edge of digital photography has given the Marings a distinct quality that is clearly visible. The Marings have been capturing their photographs with digital cameras for nine years, and they credit their early start in the digital arena as a major reason for attaining some of the industry's highest awards. The Marings further enhance their clients' wedding experience by designing and printing the wedding albums in house. They own R-lab, a high-end digital lab that services their needs and other discriminating pros nationwide.
—*Harvey Goldstein*

INGREDIENTS
Camera: Nikon D1X
Lens: AF Nikkor 17–35mm f/2.8
Exposure: ⅛ second at f/2.8, handheld
Garnish: Patience, instinct and the willingness to take an educated risk

Dennis Orchard: Recreating Spontaneity

Although I run my business from a studio in central London, it is rare for me to accept a commission for a wedding in the city. Rather than fighting through city traffic, I would much prefer to photograph an event at a country church followed by a manor-house reception.

Emily and Steve, however, were very persuasive when they asked me to cover their wedding at St. Bride's church, followed by a reception at the famous Ivy Restaurant in Covent Garden. They are both journalists and chose St. Bride's because it is regarded as the spiritual home for journalists and the media. Many famous historical writers and photographers have plaques commemorating their lives set within the walls of the church.

I knew the family quite well, and they were aware of my relaxed style of photography. We had arranged a fifteen-minute slot in the day to cover the formals, but the rest of the photo coverage was to be candid. In particular, they didn't wish to be kept waiting outside the church while I took endless family groups.

At one point I glanced down and realized I had chosen to stand directly in front of a plaque commemorating the life of Bert Hardy (1913–1995), a great British photojournalist, famous for his coverage of the London Blitz during the Second World War. His passion was people. This put me in a very creative frame of mind.

While outside watching the wedding guests, I noticed Emily's mother, Lindy, hugging her two boys. I saw the moment, but I was a good six feet away. By the time I had jumped onto a nearby bench to gain a higher viewpoint, Lindy had turned away, and the moment had passed.

One of the techniques I have tried to master in wedding photography is to memorize people's names. This is invaluable when trying to make things happen. I was able to quickly shout out, "Lindy, could you do that again for me?" She replied, "Certainly." Because only a couple of seconds had passed, the spontaneity of the hug was still there. I just took one exposure, and I knew I had captured something special.

Back in the studio I opened Photoshop and added a sepia tone plus a little Radial Blur to the background. Apart from that, *My Two Boys* is a full frame-image. It went on to win Photojournalism Print of the Year at the WPPI convention in 2002.

INGREDIENTS
Camera: Canon Digital D60
Lens: Canon EOS 28–70mm f/2.8 L-series
Software: Adobe Photoshop with Radial Blur on background

Parker Pfister: The Wait

According to acclaimed fine art wedding photographer Parker Pfister, "One of the greatest things about being a wedding photographer is constant change. Each wedding brings new souls, new environments, new light, and new challenges.

"When I walked into this amazing hall, my eyes went right to the spiral staircase and the tall French doors leading to the iron balcony overlooking the downtown area. My heart, however, went to this concave glass-block wall in the corner of the back of the room that was filled with spare tables and chairs. The light was reflecting off of a building across the street and coming through the glass, creating a perfect lighting condition.

"After quickly dragging the tables and chairs out of the area, I asked the bride to walk into the light. She threw her arms up and then quickly dropped them to leave the veil suspended.

"No additional lighting or reflectors were needed as the glass wall wrapped around to the back of her dress. This image was photographed in color, which I later converted to black & white in Adobe Photoshop using a Channel Mixer technique. I then gave it a subtle brown tone by creating a new adjustment layer and selecting Hue/Saturation. In the Hue/Saturation dialog box, I selected the Colorize option and then adjusted the saturation and hue to create the precise overall tonality of the image with great subtlety. All that was left to do was to create a vignette and a softening of the edges.

"This image was printed on Legion Somerset watercolor paper with an Epson 2200 printer."

Parker has found his home in the world of fine-art photography. His style has been described as "journalistic portraiture"; it's not quite photojournalism and not quite portraiture, but somewhere in between.

In his words, "Most of all, I make it fun for everyone. No posing, we just have fun—we laugh, jump, whatever it takes. And the couples always say, 'We had a blast!'"

To see more of Parker Pfister's work, including his non-wedding images, visit his web site: www.pfisterphoto-art.com. —*Harvey Goldstein*

INGREDIENTS
Camera: Nikon D100
Lens: Sigma 20mm f/1.8
Exposure: 1/20 second at f/4, 200 ISO
Computer: Apple G4 with Adobe Photoshop
Printer: Epson 2200 with Legion Somerset paper

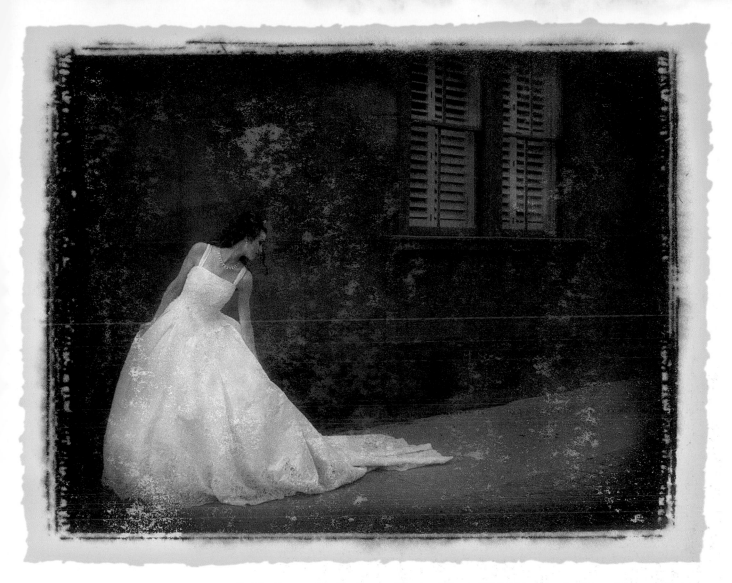

A Unique Collaboration: Ken Sklute and Jonathan Penney

Ken Sklute of Tempe, Arizona, created the original photograph (right) using a Canon A1 with a 35–105mm lens at ⅟₆₀ second at f/16 with yellow filter. He then sent the negative to master printmaker Jonathan Penney of Center Moriches, New York, to create the final image. After consulting with Ken, Jonathan suggested going for a look that would replicate a Polaroid transfer image. Jonathan scanned the negative in grayscale mode on an Imacon Photo Flextight scanner, brought the scanned image into Photoshop, adjusted for contrast and density using Levels, then converted to the image to RGB. Adjusting the red and blue channels in Curves to the desired color produced the "split-tone" effect (warm-toned highlights; cool-toned shadows). The

INGREDIENTS
Camera: Canon A1
Lens: 35–105mm
Exposure: ⅟₆₀ second at
 f/16 with yellow filter
Film: Kodak high-speed
 infrared film
Scanner: Imacon Photo
 Flextight
Software: Adobe Photoshop,
 Auto FX PhotoGraphic
 Edges

border effect is from the Auto FX PhotoGraphic Edges collection, a Photoshop plug-in. Final adjustments included sizing and sharpening with Unsharp Mask. The resulting image was output on Somerset Enhanced watercolor paper using an Epson 9600 printer. —*Harvey Goldstein*

Paul Thompson: Don't Be Afraid to Direct

During the 1980s, all of my wedding photographs were formal, elegant, and very romantic—yet mostly posed. The images looked like they could be on greeting cards (and many were). Through the 1990s, photojournalism was the norm, and my style was more documentary.

Today, I still use my entire arsenal of posing, speed, and creativity, but I have added some direction. Posing is not popular today, but brides and grooms must still be photographed looking their best. Incredible moments don't always happen; however, it is my responsibility to grab the emotion surrounding me on the day of the wedding. If a soul-baring moment is happening—say, the bride is looking lovingly at the groom—and I cannot capture it because he has his back to me, I simply say, "Look here."

I don't pose or move the couple or take a lot of time with them, I just get their attention. My philosophy is to try and capture emotional photographs. If I can do it as a candid photographer or photojournalist, I will. If I have to place and pose someone, I will. If I have to capture that incredible photograph with a little direction, I will.

There is one word that has guided my career: enthusiasm. Photography is my obsession. The more education that I receive, the more passion I have. Today, new ideas, new equipment, new books and new styles are making this time the most exciting of my career.

This image was originally a digital color file. I desaturated it in Photoshop, then added a different color to the flowers than they were originally. I made several layers and painted on the flowers, then switched the blending mode of each layer from Normal to Color and reduced the opacity.

The most important aspect of this image is emotion. I could have posed the couple and made it look a little different, yet because I didn't want to lose the spontaneity, I chose to direct them and capture the impact of emotion that was exploding. They were having fun—and with a little direction, I was lucky enough to capture an incredible expression.

INGREDIENTS
Camera: Canon EOS 10D
Lens: EOS 70–200mm f/2.8
Strobe: Canon 550-EX
Flash Output: ¼ power for a wink of light in the shadows
Exposure: $\frac{1}{15}$ or $\frac{1}{30}$ at f/2.8
Computer and Software: Apple Power Mac G4 with Adobe Photoshop

Alisha and Brook Todd share a passion for art in their blend of documentary and fine-art photography, and they are fast becoming known for their elite brand of wedding photojournalism. They feel that every wedding is a spectacular, momentous occasion—mere snapshots cannot do it justice, and large-format photographs are often too formal and posed. It's their combined perspective that allows them to comprehensively and personally record the events of the day.

Most of the couple's work takes place in San Francisco, Napa Valley, and Carmel, but they also travel for events both nationally and internationally, and their work has been published extensively in numerous books and magazines.

One of their recent notable images was taken near a beautiful vineyard. Alisha remembers, "The bride and groom did not want to see each other before the wedding. This gave us a chance to photograph most of the traditional wedding party and make family group pictures first. But the ceremony was near sundown, so as soon as it ended we had to work furiously to finish photographing the wedding party and take the family shots before the light disappeared. Unfortunately, that left us with virtually no light for the bride and groom photography.

"We took a few shots in the vineyard using flash, but the lighting was too hard, and we weren't satisfied. We wanted more images but didn't want to continue using flash. Then we saw the large reception tent and realized what we needed to do.

"After the toasts, when the guests had begun eating, we pulled the bride and groom aside. There were bright lights in

INGREDIENTS
Camera: Canon EOS-3
Lens: Canon 85mm, f/1.2L
Film: Kodak T-MAX P3200
Film Speed: E.I. 1600

each corner of the tent, and the lighting that reflected off the tent interior was beautifully soft. But there was a background of hundreds of people, so we had the groom sit in a chair and the bride sat on his lap. We then stood on another chair so we could shoot down. We asked them to put their faces close together. With careful composi-

tion and the lens wide open, we were able to just crop in on the couple.

"They were really very affectionate, and it shows. We got a series of beautiful images that are some of this couple's very favorite shots from the wedding—and ours as well. It's funny to think how they were just a few feet in front of all the tables full of guests."

To find out more about Alisha and Brook Todd, or to see their work, check out www.fineartweddings.com. —*Bob Rose*

Robert T. Williams: *The Bride & Groom Borrowed a '57 T-Bird*

For nine years, Robert T. Williams was the East Coast's best-kept secret. No longer is this true. The Mississippi native's think-outside-the-box approach to photography has made him a highly sought-after wedding photojournalist. This self-taught lensman skillfully uses the camera to unobtrusively capture the personality, style and exuberance of his clients on their special day. Williams has shot weddings in Palm Beach, New York, Philadelphia, Houston, the Bahamas, Mexico, Rhode Island, and San Francisco, among other places. For the past two years in a row, he was named one of the region's top wedding photographers—an honor bestowed upon him by his peers.

For this wedding, Williams knew the bride and groom borrowed a 1957 T-Bird from a friend to drive just a couple of miles from the church to the reception. He recalls, "They made it clear that it was important for me to somehow capture them driving this classic car. At the time, I had no idea how I was going to do this, but the night before the wedding I made my plans.

"After the ceremony, while the bride and groom were in the car saying their goodbyes, I drove ahead to locate a spot to catch them en route. They had to pass through a roundabout, and I thought this would be the perfect spot.

"First problem: There was nowhere for me to park my car in this area. So I pretended to have car trouble, put my flashers on, and left it the center of the road blocking one of the three lanes. I grabbed one camera and stood in the middle of the circle waiting for them to come around. As I spotted their car about to enter the roundabout, they also spotted me because my car was causing a problem by blocking traffic.

"Second problem: Something told me to look at my camera. When I did, I saw I only had one shot left on the roll with no time to change or get another camera. I took a deep breath and said to myself, 'Let's make this one shot count.' As they got closer they both waved over the top of the front windshield. While holding the camera to my eye I said to myself, 'Not yet.' When they were beside me, the groom looked over and waved again. And again I said, 'Not yet.' As they passed me the bride leaned back one final time and waved, and I took the shot!

"When I told them the story, they said it was perfect! And so is the image."

Visit Robert at www.rtwphoto.com. —*Bob Rose*

INGREDIENTS
Camera: Canon EOS-1N
Lens: Canon 70–200mm
f/2.8 L Zoom
Film: Kodak T-MAX 400

Yervant Zanazanian: *Poppy*

Yervant Zanazanian is based in Melbourne, Australia, but travels extensively, catering to the high-end wedding market throughout Asia and the U.S. He pioneered the introduction of digital imaging and design to professional wedding photography in Australia and helped establish the popular magazine-style wedding album.

He says, "I have been in the wedding photography business for over twenty years now and I love it unconditionally. I love the challenge of spontaneity where I have to be a fashion, landscape, portrait, and journalistic photographer at any given moment with no second chances. I love the real-life capture. And for this reason, I never plan my shots at any time; I let it all happen and just react to the moment. This is why I work mainly with available light. I do not have a lot of gear around, just my camera and me. I believe if the couple feels less intimidated, I will capture a more relaxed and comfortable expression and get the best out of them."

Yervant really enjoyed the way this beautiful and elegant bride, named Poppy, played so well to his camera. He remembers, "This image was shot with available light on a windy and overcast day in Melbourne. Poppy's veil was a very light silk and kept flying in the wind while she had fun under it with her bridesmaids. After a few moments of action and several amazing images, I knew I had the shot."

"Although I shoot very much unplanned, with every wedding I personally choose a few images that I work on, even before showing any proofs to the couple. These are my 'signature' images where I see that extra finishing will make a great image even greater. I like to use these shots as features in the album story, and I usually like to keep them for my personal collection."

INGREDIENTS
Camera: Canon EOS-1Ds
Lens: Canon 24–70mm f/2.8 L Zoom
Software: Adobe Photoshop

In this case, he finished the image in Photoshop by applying some motion blur and coloring the background to direct the viewer's attention. Yervant's recipe: "In Photoshop, I copied sections of the image to make a new layer: the veil. Then I added Motion Blur in the direction of the veil's natural flow to boost the sense of moment. Next, I selected a section of the background and applied the purple hue to separate the background from my main subject and bring all possible viewer attention to the core of the subject. I chose purple as I felt it suited the image and also the feel of the day—it also brought an elegance to the overall look. After I flattened the image, I added a bit of noise to make the image grainy to suit my personal taste."

Visit Yervant at www.yervant.com and check out his Page Gallery software and Photoshop actions. —*Bob Rose*

Joe Buissink: *Between Two Walls*

When one closely examines this image, it is easy to see why Joe Buissink was chosen to shoot the weddings of Kelsey Grammer, Jennifer Lopez, and Barry Bonds. He has also photographed President Bill Clinton and Martha Stewart.

INGREDIENTS
Camera: Nikon D2H
Lens: 17–35mm f/2.8D ED-IF AF-S Zoom-Nikkor at 22mm setting
Light: Available, outdoor
Exposure: 1/200 second at f/7, 400 ISO

Asked to describe the events surrounding the creation of his semi-surreal photograph, *Between Two Walls*, Buissink's reply encompassed more than just photographic technique.

"*Between Two Walls*, was taken in San Miguel de Allende, Mexico, in 2004," Buissink explained, "where I went to cover a wedding for *Grace Ormonde Wedding Style* magazine.

"On the day of the wedding, the bride and groom were about to walk down a set of stairs between two blue walls on their way to the ceremony on the beach. When I called out their names, they both looked at me, and—click—it became a vertical full-page shot.

"As I was climbing up the stairs to leave, something compelled me to look over my shoulder at the couple as they descended the stairs. What I saw was this image of the bride between the walls."

The groom had left before his bride, and this was the last glimpse Buissink caught before she disappeared.

Buissink used only available light, and he had the camera set to Program mode. The camera's metering system was set to Matrix mode. "There was nothing difficult about capturing this image," Buissink says, "and nothing in this image was altered.

"I think some photographers spend their entire career trying to create the perfect picture, but I believe the perfect picture does not exist. What does exist is the perfect moment, and there are many perfect moments."

Buissink went on to explain that he feels his cameras are extensions of his hand, heart, and eyes—and he utilizes them as a painter would utilize brushes. He uses his 70–200mm f/2.8 lens as a fine brush, his 17–35mm f/2.8 as a broad brush, and his 28–70mm f/2.8 as a medium brush.

"I am lucky," Buissink says. "As a photographer, I begin with a full canvas. I merely look for the parts of the canvas I wish to record.

"When I shoot a wedding, I am honored to be given the chance to capture this most special day. I try to preserve the perfect moments that will not only bring back memories, but feelings—moments crystallized in time." —*Larry Singer*

Hanson Fong: *Nighttime Silhouette*

This low-key evening photograph was taken by Hanson Fong using the Golden Gate bridge as a background. Fong says, "This setting was chosen because this is where the groom proposed to the bride. One of the most important elements in a photograph is the setting. It establishes time and place and sets the mood and theme of the photograph. The design and placement of the subject within this setting will then determine the impact of the image.

"This photograph has several design elements that create an impact. There is diagonal movement within the photograph; the bridge starts on the left side of the picture and stops with the couple at the other end. If the couple were placed anywhere else in the frame, the flowing lines in the photograph would have been broken. All photographs have leading lines, and it is the bridging of the elements with the subject that makes or breaks the photograph's composition.

"I had to wait until it was almost completely dark," Fong adds, "to capture the dark-blue color of the sky and for the Golden Gate bridge to glow."

For this picture, Fong chose a Kodak DCS Pro SLR/c digital camera, with its 4536x3024-pixel, 12-bit CMOS sensor that covers the same 24x36mm image area as 35mm film frame.

For added drama, Fong set his aperture at f/22 to get the bridge and the couple in focus, and used a shutter speed of ten seconds. A Lumedyne remote flash and a cordless PocketWizard were used to rimlight the couple.

The image was captured on a SanDisk Extreme CF card, which delivers a minimum write speed of 9MB/second and a minimum read speed of 10MB/second. Fong finds that this high speed is critical when shooting large numbers of high-resolution images and transferring them to a computer.

For more, visit Hanson Fong's web site at www.hanson fong.com. —*Larry Singer*

INGREDIENTS
Camera: Kodak DCS Pro SLR/c digital
Lens: Canon 24–70mm f/2.8 zoom
Lighting: Lumedyne remote flash
Other: PocketWizard, Sekonic 508, Titan Cullmann CT 100 tripod, SanDisk Extreme CompactFlash card

Curt Littlecott: *Mark and Victoria*

Orlando-based wedding photographer Curt Littlecott skillfully weaves the art of photojournalism into his style of shooting nuptials. He considers wedding photographers the Green Berets of the industry. "We are trained to get in and out of hostile environments (churches) quickly, while avoiding friendly fire (Uncle Bob with a Canon Digital Rebel)."

For this featured photograph, *Mark and Victoria*, Littlecott placed the white and brown electric guitar prominently in the foreground for a very logical reason. "The picture was taken at the wedding reception of rock guitarist Mark Tremonti and his bride, Victoria," Curt recalls, "Throughout the day I found myself in awe of Mark's great life. As the guitarist and songwriter for the rock band Creed, Mark had everything I could dream of that exemplified the jet-set lifestyle: a beautiful home surrounded by Grammies and MTV awards, and now a gorgeous wife.

"I was so wrapped up in the fact that I was surrounded by celebrities and so many beautiful people to capture on film that I didn't realize an important person, his mother, was missing from the festivities.

"The reception took place at a country club famous among local photographers for its difficult lighting issues with highly reflective windows and large mirrors on nearly every wall.

"During the toasts, Mark was given the guitar as a gift, and my attention was centered on lighting both the guitar and the couple evenly, while trying to avoid showing my reflection in the glass behind them. I had placed a monolight in the corner of the hall, and the light was bounced off the white ceiling, which perfectly illuminated the scene.

"Once I had the shot, I heard Mark's father saying, 'As all of you know, Mark's mom, my wife and best friend of 41 years, passed away a couple of months ago. She was the most protective and wonderful mom you could run across.'"

Curt continues, "This moment, which I captured on film, is especially poignant because Mark's mother had been ill for quite some time, and the symptoms of her affliction had erased many of her current memories.

"Seconds after I took this picture, Mark's father told the wedding guests that two days before she passed away, when she was still able to speak, the last thing she told him was, 'Protect my babies.' I can't think of anything that could be more a sign of love than this last wish.

"I then looked up at my friend, celebrity videographer Jeff Stoner, and we were speechless. None of the material things we had envied all day seemed important after that toast. I'm certain Mark would have traded them all for another day with his mom. At that point," Curt says, "I realized how lucky I am to be able to observe and record these great moments in time. I wouldn't change my job for anything."
—*Larry Singer*

INGREDIENTS
Camera: Nikon D1X
Lens: 28mm f/2.8D AF Nikkor
Flash: Photogenic 1250 bounced off ceiling
Exposure: 1/15 second at f/4.0, 400 ISO
Format: High-resolution JPEG

This image by Ryan Schembri, son of Martin Schembri, was shot at a wedding in Sydney. "It was a big wedding," Ryan says, "with a lot going on during the day, including a bridal party of ten and some inclement weather.

"I like to ask the couple for descriptive words about how they want to see their wedding photography produced. Before this wedding, the bride told me they were a contemporary couple that loved the natural way of shooting, but they were having a traditional Italian wedding. With that in mind, we headed into the city to an area that has a great mix of architecture—a cityscape with granite walls, stainless steel doors and sandstone buildings.

"After the more traditional shots with the bridal party, I took the bride and groom to this location. As we walked down the street, the light had just fallen behind a nearby building and was reflecting off a glass building up the road, creating a glow.

"This image was composed to get the naturalistic look the bride wanted. I told the bride and groom to walk along the edge of the buildings, talking and kissing as they went. I found myself shouting at them from a hundred meters away, 'Kiss now! Kiss now!'

"The image was finalized in Photoshop. The first step was color correction. I then added an overall vignette. I played with the Levels to create more depth in the background and slightly highlighted the statues protruding from the wall. A much tighter vignette was then placed around the couple. I also added a minimal diffuse glow for a little bit a grain and a blur to give the print that soft, painterly quality. My final step was to adjust the overall tonality of the image. I wanted it to have a very rich, but not vibrant, color saturation.

"I love the feeling, tone, and expression of love from the bride and groom—and the love they feel for the image!" —*Larry Singer*

INGREDIENTS
Camera: Nikon D100
Lens: Nikkor 70–200mm f/2.8G ED-IF AF-S VR Zoom
Format: JPEG, High
Exposure: 1/60 second at f/5.6
Lighting: Available
Software: Adobe Photoshop

CONTRIBUTORS

Suzette Allen of Sacramento, California, is a professional portrait photographer and instructor best known for her digital composites and Photoshop expertise. Suzette has received the Fuji Masterpiece Award, Commercial Photographer of the Year in California and many other awards for her unique images. (www.suzetteallen.com)

Don Ayotte began his career doing photographic reconnaissance with the U.S. Air Force. After attending Brooks Institute, he operated a studio for 20 years. He then worked at Rhode Island School of Photography before joining Hallmark Institute. He was inducted into the Photography Hall of Fame in 1988. (www.hallmark.edu)

David Bentley owns and operates Bentley Studio, Ltd. in Frontenac, Missouri, with his wife, Susan. With David's background in engineering, he calls upon a systematic as well as creative approach to each of his assignments. Thirty years of experience and numerous awards speak to the success of the system. (www.bentleystudio.com)

Jen Bidner is an editor, author, Internet content manager, public relations professional and photographer. She is the author of many books on conventional and digital photography, including the top-selling *Lighting Cookbook: Foolproof Recipes for Perfect Glamour, Portrait, Still Life, and Corporate Photographs* (Amphoto, 2003).

Randy Brister owns RSBphoto, which exclusively photographs youth and high-school sports and presently photographs over 25,000 young athletes each year. Randy authored a manual on action photography, called *Capture the Action Market,* and has written numerous articles on sports photography and marketing. (www.rsbphoto.com)

Joe Buissink is an internationally recognized wedding photographer from Beverly Hills, California. His images appear widely in bridal magazines and he has photographed many celebrity weddings, including Christina Aguilera's 2005 wedding. He is a Grand Award winner in WPPI print competition. (www.joebuissink.com)

Jake Butler graduated from Brooks Institute in 2004. His fine art landscape images and writing have been published internationally in books and magazines and have won international awards. He is also a professional motion-picture camera operator as well as a part owner of a production company/post-production facility.

Michael Campbell is an freelance photographer based in San Diego. He specializes in digital portraiture as well as landscape and digital fine art prints. He has been a professor of photography in California and in England. He first came to the U.S. from London to visit and interview Ansel Adams in Carmel. (www.michaelcampbell.com)

NyxoLyno Cangemi is a public affairs specialist with the U.S. Coast Guard. Cangemi's work during Hurricane Ivan earned him the Coast Guard's JOC Alex Haley award in photojournalism for 2005. Cangemi's work has appeared in the *The Washington Post, The Los Angeles Times,* and *The Chicago Tribune.* (www.nyxcangemi.com)

Bambi Cantrell is a wedding and portrait photographer based in Pleasant Hill, California. Her images have appeared in *Martha Stewart Living, American Photo, Time,* and *Ebony* magazine. She is author of the best-selling book *The Art of Wedding Photography* (Watson-Guptill Publications, 2000). (www.cantrellportrait.com)

Gigi Clark has a background in multimedia and instructional design. She brings her talents to her photography business, Rituals by Design, in Southern California. She has received numerous honors including several First Places in both PPA and WPPI competitions, as well as the Fujifilm New Approach Award. (www.ritualsphoto.com)

Mike Colón is celebrated wedding photojournalist from the San Diego, California, area. Colón's work reveals his love for people and his passion for celebrating life. His natural and fun approach frees his subjects to be themselves, revealing their true personalities and emotions. He has spoken before national audiences on the art of wedding photography. (www.mikecolon.com)

Ken Cook is a master photographer who has devoted the last 47 years of his life to perfecting his craft. He amassed over 225 merits before his retirement from the lecture circuit in 1979. Ken has lectured throughout the United States and in Canada, Germany and Austria. (www.cooksphotography.com)

Bleu Cotton runs Bleu Cotton Photography in Costa Mesa, California. His award-winning style of photography has been internally recognized. As a Master Craftsman of Photography, he has photographed many high profile clientele and shared his work, vision and talent with international organizations and schools. (www.bleucotton.com)

Jerry Courvoisier of Santa Fe Workshops in New Mexico is a photographer, educator, digital artist, and technology consultant. In addition, he has directed the Santa Fe Workshops' digital program for eleven years, building it into one of the most respected digital educational programs in the world. (www.sfworkshop.com)

Stephen Dantzig is a renowned lighting expert and author of *Lighting Techniques for Fashion and Glamour Photography* (Amherst Media, 2004). He has has written for magazines such as *Rangefinder* and *PC Photo.* Stephen runs a commercial photography business from Honolulu, Hawaii. (www.dantzigphotography.com)

Jim DiVitale of Atlanta, Georgia, has been a commercial advertising photographer and instructor for over 25 years. During the last twelve years, Jim has specialized in digital photography and computer photo illustration for ad agencies, design firms, and corporations nationwide. (www.divitalephoto.com)

Darton Drake has been a professional photographer since 1971 and degreed as a Master since 1994. He specializes in children, high-school senior, and family portraiture and operates Photography by Drake in Baraboo, Wisconsin. He is also a well known educator in the field of photography. (www.dartondrake.com)

Fuzzy and Shirley Duenkel operate a thriving portrait studio concentrating primarily on seniors. Fuzzy has been highly decorated by PPA in both national and regional competition. Fuzzy's custom senior portraits, created in and around his subjects' homes, allow and encourage an endless variety. (www.duenkel.com)

Joe Elario has owned a highly successful wedding and corporate photography studio in upstate New York for 25 years. Joe and his son are also photographers for the City of Albany Mayor's Office and serve the Special Events Department. Elario's work has appeared in *Studio Photography & Design* and *Rangefinder* magazines. (www.joeelariophotography.com)

Fernando Escovar is a Los Angeles-based commercial and advertising photographer. Recent shoots include Tom Green, Shaquille O'Neil, Patricia Heaton and Jon Bon Jovi. Fernando is releasing a Cool Photo Tips DVD series with *Car Photography, Shooting Swimwear* and *Aerial Action.* (www.fotographer.com)

Deborah Lynn Ferro often calls upon her background as a watercolor artist. She has studied with master photographers around the world and currently works with her husband, Rick Ferro, in Jackson-

ville, Florida. She is the coauthor of *Wedding Photography with Adobe Photoshop* (Amherst Media, 2003). (www.rickferro.com)

Hanson Fong is a highly acclaimed wedding, portrait and fine art photographer and instructor based out of San Francisco, California. As an award-winning photographer and instructor, Hanson is on the cutting edge of photography. (www.hansonfong.com)

Jennifer George-Walker was named California Photographer of the Year in 2001 and won the People's Choice Award 2001 at the Professional Photographers of California Convention. In 2003, she won the WPPI Premier category Grand Award. She has since won more awards and helped judge the competition. (www.jwalkerphotography.com)

Jerry Ghionis of XSiGHT Photography and Video started his career in 1994 and quickly established himself as one of Australia's leading photographers. He has won many awards including the AIPP Victorian Wedding Album of the Year and the WPPI Album Competition Grand Award. (www.xsight.com.au)

Harvey Goldstein from Branford, Connecticut, has been in the photographic industry for 30 years. He is a former studio owner and presently edits numerous association newsletters and magazines, as well as being a freelance writer.

Larry Hamill's clients include Battelle Memorial Institute, Chase Bank, Getty Images, Children's Hospital, Ohio Health and Columbus State Community College. Based in Columbus, Ohio, Larry also has extensive stock photography and is represented in Spain, Japan, India and Germany. (www.larryhamill.com)

Robert Hughes is located in Columbus, Ohio. He and his wife, Elaine, are the most awarded wedding specialists in Central Ohio. Robert invented the term "Introspective Wedding Commentator." According to Hughes, "First I observe reality for what it is, then for what else it is." (www.roberthughes.net)

Claude Jodoin has been involved in professional digital imaging since 1986 and has not used film since 1999. He is a consultant and educator for photographers and has taught at WPPI Conventions. (www.claudejodoin.com)

Tim Kelly of Lake Mary, Florida, holds Master of Photography and Photographic Craftsman degrees and has amassed numerous awards. In 2001, he was awarded a fellowship in the American Society of Photographers and was named to the prestigious Cameracraftsmen of America. (www.timkellyportraits.com)

Craig Kienast of Clear Lake, Iowa, has been involved in photography since 1985. With the advent of digital, he began to stand out in his field. He has won numerous awards and his prints have been accepted to the PPA Loan Collection. Craig's abundant artistic talent shows in his portrait work. (www.photock.com)

Julieanne Kost serves as Senior Digital Imaging Evangelist at Adobe Systems. She is a frequent contributor to several publications, a speaker at conferences and tradeshows, and a teacher at distinguished photography workshops and fine art schools around the world. (www.adobeevangelists.com)

Robert L. Kunesh began his career photographing weddings for a studio in Cleveland. He has since received numerous awards including a Kodak Gallery Award, three PPA Loan Images, and WPPI's Accolade of Outstanding Achievement, as well as a Master of Photography degree. (www.studiokphoto.com)

Christian Lalonde is a principal photographer at Photolux Commercial Studio in Ottawa, Canada. His work has been highlighted in several international trade magazines and publications. In addition, he was named Canadian Commercial Photographer of the Year in 2001 and in 2002 by the PPOC. (www.photoluxstudio.com)

Robert Lino of Miami, Florida, specializes in fine portraiture and social events. His photographic style is formal and elegant; he excels in posing, and the ability to capture feeling and emotion in every image. Lino is a highly decorated photographer in national print competitions and is a regular on the workshop and seminar circuit. (www.robertlino.com)

Curt Littlecott left London in 1987 to see the world and settled in Florida to pursue his passion for photography. Today he has a busy three-story studio in downtown Orlando, specializing in fashion and fashionable weddings. He has received numerous awards for his unique style. (www.nuvisionsinphotography.com)

Oscar Lozoya's images are exhibited internationally, and his work is represented in the United States by the Andrew Smith Gallery in Santa Fe and in Latin America by Dr. Enrique Cortazar of The National Fine Arts Institute of Mexico. He is the author of *The Art of Black & White Portrait Photography* (Amherst Media, 2002). (www.lozoya.com)

Roy and Deborah Madearis operate Madearis Studio in Dallas, Texas. Roy has received numerous awards for his work, including the TPPA's (Texas Professional Photographers Association) National Award. In addition to being a decorated photographer, Roy is a respected mentor and lecturer. (www.madearis.com)

Scott Mansfield is a fine-art landscape photographer. His approach to photography is a dichotomy of preconceived images and chance encounters. Scott graduated from Brooks Institute in 2004 and resides in Salt Lake City, Utah, with his wife Sara. (www.scottmansfield.com)

Charles and Jennifer Maring own Maring Photography Inc. in Wallingford, Connecticut. They have won and judged in WPPI Awards of Excellence Competitions. Charles's parents operate Rlab (resolutionlab.com), a digital lab that does work for the Maring Photography and others needing high-end digital work. (www.maringphoto.com)

Gene Martin studied photography in college but spent the next 15 years as a professional guitar player. In the early 1980s, he returned to photography and has since earned numerous awards; his work has been featured in *Professional Photographer, Studio Photography & Design* and *Rangefinder*. (www.genemartinphotography.com)

Cliff Mautner is a former photojournalist for the *Philadelphia Inquirer* turned wedding photographer. He has spoken at a WPPI convention. With over 22 years of experience, his images have appeared in such publications as *Modern Bride, Elegant Wedding* and *The Knot*. (www.cmphotography.com)

William S. McIntosh has established himself as a skilled artisan and gifted teacher and speaker during his past 50 years of producing portraiture. His clients include the Joint Chiefs of Staff and numerous judges and dignitaries. His portraits and presentations are in high demand worldwide. (www.portraitsbymcintosh.com)

Mercury Megaloudis is an award-winning Australian photographer and the owner of Megagraphics Photography. The AIPP awarded him the Master of Photography degree in 1999. He has won awards all over Australia and has recently begun entering and winning print competitions in the United States. (www.mega.com.au)

Todd Morrison is the owner of Morrison Photography near Nashville, Tennessee. He specializes in fine portraits of infants and children, and his other experience includes commercial, editorial and stock photography. Todd also teaches advanced Photoshop for portrait photographers. (www.morrisonphotography.com)

Mateo Muñoz began his career working with other photographers in Mexico City, and the experiences gained during this part of his life developed his interest in visual communication. In 2002 Mateo moved to the United States to study photography. He currently specializes in advertising photography. (www.mattimages.com)

Chuck Nacke's images have appeared in *Newsweek, Time* and *U.S. News and World Report*. He has also photographed for large U.S. and European companies and universities, and has been recognized for his editorial photography. He currently works in San Jose, California. (www.chucknacke.com)

Robert Neubert is a communication consultant who provides strategic PR and marketing programs for clients throughout North America. He has contributed to dozens of publications, from *Rolling Stone* to *Sports Illustrated,* and has had articles published on photographers such as Brett Weston and Susan Middleton. (www.neubs.com)

Dennis Orchard is an award-winning photographer from Great Britain. He has been a speaker and an award winner at WPPI conventions and print competitions. He is a member of the British Guild of portrait and wedding photographers. He has been awarded U.K. Wedding Photographer of the Year. (www.dennisorchard.com)

Jonathan Penney is a Master Printmaker and the owner of Jonathan Penney, Inc., located Center Moriches, New York, a specialty lab providing high-end digital printmaking services with creative vision to wedding and portrait photographers all across the country. (www.jonathanpenney.com)

Larry Peters is one of the most successful and award-winning teen and senior photographers in the nation. He operates three studios in Ohio and is the author of *Senior Portraits* (Studio Press, 1987) and *Contemporary Photography* (Marathon Press, 1995). His award-winning website is loaded with information. (www.petersphotography.com)

Parker Pfister has won numerous awards for his unique style of photography; in addition, his work has been featured in magazines such as *Modern Bride* and *Today's Bride*. He has been an acclaimed speaker at the WPPI Convention. He is currently based in Cincinnati, Ohio. (www.pfisterphoto-art.com)

Norman Phillips holds the WPPI Accolade of Outstanding Photographic Achievement and is a registered Master Photographer with Britain's Master Photographers Association. He is a frequent contributor to photographic publications, a print judge, and a guest speaker at seminars across the country. (www.normanphillipsoflondon.com)

Luke Pinneo is an active-duty photographer for the U.S. Coast Guard who has captured countless action- and emotion-filled scenes, including portions of the Coast Guard's response following Hurricane Katrina. Pinneo continues to build upon fundamentals while developing his own style of artistic expression.

Fran Reisner is a national award-winning photographer from Frisco, Texas. She is a Brooks Institute graduate and has been Dallas Photographer of the year twice. She runs a successful portrait/wedding business from the studio she designed on her residential property and has won numerous awards for her photography. (www.franreisner.com)

Patrick Rice is a popular author, lecturer, and judge. He has won numerous awards, including the International Photographic Council's International Wedding Photographer of the Year Award, presented at the United Nations. He has written several books on wedding, portrait and infrared photography for Amherst Media. (www.ricephoto.com)

Jim Rode photographs weddings and high-school sports, creating watercolor art of the images he captures. He is president of the Trinity Writers Workshop and a member of the National Society of Newspaper Columnists. He received the Monte Zucker Award for Photographic Excellence. (www.fridaynightart.com)

Ralph Romaguera and his sons, Ryan and Ralph Jr., operate three successful senior and teen studios in the greater New Orleans area. Ralph has been profiled in *Rangefinder* magazine and has been a speaker at past educational events and conventions. (www.romaguera.com)

Bob Rose joined the photo industry in 1978 after graduating from RIT. He has been a contributor to a number of publications including the *Focal Encyclopedia of Photography* (Focal Press) and has taught a Parsons School of Design. In 1999 he formed his own company, VMI. He can be reached at: vmi-info@earthlink.net.

Jacob Rushing graduated from the Brooks Institute of Photography in Santa Barbara, California, in 2005. He has since studied under fashion photographer and 2005 Hasselblad Master Tarun Khiwal in New Delhi, India. He currently works as a commercial photographer and digital retoucher in Los Angeles and San Francisco. (www.jacobrushing.com)

Martin Schembri has achieved a Double Master of Photography with the Australian Institute of Professional Photography. He is an internationally recognized portrait, wedding and commercial photographer and has conducted seminars on his unique style of creative photography all over the world. (www.martinschembri.com.au)

Ryan Schembri has grown up in the world of wedding photography, working with his dad, Martin Schembri, since the age of 12. At 20, he became the youngest Master of Photography with the Australian Institute of Professional Photographers. He since earned other distinctions and spoken at numerous seminars. (www.martinschembri.com.au)

Rainer W. Schlegelmilch saw his first race in 1962, when he photographed a series of portraits at the Nürburgring road racing circuit. Eighteen months later he opened his own studio in Frankfurt, Germany. He has photographed for numerous motorsport publications, including *Powerslide, Auto, Motor und Sport* and *Road and Track*.

James Schmelzer studied at West Coast School and Winona School. He received his Master Craftsman degree from PPA and Accolade of Photographic Mastery from WPPI. As technical rep for the FJ Westcott Company, he helps develop light control products. His Michigan studio specializes in seniors and weddings. (www.elitefoto.com)

Brian and Judith Shindle own Creative Moments Photography and the Shindle Gallery in Westerville, Ohio. Brian's images have been published extensively in books and magazines for over 20 years. He has earned numerous honors and awards, including Fuji awards and PPA's Masters Loan Collection. (www.shindleweddings.com)

Marilyn Sholin is an acclaimed photographer, speaker and consultant based out of Miami, Florida. She is the author of *Studio Portrait Photography of Babies and Children* (Amherst Media, 2002). She is best known for her digitally enhanced children's portraits using Adobe Photoshop and Corel Painter. (www.marilynsholin.com)

Louise and Joseph Simone met many years ago while working at a photo studio in Montreal. In 1975 they opened their photography studio and have since been recognized by numerous awards. They have taught seminars around the world as Eastman Kodak Pro Mentors. (www.simoneportrait.com)

Larry Singer is a professional writer and photographer for the *Daily Journal* and *Daily Messenger* newspapers in Seneca, South Carolina. He is also a long-time contributor to *Rangefinder* magazine. Some of his award-winning images can be seen at homepage .mac.com/larrysinger. His newspaper photographs can also be seen at www.dailyjm.com.

Peter Skinner's magazine articles and photography have been published internationally and he has co-authored or edited numerous publications and books including the fifth and sixth editions of the authoritative *ASMP Professional Business Practices in Photography* (Allworth Press, 2001). He can be reached at: prsskinner@bigpond.com.

Ken Sklute began his wedding photography career at 16 in Long Island, New York, and quickly advanced to shooting 150 weddings per year. Today he enjoys a thriving business at his Arizona studio. He

as earned numerous Fuji Masterpiece and Kodak Gallery Awards. (www.kensklute.com)

Matthew Jordan Smith is a celebrated photographer and the author of *Sepia Dreams: A Celebration of Black Achievement Through Words and Images* (St. Martin's Press, 2001). Matthew is also an accomplished teacher, speaker and volunteer who currently resides in New York and Los Angeles. (www.matthewjordansmith.com)

Jeremy Sutton is a former faculty member of the Academy of Art College and the author of four books, including *Painter IX Creativity: Digital Artist's Handbook* (Focal Press, 2005). His artwork is numerous private collections and has been exhibited in museums and galleries. (www.jeremysutton.com)

Tony Sweet is a professional nature and fine art photographer and the author of *Fine Art Nature Photography* (Stackpole Books, 2002) and *Fine Art Flower Photography* (Stackpole Books, 2005). His work is represented by Getty, Panstock, ChromaZone and Rubberball stock agencies. (www.tonysweet.com)

Paul Thompson has been photographing weddings for 30 years and given seminars all over the world. The artistry that he captures on weddings is world-renowned. Eight years ago, Paul and partner Larry Crandall started the digital book industry and formed White Glove First Edition Books. (www.wgbooks.com)

Brook and Alisha Todd have become known for their elite brand of wedding photojournalism. Together, they photograph the wedding with "one passion and two visions." The Todds are members of PPA and WPPI and have been honored in WPPI's print competition. (www.fineartweddings.com)

Ellie Vayo owns a successful studio in Mentor, Ohio. She is part of the Fuji Talent Team and lectures throughout the country. In partnership with General Products, she created the "Ellie Vayo Senior Album." She is the author of *The Art and Business of High-School Senior Portrait Photography* (Amherst Media, 2002). (www.evayo.com)

J.D. Wacker owns Photography by J.D., a studio in Clintonville, Wisconsin. J.D. is a recipient of the Kodak Gallery Elite Grand Award and a member of Kodak's Digital Focus Group, an advisory panel of digital imaging experts. He is the author of *Master Posing Guide for Portrait Photographers* (Amherst Media, 2001). (www.photobyjd.com)

Tim and Beverly Walden of Kentucky both hold Master of Photography and Craftsman Degrees and have been awarded many Kodak Gallery and Gallery Elite Awards. Beverly and Tim have also been awarded the Master Photographer of the Year Award several times. (www.waldensphotography.com)

David Wendt of Cincinnati, OH, spent years shooting traditional commercial work and stock photography and is now best known for his photographs of "fast, expensive" cars. He is an expert and setting up, lighting, and shooting cars, and his images can be seen in his calendars (available from www.calendars.com). (www.wendtworldwide.com)

David Anthony Williams owns and operates Heartworks, a wedding and portrait studio located in Australia. Williams is a lauded member of the Australian Institute of Professional Photography and WPPI, having won numerous distinctions from both. (www.davidwilliams-heartworks.com)

Robert L. Williams is a three-time recipient of the Akron Society of Professional Photographers' Photographer of the Year award. He is in the 2005 top five photographers of the year in the Mid-East region. In addition, Robert holds a Master of Photographer degree and Photographic Craftsman degree.

Robert T. Williams is a wedding and lifestyle photographer. He has been a featured speaker at conventions across the country and his images have appeared in *Ebony, Jet, InStyle Weddings, Wedding Style, Elegant Bride, Town & Country, Studio Photography & Design* and *Bride's Day.* (www.roberttwilliams.com)

Reed Young graduated from Brooks Institute of Photography in February of 2005 and currently works and lives in New York City. He plans to attend Fabrica, a sponsored artists' "factory" in Northern Italy, in 2006. He looks forward to collaborating with other artists and building a new body of work while he's there. (www.reedyoung.com)

Yervant Zanazanian was born in Ethiopia then lived and studied in Italy prior to settling in Australia 25 years ago. Today Yervant owns a prestigious photography studio that services national and international clients. He has won countless awards and has been Australia's Wedding Photographer of the Year three times. (www.yervant.com)

Monte Zucker is famous for perfection in posing and lighting and contemporary yet classical photographs. He has been bestowed every major honor the photographic profession can offer, including WPPI's Lifetime Achievement Award. He is also known industry wide as an exceptional photographic instructor. (www.montezucker.com)

INDEX